The Relationship of
Painting and Literature

AMERICAN STUDIES INFORMATION GUIDE SERIES

Series Editor: Donald Koster, Professor of English, Adelphi University, Garden City, New York

Also in this series:

AFRO-AMERICAN LITERATURE AND CULTURE SINCE WORLD WAR II—*Edited by Charles D. Peavy**

AMERICAN ARCHITECTURE AND ART—*Edited by David M. Sokol*

AMERICAN FOLKLORE—*Edited by Richard M. Dorson**

AMERICAN HUMOR AND HUMORISTS—*Edited by M. Thomas Inge**

AMERICAN LANGUAGE AND LITERATURE—*Edited by Henry Wasser**

AMERICAN POPULAR CULTURE—*Edited by Marshall W. Fishwick and Larry Landrum**

THE AMERICAN PRESIDENCY—*Edited by Kenneth E. Davison**

AMERICAN RELIGION AND PHILOSOPHY—*Edited by Ernest R. Sandeen and Frederick Hale*

AMERICAN STUDIES—*Edited by David W. Marcell**

ANTHROPOLOGY OF THE AMERICAS—*Edited by Thomas C. Greaves**

EDUCATION IN AMERICA—*Edited by Richard G. Durnin**

HISTORY OF THE UNITED STATES OF AMERICA—*Edited by Ernest Cassara*

NORTH AMERICAN JEWISH LITERATURE—*Edited by Ira Bruce Nadel**

SOCIOLOGY OF AMERICA—*Edited by Charles Mark*

TECHNOLOGY AND HUMAN VALUES IN AMERICAN CIVILIZATION—*Edited by Stephen Cutliff, Judith A. Mistichelli, and Christine M. Roysdon**

WOMAN IN AMERICA—*Edited by Virginia R. Terris**

*in preparation

The above series is part of the
GALE INFORMATION GUIDE LIBRARY

The Library consists of a number of separate series of guides covering major areas in the social sciences, humanities, and current affairs.

General Editor: Paul Wasserman, Professor and former Dean, School of Library and Information Services, University of Maryland

Managing Editor: Denise Allard Adzigian, Gale Research Company

The Relationship of Painting and Literature

A GUIDE TO INFORMATION SOURCES

Volume 4 in the American Studies Information Guide Series

Eugene L. Huddleston

Professor of American Thought and Language
Michigan State University
East Lansing

Douglas A. Noverr

Associate Professor of American Thought and Language
Michigan State University
East Lansing

Gale Research Company
Book Tower, Detroit, Michigan 48226

Library of Congress Cataloging in Publication Data

Huddleston, Eugene L 1931-
 The relationship of painting and literature.

 (American studies information guide series ;
v. 4)
 1. Ut pictura poesis (Aesthetics)--Bibliography.
2. Painting, American--Catalogs. 3. American
poetry--Bibliography. I. Noverr, Douglas A.,
joint author. II. Title.
Z5069.H84 [N66] 016.75913 78-53436
ISBN 0-8103-1394-4

VITAE

Eugene L. Huddleston, professor of American thought and language at Michigan State University, East Lansing, obtained his Ph.D. in early American literature from Michigan State University in 1965. Winner of the Norman Foerster Prize of 1966 for his article "Topographical Poetry of the Early National Period" in AMERICAN LITERATURE, he has since published in, among other journals, EARLY AMERICAN LITERATURE, NEW ENGLAND QUARTERLY, AMERICAN STUDIES, WESTERN FOLKLORE QUARTERLY, and PENNSYLVANIA MAGAZINE OF HISTORY AND BIOGRAPHY. Work in progress includes a reference guide on Thomas Jefferson and an article on the interior decor of McDonald's restaurants scheduled for a special issue of the JOURNAL OF AMERICAN CULTURE.

Douglas A. Noverr, associate professor of American thought and language at Michigan State University, East Lansing, earned his doctorate at Miami University of Ohio in 1972. He has published numerous articles on such nineteenth-century literary figures as Thoreau, Whitman, Dickinson, Margaret Fuller, and Charles Lanman. He is currently doing research on the relationships of nineteenth-century American literature and painting. Noverr is also actively involved in popular culture studies with published articles ranging from popular literature to baseball to radical sports literature. For a number of years he has served as an editor of THE AMERICAN EXAMINER: A FORUM OF IDEAS, an American studies journal. Work in progress includes a book on Thoreau and nineteenth-century American society and culture. In 1976-77 Noverr was a Senior Fulbright Lecturer in American Literature at Marie Curie Sklodowska University in Lublin, Poland.

CONTENTS

Contents

FOREWORD

More than a century ago Sidney Lanier in his unique poem "The Symphony" defined poetry as "music in search of a word." His recognition of the close association of the two arts has been noted by many others through the years. Nor has music been the only artistic medium related to literature. Most particularly, the relationship of painting to literature, and most frequently to poetry, has been increasingly remarked within the past hundred years.

In the present volume of the Gale information guides in American Studies, Eugene Huddleston and Douglas Noverr have provided a useful key to the connection of American literature and painting. Their bibliographical guide should be helpful to those engaged in interdisciplinary research, to students of American cultural history, and to all those who may have discerned a kinship between the two arts without fully realizing its extent.

The salient feature of the present work is its extensive checklist and appendixes that underscore the relationship of specific American poems to specific American paintings. But there is much else in this unusual book, including an extensive listing of books, monographs, and articles on the ut pictura poesis theme. Teachers who are interested in making their courses in American literature or art history more interdisciplinary will find that this guide leads to much material that they can readily employ toward achieving that goal. Above all else, it is my confident expectation that Huddleston and Noverr will, through this work, assist the breaking down of the artificial compartmentalization of learning.

Donald N. Koster
Series Editor

PREFACE: HOW TO USE THIS GUIDE

The guide comprises a checklist of analogous American poems and paintings as well as appendixes containing previously published pairings, in addition to other bibliographical compilations on the relationship of American literature to painting.

As a practical reference tool the checklist and appendixes, together with the bibliographical listings which follow, fill a gap in the study of the relationship of literature to painting, a relationship which, as explained in the introduction, has been so close that it has inspired reactions from notable poets, artists, and philosophers from Horace, through Lessing, to the late Frank O'Hara. Because any study of the relationship involves a cross-cultural approach, neither wholly in literature nor art, few have attempted bibliographies on the relationship and its history. Even fewer have compiled specific poems and paintings directly or otherwise analogically related as we have done in our checklist and appendixes.

Our bibliographical guide, besides being a practical reference and research tool, will enhance the pleasure of poetry readers and art observers, disclosing a kinship that they probably did not realize was so extensive. Students of American culture and students of the history of poetry and of art will find defined, delimited, and classified an area in which previously they would be fortunate to come across an occasional article on the relationship in an art periodical such as ART IN AMERICA, or in an American studies journal such as AMERICAN QUARTERLY. Students' only resources on the relationship in indexes would have been the voluminous ART INDEX, under the heading "Art and Literature," or under similar headings in the ESSAY AND GENERAL LITERATURE INDEX, READERS' GUIDE, SOCIAL SCIENCES AND HUMANITIES INDEX (superseded by the HUMANITIES INDEX), or GRANGER'S INDEX TO POETRY (1973 edition). Hopefully they might come across a painter's name in the index to the annual summary of literary scholarship published as AMERICAN LITERARY SCHOLARSHIP, which, however, contains only articles with a literary emphasis. The same limitation applies to the bibliography on the relationship of literature to the other arts published under separate cover by the Modern Language Association in 1959 and issued later with supplements derived from listings in the MLA INTERNATIONAL BIBLIOGRAPHY, itself issued yearly; these indexes are restricted to secondary sources and to literature and general esthetics. The most recently published bibliography on the relationship would be the January

1972 issue of the BULLETIN OF BIBLIOGRAPHY, but it too emphasizes theory and esthetics and general history of the relationship.

Our bibliography features an extensive listing of work done on theory, esthetics, and history (section V). It includes all the books, articles, and monographs we could find in English on the ut pictura poesis theme, arranged in five groups for convenience of use, one group comprising sources on the study of concrete poetry. Although we did not include in our checklist specific concrete poems--that is, poems breaking the barrier between word image and visual image--we believe that users of our listings would want to know the meaning of the term and the types and sources of concrete poetry. We also list a surprisingly wide variety of poems on the subject of painting, broken down into American poems on painters, American and foreign (section III), and into American poems on paintings themselves. We found the latter category to be so extensive that even though originally we had limited our search to poems on American paintings (for the checklist), we decided to list separately (section II) poems on foreign paintings and on American paintings not represented in the checklist. Additionally, we have grouped together all American poems we could find on unspecified paintings and painters and related subjects (IV). The compilations in our last section (VI) include sources on the relationship of American fiction to painting, and they give important evidence of the extent to which painting has influenced American prose literature and vice versa.

Section I of our guide contains the checklist and appendixes which focus on the relationship of specific American poems to specific American art works. Our checklist uncovers poems not only on specific paintings but also poems that are analogous to specific American paintings in subject, style, imagery, tone. The principles of pairing are explained in detail in the introduction.

The pairings in the checklist are grouped chronologically to conform to major periods of American intellectual development. Such arrangement discloses, from examination of titles alone, clues that suggest previously unexplored paths of American cultural and artistic history. In the individual pairings, which within each chronological group are arranged alphabetically by painters' names, we have indicated the closeness of the relationship between painting and poem (or poems) through the symbols (1), (2), and (3) placed before the title of each poem. The symbol (1) denotes the closest relationship; that is (a) the poem reacts specifically to a painting or vice versa, or (b) the poem, by poet-turned-painter, is on the poet's own painting or shares the same subject as his painting, or (c) the poem indicates a friendship or influential relationship between poet and painter but not necessarily an identical relationship in subject. The symbol (2) represents pairings of identical subjects. (They need not be identical in scope, however.) The symbol (3) stands for a closely analogous relationship as judged by more than one of the following criteria: closeness in subject, period of composition, imagery, tone, and other esthetic principles governing composition. The first two categories were determined by internal evidence, as well as by scholarship on the relationship, where such was found. The third category was determined by our judgment of the closeness of the relationship as determined by the above criteria.

In addition to our original research on the direct relationship of the Sister Arts, we have supplied an appendix bringing together all previously published pairings of poems and paintings that we could discover. Two of these resources are profusely illustrated art books, which match reproductions of American paintings with what the editors regard as appropriate (analogous) poetical excerpts (appendixes A and B). Two other appendixes (C and E) were derived from articles in art journals; one obtained its pairings through commissions to American poets for original poems which were passed on to compatible American artists for "companion pieces"; in the other, an editor asked American painters to pick a favorite contemporary poem and originate for it a work "in black and white in the medium of their choice." The other set of pairings, from ART IN AMERICA, is limited to pop poems by Ronald Gross, which he matched for the issue with his choice of pop paintings and mixed media.

INTRODUCTION

I

Horace's ut pictura poesis (as with painting, so with poetry) is so general a maxim that each age which uses it must define it anew. In the Renaissance it meant almost a virtual identification of the Sister Arts. Seeking to elevate the art of painting to a higher rank among the arts, Renaissance critics invoked the statements of Aristotle and Horace which seemed to substantiate an esthetic of interchangeability or cross-emulation in these two arts. New theories were needed to explain the particular geniuses of the age (Leonardo da Vinci and Michelangelo) as well as to advance the new humanistic ideals.

The humanistic goal of ideal imitation in form, action, and expression was reachable if the prescriptions of antiquity were followed, at least in respect to what critics believed to be the ideal models, formulas, and modes as these could be discerned in classical writings such as Horace's ARS POETICA. But as Renssalaer W. Lee has noted, French and English critics of the seventeenth century overextended these esthetic axioms, loose and general in nature during the sixteenth century, resulting in artificial parallels and "purely formal correspondences" which confused the natural boundaries between the arts and which minimized the central differences between the two arts, which were parallel or analogous but certainly not interchangeable.[1] What had started out as a laudable attempt on the part of Renaissance critics to show that painting could attain the range, power, beauty, and truth of poetry turned into a prescriptive set of rules which must be followed to attain noble expression and ideal form. The Sister Arts analogies and comparisons led to a loose and confusing critical vocabulary and to a false application of the modes of expression for one art form upon the other. A reaction set in, led by Lessing and Hazlitt, which attempted to reestablish necessary boundaries, which called for more temperate and judicious judgments and use of critical vocabulary, and which revealed the poverty of artistic expression under codified rules or dictums.

However, as Jean Hogstrum has noted, literary pictorialism, the specific tradition that supports the idea of the Sister Arts of painting and poetry, persisted

[1] Lee, "Ut Pictura Poesis: The Humanistic Theory of Painting," ART BULLETIN 22 (1940): 197-269.

and found expression in English Romantic poets, notably John Keats. It per-
sisted because the tradition of the Sister Arts relationship offered a wide range
of expression which enabled the poet to fix the poetic vision in time, place,
images, and imagination.[2] In the nineteenth century the pictorial tradition
enabled the poet to imitate the painter, to draw inspiration, visual effects,
methods of composition or structure, or to locate mythic traditions which were
compatible. Hagstrum implies, of course, that poets have always relied more
on painters than painters on poets, seeking to imitate the totality or quality of
expression found in a painting or number of paintings. Poets have often tried
to complement painting by composing poems on specific paintings and by trying
to capture in poetic form that which is expressed by the painter in overall
composition, tonality, coloring, dimensionality, visual surfaces and tactility,
conception of form and relationships of forms. Certain poets (e.e. cummings
is a notable example) have escaped the frustration of language and syntax by
becoming painters, while more modern poets have even made poems into large-
scale paintings in which poetry and painting are virtually inseparable.[3]

All of this background is necessary in order to understand the history of the
Sister Arts relationship in American poetry and painting, a rich and complex
tradition in which these two arts have paralleled and informed each other more
than American literary or art historians have suggested. An examination of
American cultural history will also reveal that American poets have been more
inspired by American painters than the reverse, thus illustrating that the visual
imagination and the capacity of the painters for externalizing this pictorial
imagination in concrete, tangible form is something greatly admired. Poets
have sought out painters for numerous personal reasons: perhaps because the
poet is a collector or art patron and wants to know the artistic source first-
hand; perhaps because the poet seeks companionship and stimulation among
those who work in a different medium and who share a camaraderie more open
and friendly than that of the artistic circle of poets; perhaps because the poet
admires and envies the physical skills and the bodily exertion of a painter,
who must of necessity be closer to the human sources of art; perhaps because
the poet finds a "kindred spirit" who, despite differences in art forms, seeks
the same ideals or esthetic goals of expression.

The Sister Arts have had such a rich and extensive history in America for two
central reasons. First, there has been the pervasive sense of democracy in the

[2] Hagstrum, "The Sister Arts: From Neoclassic to Romantic," in COMPARATISTS
AT WORK: STUDIES IN COMPARATIVE LITERATURE, ed. Stephen G. Nichols,
Jr., and Richard B. Vowles. (Waltham, Mass.: Blaisdell Publishing Company,
1968), pp. 170-73; see also, Roy Park, "'Ut Pictura Poesis': The Nineteenth-
Century Aftermath." THE JOURNAL OF AESTHETICS AND ART CRITICISM 28
(Winter 1969): 155-64.

[3] See, for example, Emmett Williams, ed., AN ANTHOLOGY OF CONCRETE
POETRY (New York: Something Else Press, 1967).

arts. Art, whether poetry or painting, has sought to evaluate, enlighten, or ennoble the life of the common man or it has celebrated or documented the commonly shared experience and the democratic assumptions, such as the innate worth and importance of each person to the life of the nation. Elitism or "art for art's sake" has never found widespread acceptance, although its proponents can be found at any time period. From the efforts of John Trumbull and Samuel F.B. Morse to popularize a heroic conception of the newly founded nation in subscription engravings or public exhibitions of canvases to the WPA Federal Arts Project programs of the 1930s, artists have always been aware of the virtues of a national art that was closely tied to the cultural, social, and political life of the people. Poets also sought to explore themes which would reveal the truths and strengths of a high-minded nation dedicated to political ideals which were undergirded with religious convictions and faith, as in the poetry of Philip Freneau, John Greenleaf Whittier, Walt Whitman, Carl Sandburg, and Robert Frost. This pervasive sense of the democratic ideal and its potential, although at certain historical periods waning and causing bitter national disillusionment, has made poets and painters aware of a common audience. The arts could serve the national ideals and could educate, enlighten, or reawaken a people to the underlying consensus that marked their nation as one of destiny and mission. If democracy found its strength in the people, then art could reveal how the people's lives and activities supported and strengthened the nation. These national virtues have been consistently seen as: uncommonly good common sense; simple, unaffected ways of living; hard work and productive contribution to the economy; healthy respect for others' opinions and beliefs; willingness to sacrifice personal advantages for the public good, and active interest in government. Not all American artists have been democrats, nor have all supported the democracy of the arts. However, the belief that the arts, society, the nation, and the people are all closely dependent and interrelated has facilitated an unusually close relationship between poetry and painting with more concern for practical applications than for abstract esthetics. The moralistic and social strains predominated in American art and poetry well into the twentieth century, when artists and poets became more interested in technique, innovation, and experimentation, in terms of form than in portraying moral or social truths.

The second factor which has enhanced a close parallel between American painting and poetry has been the ingrained predilection of artists for concrete things, visual facts, documentation of objects, places, activities, and situations. This literalism can be found in fashionable portraits, still life, primitives, landscapes, genre, scenes, and even in contemporary pop and op art. American taste in painting has, as Matthew Baigell noted, preferred the strongly mimetic or representational which values the thing, place, action, or person for itself and in itself.[4] Perhaps this preference exists because America has always valued the mechanical, inventive, and material as the means to an end--a more satisfying and comfortable life. The principle here is that things are what they are,

[4] A HISTORY OF AMERICAN PAINTING (New York: Praeger, 1971).

and painting is an especially suitable art form because it can intensify the per-
ceiver's awareness of form, solidity, shape, texture, rhythm, or movements as
well as call into play associational meanings which intensify understanding or
appreciation.

The ut pictura poesis tradition has flourished precisely because the words and
images of a poem based on a painting serve to articulate the experience of
responding to the particular and concrete in the work of art. As Jean Hag-
strum has noted, the ut pictura poesis tradition and the iconic tradition--the
poet's writing about actual and imagined art objects--have encouraged poets
to imitate the Sister Art of painting.[5] The poet recognizes and pays homage
to the intensely realized vision of the painter, who deals in visual icons,
symbols, and forms that often express a universality that poetry can never
achieve, even with the best of translation. Poets often use the terms "portrait,"
"sketch," "landscape," and "figure" in the titles of poems or as part of poetic
language; however, these are only broad parallels to what the painter does.
Painting differs from poetry in conception, painting being more pictorial and
formative; in execution and strategy, painting requiring more specific technical
skills which have long traditions of development in terms of innovation and
mastery; in finished product, painting having a greater sense involvement and a
more direction relation between the work and the perceiver.[6]

Poets recognize these critical differences and show their respect for painters
when the poets write their tributes to certain paintings or artists. Certain
painters--Washington Allston, Thomas Cole, Albert Blakelock, Albert P. Ryder,
and Marsden Hartley, notably--have also been poets but not accomplished nor
recognized poets. Their poetry was an extension of their whole artistic tem-
perament, a way of utilizing excess artistic energy or a way of complementing
their accomplishments in the visual and technical art of painting. Few poets
have been productive painters, although e.e. cummings was a notable exception,
and Henry Miller, a novelist, has shown skill as a painter.

Despite this limited crossing over between the two arts, the close associations
of painters and poets in American cultural history have been extensive and
vitally important. Poetry has strongly paralleled painting and at times, such
as during the romantic landscape period (1825-1870) and the period of experi-
mentation and innovation from the 1920s on, the two arts have been particu-

[5] COMPARATISTS AT WORK, p. 172.

[6] For important cautions on the differences between painting and poetry and the
importance of recognizing these in criticism and analysis, see Svetlana and Paul
Alpers, "Ut Pictura Noesis? Criticism in Literary Studies and Art History,"
in NEW DIRECTIONS IN LITERARY HISTORY, ed. Ralph Cohen (Baltimore, Md.:
The Johns Hopkins University Press, 1974), pp. 199-220 and Wilson O. Clough,
"Poetry and Painting," COLLEGE ART JOURNAL 17 (Winter 1959): 117-29.

larly close with relationships like those of Thomas Cole and Asher B. Durand with William Cullen Bryant, Charles Sheeler and Charles Demuth with William Carlos Williams, and Jackson Pollack and Willem deKooning with Frank O'Hara. In certain ways these friendships were accidents of place and circumstance, but they also show how American poets have always found something in painting which they found lacking in poetry.

Poets, after all, view art galleries, exhibitions, museums, and private collections, and they often collect art. Thus, many of the poems that have been written on a painting or painter are occasional verse; that is, they are inspired by specific place, time, experience, and circumstances. Many poets are also art critics, and thus poems reflect personal judgments, appreciations, observations, or revelations on art. The time-honored discourse of the painter to the poet, usually in the form of advice or admonition, shows the extent to which painting has inspired poets to address painters or pay tribute to the deep impressions paintings have made on the senses, mind, and imagination of the poet. Painters rarely respond that personally or intensely to poetry, although of course American painters have based paintings on poetry or done illustrated scenes from works of fiction.[7] Most notable among these have been Samuel F.B. Morse's UNA AND THE DWARF and Washington Allston's THE FLIGHT OF FLORIMEL from Spenser's FAERIE QUEEN, Thomas Cole's EXPULSION FROM THE GARDEN OF EDEN after Milton's PARADISE LOST and Cole's MOONLIGHT inspired by the opening stanza of Lord Byron's PARISINA, and John Trumbull's SCENE FROM OSSIAN'S 'FINGAL': LAMDERG AND GELCHOSSA. Artist William Page was said to have painted his FLIGHT INTO EGYPT intoning repeatedly verses from Browning's CHILDE ROLAND TO THE DARK TOWER CAME and Page's VENUS found lyrical inspiration from Thomas Hood's THE BRIDGE OF SIGHS, thus illustrating a different kind of influence that poetry has had on painters.[8] Painters are perhaps more independent and secure than poets, since painting requires more specific training, acquisition, and testing of skills, more exact tutelage, a knowledge of the patrons and buying public, and more accommodation to prevailing tastes and standards. Painters have therefore been more technically oriented. They have been more conceptually and perceptually developed to see, apprehend, conceive, and internalize what is already there. And they have been less philosophical or literary in the broad sense. The worlds of painting and poetry are notably different, and painters prefer things and visual representation of things, strongly conceived and expressed, to poetry. Painting requires vital and fresh vision with the skills and maturing style to express what is seen, felt, and known. Poetry relies more on traditions in terms

[7] For an interesting and revealing experiment see "Painters and Poets," ed. Francine du Plessix, ART IN AMERICA 53 (October-November 1976): 24-56. Francine du Plessix asked twenty-two American painters to illustrate in black and white "a contemporary poem of their own liking."

[8] Joshua C. Taylor, WILLIAM PAGE THE AMERICAN TITIAN (Chicago: University of Chicago Press, 1957), pp. 151, 153.

of types of poems, poetic form, and language usage. Meaning in poetry is subject to the verbal skills which the reader can bring to the poem in understanding its texture, its nuances and verbal tensions, its imagery, its pattern, its set of internal and external references. The poem as an art object is usually experienced more privately and personally, often in the context of other poems in a volume of poetry or an anthology.

American poetry has shown a vital responsiveness to American and European painting. Poets have created occasional poems on specific paintings and painters, and poets have emulated in their poetry the virtues of visual pictorialism found in the paintings they admire. Painters have always been concerned with seeing things, and by seeing them understanding and knowing them. Poets have recognized that painters have been less restricted in terms of the vital areas of conceptualization, perception, and visualization; and because poetry seeks to maximize expression through compression of form and language, the two arts have kindred ends. These ends are the producing of higher levels of awareness about the external, verifiable world and the internalizing of that world through a visual or verbal medium which enhances the experienced world in a pleasurable or ideal way. The Sister Arts in America have not borrowed substantially from each other in terms of modes, forms, and styles. But they have shown remarkable affinities which demonstrate that art seeks to inform and enhance life and that painter and poet can work in different art forms with mutual respect and often deep understanding for each other's particular way of examining and creating.

Being devotees of the fine arts and humanistic tradition, poets have found in painting intense visual stimulation because the discerning eye of the painter captures a wide range of detail, form, color, harmony, and texture. Stanley Kunitz has characterized the relation of poets and painters as one of a "civilized discourse" which it is imperative to continue, but he also admits that he envies painters for their natural gregariousness, their release of creative energy through the physical activity of painting, and their vital friendships with other painters. Kunitz also states that there is a radical movement in the arts which rejects "aesthetic limits" and which is pushing toward a "dissolution of boundaries."[9] Perhaps this is true, but the visual-verbal differences between painting and poetry as act of conceiving, creating, and communicating will always exist. Paintings are self-contained and self-explanatory, directly engaging, and demanding of visual response. Poems will always depend on the degree of language sophistication and sensitivity the reader brings to the poem, and the poet must accept the limitations of line, page enclosure, typesetting, and black and white visual relationship of words and page, and bound book format. But poetry will always have the advantages of the individual speaking voice behind the poem or in the poem and the universal stimulus of the universal vocabulary of sound and images or associations connected to words.

[9] Kunitz, "Editorial: The Sister Arts," ART IN AMERICA 53 (October–November 1965): 23.

The diversity of the two arts is an important part of their ability to engage, please, startle, and enlighten. Painters and poets have respected these differences as fellow creators, but there have been important points of contact, interrelationship, mutual support and encouragement, and exchange or interplay. If the two Sister Arts in America have been largely parallel, and if poetry has complemented or emulated painting, then a bibliographical history of the Sister Arts will aid in understanding and studying the history of this idea and relationship.

II

This checklist of paired American paintings and poems, the bibliography of American poems on painting and painters, and the bibliographical materials that follow are intended to provide an important source for those interested in the interrelationships and affinities in the arts.

The main part of the book consists of pairings of significant American paintings and poems, with the checklist divided into six chronological periods. The pairings were made according to strict criteria and considerations.

First, we located poems written about or inspired by specific paintings or paintings which were based on specific poems or parts of poems. These exact pairings are important to any study of notable friendships between painters and poets and the specific nature of the reciprocal influence of the Sister Arts. Further, these exact pairings illustrate the powerful attraction that painting has had for poets in evoking poems which attempt to capture or pay tribute to the strongly realized images and visions of major American artists.

Second, pairings were made between paintings and poems where known relationships or affinities between a painter and poet or vice versa could be established. These pairings reveal analogous or parallel modes of expression. At specific times or periods two artists (painter and poet) have employed similar techniques of revelation and artistic statement: association and extension; visual description and narration; use of iconographical, metaphorical, allegorical, historical, or esthetic symbols; compatible visions of the ideal in the form of the sublime, picturesque, beautiful; new visions of change and its impact on the physical and human worlds. It is important to see, in a specific context of comparison and contrast, how artistic visions are externalized and adapted to prevailing modes of expression or established conventions of style.

Third, pairings were established between paintings and poems which share in a more general way the characteristic spirit or expression of a literary period (neoclassical, romantic, realistic, naturalistic, modern) in which painting and poetry share a strong interest in the same topics, themes, or effects. Here the pairings document the ways in which the kindred arts of painting and poetry reveal continuous new developments in capturing and recording the texture of the American experience at both crucial and commonplace moments in the

history of the nation. American painting and poetry have been particularly reflective of the cross currents and significant shifts in national, regional, and local life. Art has variously played the roles of celebrator, commentator, mirrorer, satirizer, documentor, and idealizer. The poems and paintings should help to indicate the various transmutations which have taken place in the explicit and implicit social roles assigned to art. The verbal or visual context reveals a rich undersurface which often exposes the underlying social and artistic assumptions of the artist, helping one to understand the role that art plays in constantly orienting and reorienting society to life.

Pairings of a historical nature aid one in further understanding how extensive the thematic parallels can be or how complementary the artistic visions and statements can be. However, at the same time one can also appreciate the crucial differences between painting and poetry in terms of conception, execution, and composition; traditions and conventions in which the art object must be placed and understood; the experience of engagement; and the esthetic or critical judgments that are made. By seeing the richness of the parallelisms of the two arts, one can gain a greater understanding of why the temperaments, facilities, and lifestyles of painters and poets have been, and continue to be, so radically different.

It is hoped that the chronological divisions of the pairings will help those who by training and orientation prefer a chronological approach according to acknowledged major periods and divisions. Certain literary and historical periods, notably those of the nineteenth century, are fuller than others in terms of the number of pairings provided. The nineteenth century saw remarkably similar interests and expressions in the areas of romantic landscape (whether sublime, picturesque, beautiful, topographical); genre scenes or objects of typical American life which revealed local, regional, or national traits or conditions; sentimentalized views of home, women, and cherished customs which stemmed the tide of change; and visions of a grand continent destined to be a glorious Western empire. Other chronological periods, such as the last (after 1940), show painting and poetry concerned more with experimentation, esthetic involvement on the part of the artist with the art object and its qualities, radical protests against a Philistine mass culture and against the evils of government and technology, art as radical and humanistic statement, art as total freedom of expression and living.

In addition to these pairings we have also included a bibliography of poems by American poets on specific painters, paintings, and subjects related to painting, extending the focus to include American poets' interest in European painting as well as American. This listing, organized alphabetically is intended to show the extent of the attraction of painting for poets, the specific painters or kinds of paintings preferred, and the particular affinities or friendships that have developed between painters and poets. Neither this listing nor the pairings are intended to be exhaustive. It is hoped that the major poems on painting and painters have been located and included and that this listing will provide the nucleus for a more complete list. The compilers' intent is primarily to open up to serious investigation this subject of the relationship of the Sister Arts

and the parallel or complementary trends in literature and painting and to provide with a ready source of materials those who teach interdisciplinary courses.

To aid individual research we have added a bibliography of books and articles in the English language which have advanced the study of the relationship of painting and literature in terms of theory, esthetics, cross-influences, specific friendships and interrelationships, and historical developments. In our appendixes we have included sources and listings of specific pairings between American painting and literature which have already been made and published. These indicate the focus and direction of work already done in this area.

We hope that this bibliographical work will stimulate substantial new research into this vital area of American literature and art history as well as document the important work which has been accomplished by resourceful scholars with interdisciplinary talents. We hope that teachers will find materials that will aid in making American literature or art history courses more interdisciplinary. Lastly, we hope that this work will further our national appreciation of the Sister Arts as distinct yet complementary modes of expression and statement which inform and enrich our lives, collectively and individually.

Section I

CHECKLIST OF ANALOGOUS PAINTINGS
AND POEMS

Pairings 1620-1790
FROM BRITISH COLONIALS TO AMERICANS:
STRUGGLING FOR IDENTITY

1 Anonymous. MRS. DAVID PROVOOST. ca. 1700. New York Histori-
cal Society. ---(3) Timothy Dwight. "A Female Worthy." COLUMBIAN
MUSE. New York: J. Carey, 1794, pp. 207-9.

2 _____. MRS. ELIZABETH FREAKE AND BABY MARY. ca. 1674.
Worcester Art Museum, Worcester, Mass. ---(3) Anne Bradstreet. "Be-
fore the Birth of One of Her Children." THE WORKS OF ANNE BRAD-
STREET. Ed. Jeannine Hensley. Cambridge, Mass.: Harvard University
Press, 1967, p. 224.

3 _____. REV. JAMES PIERPONT. 1711. Yale University Art Gallery,
New Haven, Conn. ---(3) John Wilson. "A Copy of Verses Made by
that Reverend Man of God Mr. John Wilson, Pastor to the first Church in
BOSTON; on the Sudden Death of Mr. Joseph Brisco Who was translated
from Earth to Heaven Jan. 1. 1657." HANDKERCHIEFS FROM PAUL.
Ed. Kenneth B. Murdock. New York: Garrett Press, 1970.

4 Copley, John Singleton. WATSON AND THE SHARK. 1778-82. De-
troit Institute of Arts. ---(3) Philip Freneau. "The Hurricane." THE
POEMS OF PHILIP FRENEAU. Ed. Fred L. Pattee. Princeton, N.J.:
The University Library, 1902, vol. 2: 250-51.

5 Earl, Ralph. LOOKING EAST FROM DENNY [LEICESTER] HILL. ca.
1798. Worcester Art Museum, Worcester, Mass. ---(3) Henry Maurice
Lisle. MILTON HILL; A POEM. Boston: E. Lincoln, 1803.

6 Hesselius, Gustavus. BACCHUS AND ARIADNE. ca. 1720-30. Detroit
Institute of Arts. ---(2) William Maxwell. "Ariadne to Theseus."
SPECIMENS OF THE AMERICAN POETS, (1822). London: Printed for
T. and J. Allan, 1822, pp. 174-80. Rpt. Delmar, N.Y.: Scholars'
Facsimiles and Reprints, 1972.

7 Peale, Charles Willson. GEORGE WASHINGTON (AT PRINCETON).
 1779. Pennsylvania Academy of Fine Arts, Philadelphia. ---(2) Emilia.
 "Addressed to General Washington, in the Year 1777, after the battles of
 Trenton and Princeton." COLUMBIAN MAGAZINE 1 (January 1787): 245.

8 Pelham, Peter. REV. MATHER BYLES. ca. 1730. American Antiquarian
 Society, Boston. ---(3) Mather Byles. "To an ingenious young Gen-
 tleman, on his dedicating a Poem to the Author." POEMS ON SEV-
 ERAL OCCASIONS. Boston: S. Kneeland and T. Green, 1744, pp. 49-57.
 Rpt. New York: Facsimile Text Society by Columbia University Press,
 1940.

9 Smibert, John. THE BERMUDA GROUP. 1729. Yale University Art Gal-
 lery, New Haven, Conn. ---(2) George Berkeley. "Verses on the Pros-
 pect of Planting Arts and Learning in America." OXFORD BOOK OF
 EIGHTEENTH CENTURY VERSE. Oxford: Oxford University Press, 1926,
 pp. 219-20. Also, (3) Philip Freneau and H.H. Brackenridge. "The
 Rising Glory of America." [1772] THE POEMS OF PHILIP FRENEAU.
 Ed. Fred L. Pattee. Princeton, N.J.: The University Library 1902,
 vol. 1: 80-81.

10 Smith, Captain Thomas. SELF-PORTRAIT. ca. 1690. Worcester Art
 Museum, Worcester, Mass. ---(3) John Saffin. "Consideratus Consideran-
 dus." SEVENTEENTH-CENTURY AMERICAN POETRY. Ed. Harrison T.
 Meserole. New York: Doubleday, 1968, pp. 196-97.

11 Stuart, Gilbert. CHIEF JOSEPH BRANT. 1786. New York State His-
 torical Association, Cooperstown. ---(3) Charles A. Jones. "Tecumseh."
 SELECTIONS FROM THE POETICAL LITERATURE OF THE WEST. Ed.
 William D. Gallagher. Cincinnati: U.P. James, 1841, pp. 40-42.
 Also, (3) William Dunlap. "Logan." AMERICAN POEMS, SELECTED
 AND ORIGINAL. Ed. Elihu H. Smith. Litchfield: Collier and Buel,
 1793, p. 287. Also, (3) Samuel Webber. "Logan." SPECIMENS OF
 AMERICAN POETRY. Ed. Samuel Kettell. Boston: S.G. Goodrich,
 1829, vol. 3: 155-59.

12 _____. MRS. PEREZ MORTON. ca. 1802. Worcester Art Museum,
 Worcester, Mass. ---(1) Sarah Wentworth [Mrs. Perez] Morton. "To
 Mr. Stuart on his portrait of Mrs. M." and Gilbert Stuart [?]. "To Mrs.
 M----n." PORTFOLIO 3 (June 1803): 193. See William T. Whitley.
 GILBERT STUART. Cambridge, Mass.: Harvard University Press, 1932,
 pp. 118-20.

13 _____. GEORGE WASHINGTON (Vaughan Portrait). 1795. National
 Gallery of Art, Washington, D.C. ---(2) James Jeffrey. "Washington."
 POEMS OF AMERICAN HISTORY. Ed. Burton E. Stevenson. Boston:
 Houghton Mifflin, 1936, pp. 275-76. Also, (2) David Humphreys. "Mount

Vernon. An Ode inscribed to General Washington . . . 1786." CO-
LUMBIAN MAGAZINE 1 (January 1787): 246-47.

14 . GEORGE WASHINGTON (Athenaeum). 1796. Museum of Fine
Arts, Boston. ---(2) Philip Freneau. "Occasioned by General Washington's
Arrival in Philadelphia, on his way to his Residence in Virginia (December
1783)." POEMS WRITTEN BETWEEN THE YEARS 1768 AND 1794. Mon-
mouth, N.J.: Printed at the press of the author, at Mount-Pleasant, near
Middletown-Point, 1795, pp. 262-64. Rpt. Delmar, N.Y.: Scholars'
Facsimiles and Reprints, 1976.

15 . THE SKATER. 1782. National Gallery of Art, Washington,
D.C. ---(2) Philip Freneau. "The [Ice] Bridge of Delaware." POEMS
WRITTEN BETWEEN THE YEARS 1768 AND 1794. Monmouth, N.J.:
Printed at the press of the author, at Mount-Pleasant, near Middletown-·
Point, 1795, p. 103. Rpt. Delmar, N.Y.: Scholars' Facsimiles and Re-
prints, 1976.

16 Trumbull, John. BATTLE OF BUNKER'S HILL. 1785. Yale University
Art Gallery, New Haven, Conn. ---(2) Epes Sargent. "The Death of
Warren." POEMS OF AMERICAN HISTORY. Ed. Burton E. Stevenson.
Boston: Houghton Mifflin, 1936, p. 166.

17 . GENERAL GEORGE WASHINGTON BEFORE THE BATTLE OF
TRENTON. After 1972. Metropolitan Museum of Art, New York.
---(2) George Henry Calvert. "Washington--From Arnold and Andre."
CYCLOPEDIA OF AMERICAN LITERATURE. Ed. E.A. and G.L. Duyckinck.
Philadelphia: Rutter, 1880, vol. 2: 193-94.

18 . THE SURRENDER OF LORD CORNWALLIS AT YORKTOWN,.
VIRGINIA, 19 OCTOBER, 1781. 1824. U.S. Capitol, Washington,
D.C. ---(2) Anon. "Cornwallis's Surrender." POEMS OF AMERICAN
HISTORY. Ed. Burton E. Stevenson. Boston: Houghton Mifflin, 1936,
p. 256.

19 West, Benjamin. THE DEATH OF WOLFE. 1770. The National Gallery
of Canada, Ottawa. ---(2) Charles Sangster. "Wolfe and Montcalm."
POEMS OF AMERICA: BRITISH AMERICA. Ed. Henry W. Longfellow.
Boston: Houghton Mifflin, 1882, pp. 59-61. Also, (2) Atlanticus. "Death
of General Wolfe." PENNSYLVANIA MAGAZINE: or, AMERICAN
MONTHLY MUSEUM 1 (March 1775): 134.

20 . ELIZABETH PEEL. ca. 1756. Grosse Evans. BENJAMIN
WEST AND THE TASTE OF HIS TIMES. Carbondale: Southern Illinois
University Press, 1959, plate 12. ---(2) Lovelace [Joseph Shippen?].
"Upon Seeing the Portrait of Miss [Anne Hollingsworth Wharton] by Mr.
West." THE AMERICAN MAGAZINE AND MONTHLY CHRONICLE 1
(February 1758): 238.

21 _____. SAUL AND THE WITCH OF ENDOR. 1777. Wadsworth Athe-
neum, Hartford, Conn. Also, William S. Mount. SAUL AND THE
WITCH OF ENDOR. 1828. National Collections of Fine Arts, Smith-
sonian Institution. ---(2) William Gilmore Simms. "Saul at Endor; A
Scripture Legend." POEMS, DESCRIPTIVE, DRAMATIC, LEGENDARY
AND CONTEMPLATIVE. Charleston, S.C.: John Russell, 1853, vol. 2:
334-39.

THE RISE OF NATIONALISM AND
JACKSONIAN DEMOCRACY

22 Allston, Washington. MOONLIT LANDSCAPE. 1819. Museum of Fine
 Arts, Boston. ---(3) Philip Freneau. "The Power of Fancy." THE
 POEMS OF PHILIP FRENEAU. Ed. Fred L. Pattee. Princeton, N.J.:
 The University Library, 1902, vol. 1: 34-39.

23 _____. THE RISING OF A THUNDERSTORM AT SEA. 1804. Museum
 of Fine Arts, Boston. ---(2) Philip Freneau. "Verses Made at Sea, in
 a Heavy Gale." THE POEMS OF PHILIP FRENEAU. WRITTEN CHIEFLY
 DURING THE LATE WAR. Philadelphia: Francis Bailey, 1786. Rpt.
 Delmar, N.Y.: Scholars' Facsimiles and Reprints, 1975. Also, (2) Anon.
 "The Description of a Storm at Sea." BOSTON MAGAZINE 1 (1784):
 437-38.

24 _____. SAMUEL TAYLOR COLERIDGE. 1814. Fogg Art Museum,
 Harvard University, Cambridge, Mass. ---(1) Washington Allston. "Son-
 net on the Late Samuel Taylor Coleridge." LECTURES ON ART AND
 POEMS. New York: Baker and Scribner, 1850. Rpt. as LECTURES ON
 ART AND POEMS (1850) AND MONALDI (1841). Gainesville, Fla.:
 Scholars' Facsimiles and Reprints, 1967.

25 Anonymous. A VIEW OF MOUNT VERNON. After 1790. National
 Gallery of Art, Washington, D.C. ---(2) John Searson. "Thoughts on
 Mount Vernon, the Seat of His Excellency George Washington." POEMS
 ON VARIOUS SUBJECTS. Philadelphia: Snowden & M'Corkle, 1797,
 pp. 90-91. Also, (2) David Humphreys. "Mount Vernon: An Ode, In-
 scribed to General Washington, Written at Mount Vernon, August 1786."
 THE MISCELLANEOUS WORKS OF COLONEL DAVID HUMPHREYS. New
 York: Hodge, Allen, and Campbell, 1790, pp. 68-70.

26 _____. INDIAN TREATY OF GREENVILLE. ca. 1795. Chicago His-
 torical Society. ---(2) James Elliot. "Lines, Commemorative of the
 Victory Obtained by General Wayne, and His Gallant Army, Over the
 Whole Hostile Force of the United Indian Nations, Northwest of the
 Ohio, Near the British Fort Miami, on the 20th of August, 1794--And

the Consequent Treaty of Peace with those Nations, Concluded in the Following Year. Written at <u>Greenville</u>, Head Quarters of the Legion of the United States." THE POETICAL AND MISCELLANEOUS WRITINGS OF JAMES ELLIOT. Greenfield, Mass.: Thomas Dickman, 1798, pp. 74-77.

27 ____. MOURNING PICTURE FOR POLLY BOTSFORD AND HER CHILDREN. ca. 1813. Abby Aldrich Rockefeller Folk Art Collection, Williamsburg, Va. ---(1) Stanley Kunitz. "Sacred to the Memory." CRAFT HORIZONS 34 (February 1974): 33. See Jean Lipman and Helen M. Franc. BRIGHT STARS; AMERICAN PAINTING AND SCULPTURE SINCE 1776. New York: E.P. Dutton, 1976, p. 58.

28 Audubon, John James. KINGBIRD. 1830. Plate 79 in THE BIRDS OF AMERICA. New York: Macmillan, 1944. ---(2) Alexander Wilson. "The Tyrant Fly-Catcher, or King Bird." THE POEMS AND LITERARY PROSE OF ALEXANDER WILSON, THE AMERICAN ORNITHOLOGIST. Ed. Alexander B. Grosart. Paisley, Scotland: A. Gardner, 1876, vol. 2, p. 184. Or Audubon. BLUEBIRD. (Plate 113). ---Wilson. "The American Blue-Bird," pp. 179-80.

29 ____. THE PASSENGER PIGEON. 1827-38. THE BIRDS OF AMERICA. New York: Macmillan, 1944. ---(1) Ann Stanford. "An American Gallery: John James Audubon, 'The Passenger Pigeon.'" THE DESCENT. New York: Viking Press, 1970, p. 39.

30 Birch, Thomas. BATTLE OF LAKE ERIE. ca. 1814. Pennsylvania Academy of Fine Arts, Philadelphia. ---(2) James Gates Percival. "Perry's Victory on Lake Erie." THE PATRIOTIC ANTHOLOGY. New York: Literary Guild of America, 1941, pp. 118-21.

31 ____. CONSTITUTION AND GUERRIERE. 1812. ---(2) Anon. "Constitution and Guerriere." AMERICAN WAR BALLADS AND LYRICS. Ed. George C. Eggleston. New York: G.P. Putnam's Sons, 1889, vol. 1, pp. 115-17. Also, (2) Philip Freneau. "On the Capture of the Guerriere." THE POEMS OF PHILIP FRENEAU. Ed. Fred L. Pattee. Princeton, N.J.: The University Library, 1902, vol. 3: 310-11.

32 ____. THE "WASP" AND THE "FROLIC." 1820. Museum of Fine Arts, Boston. ---(2) Anonymous. "The WASP'S Frolic." (1812). POEMS OF AMERICAN HISTORY. Ed. Burton E. Stevenson. Boston: Houghton Mifflin, 1936, p. 293.

33 Cole, Thomas. FROM THE TOP OF KAATERSKILL FALLS. 1826. Detroit Institute of Arts. ---(2) W.C. Bryant. "Kaaterskill Falls." POEMS. New York: Worthington Co., 1892, pp. 76-80.

34 _____. LANDSCAPE WITH DEAD TREE. ca. 1827-28. Rhode Island School of Design, Providence. ---(3) [John Dore?] "An Essay Upon Great Ossipee's Northern Prospect." MASSACHUSETTS MAGAZINE 7 (August 1795): 315.

35 _____. VIEW NEAR TICONDEROGA; OR MOUNT DEFIANCE. 1826. Fort Ticonderoga Museum, Fort Ticonderoga, N.Y. ---(2) Cornelia [pseud.]. "The Ruins of Crown-Point: An Elegy." NEW YORK MAGA-ZINE; OR, LITERARY REPOSITORY, 2, n.s. (February 1797): 101-3.

36 Doughty, Thomas. WINTER LANDSCAPE. 1830. Museum of Fine Arts, Boston. ---(3) D.F. (Anon.). "A Winter-Piece." AMERICAN MU-SEUM 6 (December 1789): 484. Also, (3) [Samuel Low]. WINTER DIS-PLAYED A POEM DESCRIBING THE SEASON IN ALL ITS STAGES AND VICCISSITUDES; AND OCCASIONALLY INTERSPERSED WITH A VARIETY OF MORAL AND SENTIMENTAL REMARKS. New York: Samuel London, 1784.

37 Fulton, Robert. PLATE THE SECOND. 1804. New York Public Library. ---(1) Ann Stanford. "An American Gallery: Robert Fulton, 'Plate the Second.'" THE DESCENT. New York: Viking Press, 1970, pp. 43-44.

38 Groombridge, William. FAIRMOUNT AND SCHUYLKILL RIVER. 1800. Historical Society of Pennsylvania, Philadelphia. ---(2) R.W. [Anon.]. "Meditations on the Banks of Schuylkill, Written in September, 1799." PHILADELPHIA REPOSITORY, AND WEEKLY REGISTER 1 (20 June 1801): 256.

39 Hicks, Edward. THE FALLS OF NIAGARA. ca. 1826-35. ---(2) Alex-ander Wilson. "The Foresters: A Poem Descriptive of a Pedestrian Journey to the Falls of Niagara, In the Autumn of 1804." POEMS AND MISCELLANEOUS PROSE. New York: Macmillan, 1944, vol. 2, con-clusion. See also text in PORT FOLIO, 3, 3d ser. (1810): 159-68, 176-87.

40 _____. THE PEACEABLE KINGDOM. ca. 1830. New York State His-torical Association, Cooperstown. ---(1) Ann Stanford. "An American Gallery: Edward Hicks, 'The Peaceable Kingdom,'" THE DESCENT. New York: Viking Press, 1970, pp. 48-49. Also, (1) Marge Piercy. "The Peaceable Kingdom," CAMPFIRES OF THE RESISTANCE. Indi-anapolis: Bobbs-Merrill, 1971, pp. 215-17. Also, (1) Samuel French Morse. "The Peaceable Kingdom," THE CHANGES. Denver: Alan Swallow, 1964, p. 48.

41 Jarvis, John Wesley. COMMODORE OLIVER PERRY AT THE BATTLE OF LAKE ERIE. 1816. ---(2) Anon. "The Battle of Erie." POEMS OF AMERICAN HISTORY. Ed. Burton E. Stevenson. Boston: Houghton Mifflin, 1936, pp. 303-5.

42 King, Charles Bird. THE ROPEWALK. ca. 1825. New York State Historical Association, Cooperstown. ---(3) Henry Wadsworth Longfellow. "The Ropewalk." THE COMPLETE POETICAL WORKS OF LONGFELLOW. Cambridge ed. Boston: Houghton Mifflin, 1922, p. 195.

43 _____. THE VANITY OF AN ARTIST'S DREAM. ca. 1830. Fogg Art Museum, Harvard University, Cambridge, Mass. ---(3) Edgar Allen Poe. "The Raven." AMERICAN POETRY. Ed. Gay W. Allen et al. New York: Harper & Row, 1965, pp. 269-73.

44 Krimmel, John L. INTERIOR OF AN AMERICAN INN. ca. 1813. Toledo Museum of Art, Toledo, Ohio. ---(2) Alexander Wilson. "Pat Doughtery's Hotel and Drygoods Store." THE FORESTERS: A POEM DESCRIPTIVE OF A PEDESTRIAN JOURNEY TO THE FALLS OF NIAGARA, IN THE AUTUMN OF 1804 in POEMS AND MISCELLANEOUS PROSE. New York: Macmillan, 1944, vol. 2: 134-35, ll. 801-54. See also text in PORT FOLIO, 1, 3d ser. (1809): 538ff.

45 Morse, Samuel F.B. VIEW FROM APPLE HILL, COOPERSTOWN. 1828-29. Collection of Stephen C. Clark, New York. ---(2) Roswell Park. "Cooperstown (In remembrance of a visit to Cooperstown and Party on the Otsego Lake, August 19, 1831)." THE POETS OF CONNECTICUT WITH BIOGRAPHICAL SKETCHES. Ed. Charles W. Everest. Hartford, Conn.: Case, Tiffany, and Burnham, 1843, pp. 368-70.

46 Neagle, John. VIEW OF THE SCHUYLKILL. 1827. Art Institute of Chicago. ---(2) Philip Freneau. "Hermit's Valley, a Rural Scene on the Schuylkill." POEMS WRITTEN AND PUBLISHED DURING THE AMERICAN REVOLUTIONARY WAR. Philadelphia: Lydia R. Bailey, 1809, vol. 2: 233-34. Also, (2) O.D. [Anon.]. "Verses Written on the Schuylkill." EYE. Philadelphia. 2 (29 December 1808): 309-10.

47 Peale, Rembrandt. THOMAS JEFFERSON. 1805. New York Historical Society. ---(2) Stephen Vincent Benet. "Thomas Jefferson." SELECTED WORKS. New York: Farrar & Rinehart, 1942, vol. 1: 398-400.

48 Sargent, Henry. THE DINNER PARTY. ca. 1815-20. Museum of Fine Arts, Boston. ---(2) Daniel McKinnon. "Anniversary Dinner," in Description of the City and its Amusements in the Winter." DESCRIPTIVE POEMS, CONTAINING PICTURESQUE VIEWS OF THE STATE OF NEW YORK. New York: T. and J. Swordses, 1802, pp. 57-79.

49 Strickland, William. VIEW OF BALLSTON SPA, NEW YORK. ca. 1794. New York Historical Society. ---(1) Ann Stanford. "An American Gallery: William Strickland, 'View of Ballston Spa, New York.'" THE DESCENT. New York: Viking Press, 1970, p. 40. Also, (2)

Thomas Law. "Address to the Springs." BALLSTON SPRINGS. New York: S. Gould, 1806, pp. 6-7.

50 Trumbull, John. THE DECLARATION OF INDEPENDENCE. 1818. Rotunda, U.S. Capitol, Washington, D.C. ---(1) Joseph Rodman Drake. "The National Painting." THE NATIONAL ADVOCATE, 15 March 1819; text of poem in THE LIFE AND WORKS OF JOSEPH RODMAN DRAKE. Boston: Merrymount Press, 1935, pp. 313-14.

51 _____. VIEW OF NIAGARA ON THE BRITISH SIDE. 1807. Wadsworth Atheneum, Hartford, Conn. ---(2) Anon. "Lines Written at Niagara." PORT FOLIO 4 (11 July 1807): 31-32.

52 Vanderlyn, John. ARIADNE ASLEEP ON THE ISLAND OF NAXOS. 1814. Pennsylvania Academy of Fine Arts, Philadelphia. ---(1) Henry Theodore Tuckerman. "Vanderlyn's ARIADNE." POEMS. Boston: Ticknor, Reed, and Fields, 1851, p. 148. Also, (2) Lloyd Mifflin. "Theseus and Ariadne." AN AMERICAN ANTHOLOGY, 1787-1900. Ed. Edmund Clarence Stedman. Boston and New York: Houghton Mifflin, 1900, pp. 496-97.

53 _____. THE DEATH OF JANE MCCREA. 1804. Wadsworth Atheneum, Hartford, Conn. ---(2) Wheeler Case. "The Tragical Death of Miss Jane M'Crea, Who was Scalped and Inhumanly Butchered by a Scouting Party . . . " [1778]. REVOLUTIONARY MEMORIALS. Ed. Stephen Dodd. New York: M.W. Dodd, 1852, pp. 37-39. Also, (2) Joel Barlow. "Murder of Lucinda." THE COLUMBIAD 6 (1807): 240.

54 _____. MARIUS AMIDST THE RUINS OF CARTHAGE. 1807. M.H. deYoung Memorial Museum, San Francisco. ---(2) William Gilmore Simms. "Caius Marius." POEMS, DESCRIPTIVE, DRAMATIC, LEGENDARY, AND CONTEMPLATIVE. Charleston, S.C.: John Russell, 1853, pp. 300-11. Also, (1) Lydia M. Child. "Marius Seated on the Ruins of Carthage." ARTHUR'S MAGAZINE 2 (November 1844): 219. Also, (2) William Leggett. "Written Beneath a Dilapidated Tower, Yet Standing Among the Ruins of Carthage." THE CRITIC: A WEEKLY REVIEW OF LITERATURE, FINE ARTS, AND THE DRAMA 1 (6 December 1828): 95.

55 _____. VIEW OF NIAGARA FALLS. 1827. Senate House Museum, Kingston, N.Y. ---(2) Thomas Gold Appleton. "Niagara." POEMS OF AMERICA: MIDDLE STATES-WESTERN STATES. Ed. Henry W. Longfellow. Boston: Houghton Mifflin, 1882, pp. 459-61.

56 West, Benjamin. DEATH ON THE PALE HORSE. 1802. Philadelphia Museum of Art. ---(2) Philip Freneau. "The House of Night." THE POEMS OF PHILIP FRENEAU. Ed. Fred L. Pattee. Princeton, N.J.: The University Library, 1902, vol. 1: 212-39. Also, (3) Edgar Allan

Poe. "The City in the Sea." AMERICAN LITERATURE. Ed. Carl Bode et al. New York: Simon & Schuster, 1966, vol. 2: 23-24. Also, (1) William Leggett. "Death on the Pale Horse." THE CRITIC: A WEEKLY REVIEW OF LITERATURE, FINE ARTS, AND THE DRAMA 1 (10 January 1829): 175.

Pairings 1830-70
AMERICA AS ARCADIA

57 Allston, Washington. THE SPANISH GIRL IN REVERIE. 1831. Metro-
politan Museum of Art, New York. ---(1) Oliver Wendell Holmes.
"Illustration of a Picture 'A Spanish Girl in Reverie.'" THE COMPLETE
POETICAL WORKS OF OLIVER WENDELL HOLMES. Cambridge ed.
Boston: Houghton Mifflin, 1923, p. 325. Also, (2) Washington Allston.
"The Spanish Maid." LECTURES ON ART, AND POEMS (1850). New
York: Baker and Scribner, 1850. Rpt. as LECTURES ON ART, AND
POEMS (1860) AND MONALDI (1841). Gainesville, Fla.: Scholars'
Facsimiles and Reprints, 1967.

57a Anonymous. MEDITATION BY THE SEA. ca. 1850-60. Museum of
Fine Arts, Boston. ---(3) Robert Frost. "Neither Out Far Nor In Deep."
COMPLETE POEMS. New York: Henry Holt and Co., 1949, p. 394.

58 Baker, Charles. VIEW IN FRANCONIA NOTCH. 1848. ---(2) John
Greenleaf Whittier. "Mountain Pictures I. Franconia from the Pemigewas-
set." THE POETICAL WORKS OF JOHN GREENLEAF WHITTIER. Boston:
Ticknor and Fields, 1857, vol. 1: 363-64.

58a Beard, James Henry. THE LAST OF THE RED MEN. 1847. Museum of
Fine Arts, Boston. ---(1) William Cullen Bryant. "An Indian at the
Burial Place of His Fathers." See Bertha M. Stearns. "Nineteenth-
Century Writers in the World of Art." ART IN AMERICA 40 (Winter
1952): 33.

59 Bierstadt, Albert. THE ROCKY MOUNTAINS. 1863. Metropolitan
Museum of Art, New York. ---(2) Horatio Nelson Powers. "A Sunset
at Longmont [Colorado]." POEMS OF AMERICA: MIDDLE STATES-
WESTERN STATES. Ed. Henry W. Longfellow. Boston: Houghton
Mifflin, 1882, pp. 84-86. Also, (3) Albert Pike. "Lines Written Upon
the Rocky Mountains." SELECTIONS FROM THE POETICAL LITERATURE
OF THE WEST. Ed. William D. Gallagher. Cincinnati: U.P. James,
1841, pp. 164-66.

59a _____. THE OREGON TRAIL. 1869. The Butler Institute of American Art, Youngstown, Ohio. ---(3) James Barton Adams. "The Dust of the Overland Trail." SONS OF COLORADO 1 (March 1907): 21.

60 Bingham, George Caleb. THE COUNTY ELECTION. 1851-52. City Art Museum, St. Louis. ---(2) Walt Whitman. "Election Day, November, 1884." COMPLETE POETRY AND SELECTED PROSE. Ed. James E. Miller, Jr. Boston: Houghton Mifflin, 1959, p. 357.

61 _____. DANIEL BOONE ESCORTING A BAND OF PIONEERS INTO THE WESTERN COUNTRY. 1851-52. Washington University, St. Louis. ---(3) Daniel Bryan. THE MOUNTAIN MUSE, COMPRISING THE ADVENTURES OF DANIEL BOONE; AND THE POWER OF VIRTUOUS AND REFINED BEAUTY. Harrisonburg, Va.: The author, 1813, pp. 111-19. Also, (3) William Stafford. "For the Grave of Daniel Boone." THE NORTON ANTHOLOGY OF POETRY. Ed. A.M. Eastman et al. New York: W.W. Norton, p. 1103.

62 _____. FUR TRADERS DESCENDING THE MISSOURI. 1845. Metropolitan Museum of Art, New York. ---(3) James Kirke Paulding. "Passage Down the Ohio." POEMS OF AMERICA: MIDDLE STATES-WESTERN STATES. Ed. Henry W. Longfellow. Boston: Houghton Mifflin, 1882, p. 131.

63 _____. THE WOOD BOAT. 1850. City Art Museum, St. Louis. ---(1) Walt Whitman. "Song of the Broad-Axe." LEAVES OF GRASS. Ed. Harold W. Blodgett and Sculley Bradley. New York: W.W. Norton, 1965, pp. 184-95. See Alfred Frankenstein. "American Art and American Moods." ART IN AMERICA 54 (1966): 76-87.

64 Church, Frederic Edwin. FLOATING ICEBERGS. 1859. The Cooper-Hewitt Museum of Decorative Arts and Design, Smithsonian Institution, New York. ---(2) Herman Melville. "The Berg (A Dream)." COLLECTED POEMS OF HERMAN MELVILLE. Ed. Howard P. Vincent. Chicago: Packard and Company, 1947, pp. 203-4. Also, (2) James Otis Rockwell. "To the Ice Mountain" and Thomas Buchanan Read. "Passing the Iceburgs." THE POETS AND POETRY OF AMERICA. Ed. Rufus W. Griswold. Philadelphia: Parry and McMillan, 1858, pp. 353, 585-86.

65 _____. THE HEART OF THE ANDES. 1859. Metropolitan Museum of Art, New York. ---(1) Thomas Buchanan Read. "Church's 'Heart of the Andes.'" POETICAL WORKS OF THOMAS BUCHANAN READ. Philadelphia: J.B. Lippincott, 1866, vol. 2: 414-15.

66 _____. NIAGARA. 1857. Corcoran Gallery of Art, Washington, D.C. ---(2) Thomas Law. "Niagara." (1806). BALLSTON SPRINGS. New York: S. Gould, 1806, pp. 8-10. Also, (1) John Frankenstein. AMERICAN

ART: ITS AWFUL ALTITUDE. A SATIRE. Cincinnati, 1864. Rpt. by Bowling Green University Popular Press, 1972, pp. 55-80. Also, (2) Christopher P. Cranch. "Niagara." POEMS. Philadelphia: Carey and Hart, 1844, pp. 26-27.

67 _____. TWILIGHT IN THE WILDERNESS. 1860. Cleveland Museum of Art. ---(3) Ephraim Peabody. "Western Scenery." SELECTIONS FROM THE POETICAL LITERATURE OF THE WEST. Ed. William D. Gallagher. Cincinnati: U.P. James, 1841, pp. 217-19.

68 Cole, Thomas. THE ARCHITECT'S DREAM. 1840. Toledo Museum of Art, Toledo, Ohio. ---(3) David Humphreys. "Future State of the Western Territory." COLUMBIAN MUSE. New York: J. Carey, 1794, pp. 162-65.

69 _____. THE COURSE OF EMPIRE: DESOLATION. 1836. ---(2) Timothy Dwight. "The Fall of Empire." GREENFIELD HILL. See CYCLO-PEDIA OF AMERICAN LITERATURE. Ed. E.A. and G.L. Duyckinck, Philadelphia: Rutter, 1880, vol. 1: 376-77.

70 _____. THE OXBOW OF THE CONNECTICUT RIVER NEAR NORTH-HAMPTON. 1836. Metropolitan Museum of Art, New York, and Victor DeGrailly "View from Mt. Holyoke." About 1840. Cleveland Museum of Art. ---(2) Henry Theodore Tuckerman. "Northampton." POEMS. Boston: Ticknor, Reed, and Fields, 1851, pp. 39-43. Also, (3) John G.C. Brainard. "On Connecticut River." CYCLOPEDIA OF AMERICAN LITERATURE. Ed. E.A. and G.L. Duyckinck, Philadelphia: Rutter, 1880, vol. 1: 967-68. Also, (1) Thomas Cole. [unititled poem]. AMERICAN PAINTINGS: A CATALOGUE OF THE COLLECTION OF THE METROPOLITAN MUSEUM OF ART. Greenwich, Conn.: New York Graphics Society, 1965, p. 228. Also, (2) William Cullen Bryant. "Monument Mountain." See Evelyn L. Schmitt. "Two American Roman-tics--Thomas Cole and William Cullen Bryant." ART IN AMERICA 47 (Spring 1953): 63.

71 _____. PROMETHEUS BOUND. 1846-47. Collection of Mr. and Mrs. John W. Merriam, Philadelphia. ---(2) James Russell Lowell. "Prome-theus." POEMS. Cambridge, Mass.: Metcalf and Company, 1849, pp. 67-84.

72 _____. SCHROON MOUNTAIN, ADIRONDACKS. 1838. Cleve-land Museum of Art. ---(1) Thomas Cole. "Song of a Spirit." In Louis Legrand Noble, THE LIFE AND WORKS OF THOMAS COLE. Cam-bridge, Mass.: Harvard University Press, 1964, p. 179.

73 _____. VOYAGE OF LIFE: YOUTH. 1842. Munson-Williams-Proctor Institute, Utica, N.Y. ---(2) Samuel Ewing. "Reflections in Solitude." PORT FOLIO 1 (31 January 1801): 40. Also, (2) William Cullen Bryant.

"The Stream of Life." See Evelyn L. Schmitt. "Two American Roman-tics--Thomas Cole and William Cullen Bryant." ART IN AMERICA 47 (Spring 1953): 61-68.

74 Cranch, Christopher P. AN AUTUMNAL STUDY. 1850. and AN AUTUMNAL LAKE. 1852. ---(1) Christopher P. Cranch. "October Afternoon" and "October." THE BIRD AND THE BELL, WITH OTHER POEMS. Boston: James R. Osgood and Company, 1875, pp. 119-20, 229-30.

75 Cropsey, Jasper. STARRUCA VIADUCT, SUSQUEHANNA VALLEY. 1865. Toledo Museum of Art, Toledo, Ohio. ---(3) Harley T. Dana. "Lines in Favor of Building the Albany and Susquehanna Railroad." (1856). STRAY POEMS AND EARLY HISTORY OF THE ALBANY AND SUSQUEHANNA RAILROAD. York, Pa.: P. Anstadt & Sons, 1903, pp. 111-14.

76 Doughty, Thomas. VIEW OF THE HIGHLANDS FROM NEWBURGH, NEW YORK. ca. 1840. Private Collection. ---(2) Daniel McKinnon. "Description of the Hudson River." DESCRIPTIVE POEMS, CONTAINING PICTURESQUE VIEWS OF THE STATE OF NEW YORK. New York: T. & J. Swordses, 1802, pp. 1-13.

77 Durand, Asher B. CAPTURE OF MAJOR ANDRE. 1833. Worcester Art Museum, Worcester, Mass. ---(2) Anon. "Brave Paulding and the Spy." POEMS OF AMERICAN HISTORY. Ed. Burton E. Stevenson. Boston: Houghton Mifflin, 1936, pp. 237-38.

78 _____. THE CATSKILL MOUNTAINS NEAR SHANDAKEN. Private Collection. ---(2) Theodore S. Fay. "Catskill Mountains, N.Y." POEMS OF AMERICA: MIDDLE STATES-WESTERN STATES. Ed. Henry W. Longfellow. Boston: Houghton Mifflin, 1882, pp. 48-49.

79 _____. IN THE WOODS. 1855. Metropolitan Museum of Art, New York. ---(2) William Cullen Bryant. "Inscription for the Entrance to a Wood." (1817). POEMS. New York: Worthington Co., 1892, pp. 190-91.

80 _____. KINDRED SPIRITS. 1849. New York Public Library. ---(2) William Cullen Bryant. "To Cole, the Painter, Departing for Europe." POEMS. New York: Worthington Co., 1892, p. 232. Also, (1) Marianne Moore. "The Camperdown Elm." COMPLETE POEMS OF MARIANNE MOORE. New York: Macmillan, 1967, p. 242.

81 _____. LANDSCAPE, SCENE FROM THANATOPSIS. 1850. Metro-politan Museum of Art, New York. ---(1) William Cullen Bryant. "Thanatopsis." NORTH AMERICAN REVIEW 3 (September 1817), 338-40, and POEMS. New York: Worthington Co., 1892, pp. 29-32.

82 ____. LANDSCAPE, SUMMER MORNING. 1850. Museum of Fine Arts, Boston. ---(1) William Cullen Bryant. "A Scene on the Banks of the Hudson." POEMS. New York: Worthington Co., 1892, pp. 194-95. See Bertha M. Stearns. "Nineteenth-Century Writers in the World of Art." ART IN AMERICA 40 (Winter 1952): 32.

83 ____. THE PRIMEVAL FOREST. 1854. Museum of Fine Arts, Boston. ---(1) William Cullen Bryant. "A Forest Hymn." POEMS. New York: Worthington Co., 1892, pp. 38-42. See Bertha M. Stearns. "Nineteenth-Century Writers in the World of Art." ART IN AMERICA 40 (Winter 1952): 33.

84 ____. SUNDAY MORNING. 1839. New York Historical Society. ---(2) Minnie Hite Moody. "Country Sabbath." MUSIC MAKERS. Ed. Stanton A. Coblentz. New York: Bernard Ackerman, 1945.

85 Fisher, Alvan. CORN HUSKING FROLIC. 1829-30. Museum of Fine Arts, Boston. ---(2) John Townsend Trowbridge. "An Idyl of Harvest Time." THE POETICAL WORKS OF JOHN TOWNSEND TROWBRIDGE. Boston: Houghton Mifflin, 1903. Rpt. New York: Arno Press, 1972. pp. 221-23.

86 Frankenstein, Godfrey. NIAGARA FALLS. ca. 1860. Cincinnati Art Museum. ---(2) Linus [pseud.]. "Niagara." AMERICAN MONTHLY MAGAZINE 4 (1835): 49-50.

87 Gifford, Sanford Robinson. SUNSET OVER NEW YORK BAY. 1878. Collection of Robert P. Weimann, Jr., Ansonia, Conn. ---(3) Marya Zaturenska. "May Morning: Hudson Pastoral." COLLECTED POEMS. New York: Viking, 1960, p. 134.

88 Hart, James M. VIEW ON THE HUDSON. 1859. New York State Historical Association, Cooperstown. ---(2) William Osborn Stoddard. "The Gates of the Hudson." POEMS OF AMERICA: MIDDLE STATES-WESTERN STATES. Ed. Henry W. Longfellow. Boston: Houghton Mifflin, 1882, pp. 102-4.

89 Hart, William. AFTER THE STORM. ca. 1870. M & M Karolik Collection, Museum of Fine Arts, Boston. ---(1) William Cullen Bryant. "After a Tempest." See Bertha M. Stearns. "Nineteenth-Century Writers in the World of Art." ART IN AMERICA 40 (Winter 1952): 33.

90 Havell, Robert. VIEW OF LAKE WINIPISEOGEE. 1849. Location unknown. Thomas Cole. NORTHWEST BAY LAKE WINNEPISSEOGEE. 1829. Wadsworth Atheneum, Hartford, Conn. ---(2) John Greenleaf Whittier. "A Summer Pilgrimage" and "Summer by the Lakeside Lake

Winnipesaukee." THE COMPLETE POETICAL WORKS OF JOHN
GREENLEAF WHITTIER. Cambridge ed. Boston: Houghton Mifflin, 1894,
pp. 147, 165-66.

91 Heade, Martin Johnson. GERTRUDE OF WYOMING. ca. 1850. Col-
lection of Mr. and Mrs. J. Robert Dodge. ---(2) Fitz Greene Halleck.
"Wyoming." POEMS OF AMERICA: MIDDLE STATES-WESTERN STATES.
Ed. Henry W. Longfellow. Boston: Houghton Mifflin, 1882, pp. 275-78.

92 ____. SUNSET OVER THE MARSHES. ca. 1863. Museum of Fine
Arts, Boston. ---(2) John Greenleaf Whittier. "Sunset on the Bearcamp."
THE COMPLETE POETICAL WORKS OF JOHN GREENLEAF WHITTIER.
Boston: ·Houghton Mifflin, 1894, pp. 161-62.

93 Hidley, Joseph H. POESTENKILL, NEW YORK. ca. 1850. Metropoli-
tan Museum of Art, New York. ---(3) [Anon.]. "Lines, Written at
Hempstead, L.I." LADY'S WEEKLY MISCELLANY, 30 May 1807, p. 248.

94 Homer, Winslow. PRISONERS FROM THE FRONT. 1866. Metropolitan
Museum of Art, New York. ---(3) Herman Melville. "The College
Colonel." THE AMERICAN POETS, 1800-1900. Ed. Edwin H. Cady.
New York: Scott, Foresman, 1966, p. 209.

95 Inness, George. DELAWARE WATER GAP. 1861. Metropolitan Museum
of Art, New York. ---(2) Elizabeth F. Ellett. "The Delaware Water-
Gap." POEMS OF AMERICA: MIDDLE STATES-WESTERN STATES. Ed.
Henry W. Longfellow. Boston: Houghton Mifflin, 1882, pp. 70-71.
First published in AMERICAN MONTHLY MAGAZINE 6 (1835): 155-56.

96 ____. THE LACKAWANNA VALLEY. 1855. National Gallery of
Art, Washington, D.C. ---(3) Jones Very. "The Railroad." POEMS
AND ESSAYS. Boston: Houghton Mifflin, 1886, p. 95.

97 ____. THE OLD MILL. 1849. Art Institute of Chicago. ---(2)
John Townsend Trowbridge. "The Mill-Pond." THE POETICAL WORKS
OF JOHN TOWNSEND TROWBRIDGE. Boston: Houghton Mifflin, 1903,
Rpt. New York: Arno Press, 1972, pp. 11-14.

98 Johnson, Eastman. OLD KENTUCKY HOME. 1859. New York Histori-
cal Society. ---(3) William J. Grayson. "The Hireling and the Slave."
(1854). THE HIRELING AND THE SLAVE, CHICORA, AND OTHER
POEMS. Charleston, S.C.: McCarter and Company, Publishers, 1856,
pp. 21-75.

99 Kensett, John Frederick. CASCADE IN THE FOREST. 1852. Detroit
Institute of Arts. ---(2) Ephraim Peabody. "Falls of a Forest Stream."

SELECTIONS FROM THE POETICAL LITERATURE OF THE WEST. Ed. William D. Gallagher. Cincinnati: U.P. James, 1841, pp. 82-85.

100 _____. COAST SCENE WITH FIGURES. 1869. Wadsworth Atheneum, Hartford, Conn. ---(3) John Greenleaf Whittier. "Hampton Beach." THE COMPLETE POETICAL WORKS OF JOHN GREENLEAF WHITTIER. Boston: Houghton Mifflin, 1894, pp. 142-43.

101 _____. HIGH BANK, GENESSEE RIVER. 1857. Corcoran Gallery of Art, Washington, D.C. ---(2) William Henry Cuyler Hosmer. "My Own Dark Genesee." POEMS OF AMERICA: MIDDLE STATES-WESTERN STATES. Ed. Henry W. Longfellow. Boston: Houghton Mifflin, 1882, pp. 80-81.

102 _____. LAKE GEORGE. 1869. or Martin Johnson Heade. LAKE GEORGE. 1862. ---(2) George Stillman Hillard. "Lake George." POEMS OF AMERICA: MIDDLE STATES-WESTERN STATES. Ed. Henry W. Longfellow. Boston: Houghton Mifflin, 1882, pp. 81-84.

103 _____. THIRD BEACH, NEWPORT. 1869. Art Institute of Chicago. ---(2) Henry Theodore Tuckerman. "Newport Beach." POEMS. Boston: Ticknor, Reed, and Fields, 1851, pp. 47-52.

104 _____. THUNDERSTORM, LAKE GEORGE. 1870. Brooklyn Museum, Brooklyn, N.Y. ---(2) John Greenleaf Whittier. "Storm on Lake Asquam." THE COMPLETE POETICAL WORKS OF JOHN GREENLEAF WHITTIER. Boston: Houghton Mifflin, 1894, p. 165.

105 _____. VIEW NEAR WEST POINT ON THE HUDSON. 1863. New York Historical Society. ---(2) Henry Theodore Tuckerman. "West Point." POEMS. Boston: Ticknor, Reed, and Fields, 1851, pp. 119-21. Also, in POEMS OF AMERICA: MIDDLE STATES-WESTERN STATES. Ed. Henry W. Longfellow. Boston: Houghton Mifflin, 1882, pp. 262-63.

106 Lane, FitzHugh. OWL'S HEAD, PENOBSCOT BAY, MAINE. 1862. Museum of Fine Arts, Boston. ---(2) John Greenleaf Whittier. "Penobscot Bay." POEMS OF AMERICA: NEW ENGLAND. Ed. Henry W. Longfellow. Boston: Houghton Mifflin, 1882, pp. 165-67.

107 _____. SHIPS IN ICE OFF TEN POUND ISLAND, GLOUCESTER. ca. 1850-60. Museum of Fine Arts, Boston. ---(3) John Townsend Trowbridge. "The Frozen Harbor." THE POETICAL WORKS OF JOHN TOWNSEND TROWBRIDGE. Boston: Houghton Mifflin, 1903, pp. 6-9. Rpt. New York: Arno Press, 1972.

108 Leutze, Emanuel Gottlieb. WASHINGTON CROSSING THE DELAWARE.
 1851. Metropolitan Museum of Art, New York. ---(2) Will Carleton.
 "Across the Delaware." POEMS OF AMERICAN HISTORY. Ed. Burton
 E. Stevenson. Boston: Houghton Mifflin, 1936, p. 188. Also, (2) Anon.
 "The Battle of Trenton." CURIOSITIES OF AMERICAN LITERATURE. Ed.
 Rufus W. Griswold. New York: D. Appleton and Co., 1844.

109 McEntee, Jervis. AUTUMN SCENE. 1861. Museum of Fine Arts, Boston.
 ---(1) William Cullen Bryant. "The Death of the Flowers." POEMS.
 New York: Worthington Co., 1892, pp. 274-76. See Bertha M. Stearns.
 "Nineteenth-Century Writers in the World of Art." ART IN AMERICA 40
 (Winter 1952): 33.

110 Mayer, Constant. NORTH AND SOUTH, AN EPISODE OF THE WAR.
 1865. Museum of Fine Arts, Boston. ---(1) William Cullen Bryant.
 "The Battle Field." See Bertha M. Stearns. "Nineteenth-Century
 Writers in the World of Art." ART IN AMERICA 40 (Winter 1952): 33.

111 Meeker, Joseph R. THE LAND OF EVANGELINE. St. Louis Art Mu-
 seum. ---(2) Henry W. Longfellow. "Evangeline: A Tale of Acadie."
 THE COMPLETE POETICAL WORKS OF LONGFELLOW. Boston: Hough-
 ton Mifflin, 1922, pp. 70-98. See this pairing in AMERICA'S FAVORITE
 POEMS. Ed. Linda Ann Hughes. Waukesha, Wis.: Country Beautiful,
 1975, p. 95

112 Morse, Samuel F.B. LAFAYETTE. 1825-26. Art Commission of the
 City of New York. ---(2) Dolly Madison. "LaFayette." 1848. POEMS
 OF AMERICAN HISTORY. Ed. Burton E. Stevenson. Boston: Houghton
 Mifflin, 1936, p. 349.

113 Mount, William S. THE BONE PLAYER. 1856. Museum of Fine Arts,
 Boston. ---(3) Fenton Johnson. "The Banjo Player." BOOK OF
 AMERICAN NEGRO POETRY. Ed. James Weldon Johnson. New York:
 Harcourt, Brace, 1931, p. 145.

114 _____. EEL SPEARING AT SETAUKET. 1845. New York State His-
 torical Association, Cooperstown. ---(3) Anon. "Spearing." AMERI-
 CAN MAGAZINE 1 (September 1841): 76. Also, (3) Walt Whitman.
 "A Song of Joys." LEAVES OF GRASS. Ed. Harold W. Blodgett and
 Sculley Bradley. New York: W.W. Norton, 1965, pp. 176-83.

115 _____. THE POWER OF MUSIC. 1847. The Century Association,
 New York. ---(3) Walt Whitman. "That Music Always Round Me."
 COMPLETE POETRY AND SELECTED PROSE. Ed. James E. Miller, Jr.
 Boston: Houghton Mifflin, 1959, p. 313.

116 Neagle, John. PAT LYON AT THE FORGE. 1826-27. Museum of
 Fine Arts, Boston. ---(2) Henry Wadsworth Longfellow. "The Village
 Blacksmith." BALLADS AND OTHER POEMS. Cambridge, Mass.:
 John Owen, 1842. Reprinted: THE COMPLETE POETICAL WORKS OF
 LONGFELLOW. Boston: Houghton Mifflin, 1922, pp. 14-15.

117 Page, William. VENUS GUIDING ENEAS AND THE TROJANS TO THE
 LATIN SHORE. 1859. ---(1) William Ross Wallace. "Page's Venus"
 (New York 1859) in VENUS GUIDING ENEAS AND THE TROJANS TO
 THE LATIN SHORE (pamphlet, n.d., probably 1860). See Joshua C.
 Taylor. WILLIAM PAGE: THE AMERICAN TITIAN. Chicago: Uni-
 versity of Chicago Press, 1957, p. 151.

118 Ranney, William Tylee. ON THE WING. 1850. Kimbell Art Museum,
 Fort Worth, Tex. ---(2) Isaac McLellan. "Duck-Shooting in Barnegat
 Bay." POEMS OF THE ROD AND GUN; OR, SPORTS BY FLOOD AND
 FIELD. New York: Henry Thorpe, 1886, pp. 115-16.

119 Thompson, Cephas Giovanni. THE SIBYL. 1842. Museum of Fine Arts,
 Boston. ---(1) William Cullen Bryant. "The Past." See Bertha M.
 Stearns. "Nineteenth-Century Writers in the World of Art." ART IN
 AMERICA 40 (Winter 1952): 33.

120 Thompson, Jerome B. THE OLD OAKEN BUCKET. Collections of IBM
 Corporation. ---(1) Samuel Woodworth. "The Bucket." (1818). THE
 AMERICAN POETS, 1800-1900. Ed. Edwin H. Cady. Glenview, Ill.:
 Scott, Foresman, 1966, pp. 25-26.

121 Vedder, Elihu. THE LAIR OF THE SEA SERPENT. 1864. Museum of
 Fine Arts, Boston. ---(2) Vachel Lindsay. "The Sea Serpent Chantey."
 COLLECTED POEMS. New York: Macmillan, 1930, pp. 149-50.

122 Weir, Robert W. SIEGE BATTERY [at West Point]. After 1834. ---(1)
 Edgar Allan Poe. "Ulalume." See description of painting in Irene Weir.
 ROBERT W. WEIR, ARTIST. New York: Field-Doubleday, 1947, p. 60.

123 Whittredge, Worthington. A HOME BY THE SEA-SIDE. Los Angeles
 County Museum of Art, Hearst Collection. ---(2) Edgar A. Guest.
 "Home" ("It takes a heap o' livin' . . . "). See this pairing in AMERI-
 CA'S FAVORITE POEMS. Ed. Linda Ann Hughes. Waukesha, Wis.:
 Country Beautiful, 1975, pp. 140-41.

124 Woodville, Richard Caton. SAILOR'S WEDDING. 1852. Walters Art
 Gallery, Baltimore. ---(3) James Russell Lowell. "The Courtin'."
 AMERICAN LITERATURE SURVEY: THE AMERICAN ROMANTICS, 1800-1860.
 Ed. Milton R. Stern and Seymour L. Gross. New York: Viking Press,
 1968, pp. 644-47.

125 Wyant, Alexander H. THE MOHAWK VALLEY. 1866. Metropolitan
 Museum of Art, New York. ---(2) Daniel McKinnon. "Mohawk's
 Falls," in "Description of the Mohawk River." DESCRIPTIVE POEMS,
 CONTAINING PICTURESQUE VIEWS OF THE STATE OF NEW YORK.
 New York: T. and J. Swordses, 1802, pp. 15-37.

Pairings 1870-1910
COMPLACENCY AND
THE UNDERCURRENTS OF CHANGE

126 Bellows, George. FORTY-TWO KIDS. 1907. Corcoran Gallery of Art,
Washington, D.C. ---(3) Winfield Townley Scott. "Merrill's Brook."
FIFTEEN MODERN AMERICAN POETS. Ed. George P. Elliott. New
York: Holt, Rinehart and Winston, 1962, p. 241.

127 Eakins, Thomas. THE AGNEW CLINIC. 1898. University of Pennsyl-
vania School of Medicine, Philadelphia. ---(3) S. Weir Mitchell. "The
Birth and Death of Pain: A Poem Read October 16, 1896, at the Com-
memoration of the Fiftieth Anniversary of the First Public Demonstration
of Surgical Anaesthesia in the Massachusetts General Hospital, Boston."
THE COMPLETE POEMS OF S. WEIR MITCHELL. New York: Century
Co., 1914, pp. 408-10.

128 _____. MAX SCHMITT IN A SINGLE SCULL. 1871. Metropolitan
Museum of Art, New York. ---(1) Richmond Lattimore. "Max Schmitt
in a Single Scull." SESTINA FOR A FAR-OFF SUMMER. Ann Arbor:
University of Michigan Press, 1962, p. 5.

129 _____. THE PATHETIC SONG. 1881. Corcoran Gallery of Art,
Washington, D.C. ---(2) Henry Van Dyke. "To a Young Girl Singing."
THE POEMS OF HENRY VAN DYKE. New York: Charles Scribner's
Sons, 1911, p. 248.

130 _____. THE SWIMMING HOLE. 1883. Fort Worth Art Center Mu-
seum, Fort Worth, Tex. ---(3) Walt Whitman. "Song of Myself," sec-
tion 11. LEAVES OF GRASS. Ed. Harold W. Blodgett and Sculley
Bradley. New York: W. W. Norton, 1968, pp. 38-39.

131 _____. THE THINKER: LOUIS N. KENTON. 1900. Metropolitan
Museum of Art, New York. ---(3) Edwin Arlington Robinson. "The
Man Against the Sky," ll. 179-269. THE AMERICAN TRADITION IN
LITERATURE. Ed. Sculley Bradley et al. New York: W.W. Norton,
1967, vol. 2: 1052-59.

132 _____. WALT WHITMAN. 1887. Pennsylvania Academy of Fine Arts, Philadelphia. ---(3) Walt Whitman. "Out From Behind This Mask (To Confront a Portrait)." LEAVES OF GRASS. Ed. Harold W. Blodgett and Sculley Bradley. New York: W. W. Norton, 1968, pp. 381-83.

133 Field, Erastus Salisbury. HISTORICAL MONUMENT OF THE AMERICAN REPUBLIC. 1876. Springfield Museum of Art, Springfield, Mass. ---(3) Walt Whitman. "Song of the Exposition." THE WORKS OF WALT WHITMAN. New York: Funk & Wagnalls, 1968, vol. 1: 196-204. See Jean Lipman and Helen M. Franc. BRIGHT STARS; AMERICAN PAINTING AND SCULPTURE SINCE 1776. New York: E.P. Dutton & Co., 1976, p. 63.

134 Harnett, William M. AFTER THE HUNT. 1885. California Palace of the Legion of Honor, San Francisco. ---(3) Wallace Stevens. "Study of Two Pears." AMERICAN POETRY. Ed. Gay Wilson Allen et al. New York: Harper & Row, 1965, p. 720.

135 Homer, Winslow. BREEZING UP. 1876. National Gallery of Art, Washington, D.C. ---(2) Walter Mitchell. "Tacking Ship Off Shore." AN AMERICAN ANTHOLOGY, 1787-1900. Ed. Edmund Clarence Stedman. Boston and New York: Houghton Mifflin, 1900, pp. 302-3.

136 _____. COUNTRY SCHOOL. 1871. City Art Museum, St. Louis. ---(2) Marc Cook [Vandyke Brown]. "To a Pretty Schoolma'am." AMERI- CAN FAMILIAR VERSE. Ed. Brander Matthews. New York: Longmans, Green & Co., 1904, pp. 259-60.

137 _____. THE GULF STREAM. 1899. Metropolitan Museum of Art, New York. ---(3) Edwin Arlington Robinson. "Lost Anchors." COL- LECTED POEMS. New York: Macmillan, 1961, pp. 577-78.

138 _____. ON A LEE SHORE. 1900. Rhode Island School of Design, Providence. ---(3) S. Weir Mitchell. "Storm-Waves and Fog on Dorr's Point, Bar Harbor." COMPLETE POEMS OF S. WEIR MITCHELL. New York: Century Co., 1914, p. 373.

139 _____. SNAP THE WHIP. 1872. Metropolitan Museum of Art, New York. ----(1) Ann Stanford. "An American Gallery: Winslow Homer, 'Snap the Whip.'" THE DESCENT. New York: Viking Press, 1970, pp. 41-42.

140 Hunt, William Morris. GLOUCESTER HARBOR. 1877. Museum of Fine Arts, Boston. --(2) William Vaughan Moody. "Gloucester Moors." AMERICAN POETRY. Ed. Gay Wilson Allen et al. New York: Harper & Row, 1965, pp. 598-601.

141 Inness, George. AUTUMN LANDSCAPE, OCTOBER, 1886. 1886. Los
 Angeles County Museum of Art. ---(3) Sidney Lanier. "The Marshes of
 Glynn." AMERICAN LITERATURE SURVEY. Ed. Milton R. Stern and
 Seymour L. Gross. New York: Viking Press, 1968, pp. 22-26.

142 _____. AUTUMN OAKS. ca. 1875. Metropolitan Museum of Art,
 New York. ---(3) John Crowe Ransom. "Vaunting Oak." THE VOICE
 THAT IS GREAT WITHIN US. Ed. Hayden Carruth. New York: Bantam
 Books, 1970, pp. 148-50.

143 Johnson, Eastman. CORN HUSKING BEE. 1876. Art Institute of
 Chicago. ---(2) John Greenleaf Whittier. "The Huskers." SONGS
 OF LABOR, AND OTHER POEMS. Boston: Ticknor, Reed, and Fields,
 1851, pp. 34-41.

144 Kensett, John F. THUNDERSTORM, LAKE GEORGE. 1870. Brooklyn
 Museum, Brooklyn, N.Y. ---(3) Marya Zaturenska. "The Tempest."
 COLLECTED POEMS. New York: W.W. Norton, 1965, p. 115.

145 Meeker, Joseph R. LAND OF EVANGELINE. 1874. City Art Museum,
 St. Louis. ---(2) Henry Wadsworth Longfellow. "Evangeline: A Tale
 of Acadie." THE COMPLETE WORKS OF LONGFELLOW. Boston:
 Houghton Mifflin, 1922, pp. 70-98.

146 Metcalf, Willard. THE WHITE VEIL. 1909. Detroit Institute of Arts.
 ---(3) Robert Frost. "Stopping by Woods on a Snowy Evening." THE
 NORTON ANTHOLOGY OF POETRY. Ed. A.M. Eastman et al. New
 York: W.W. Norton, 1970, p. 945.

147 Moran, Thomas. GRAND CANYON. 1913. Milwaukee Art Center.
 ---(2) Harriet Monroe. "At the Grand Canyon." CHOSEN POEMS, A
 SELECTION FROM MY BOOKS OF VERSE. New York: Macmillan,
 1935, p. 43.

148 Ogilvie, Clifton. SUNSHINE AFTER SHOWER. 1872. ---(1) William
 Cullen Bryant. "After a Tempest." See Bertha M. Stearns. "Nineteenth-
 Century Writers in the World of Art." ART IN AMERICA 40 (Winter
 1952): 33.

149 Prendergast, Maurice. CENTRAL PARK. 1901. Whitney Museum of
 American Art, New York. ---(3) Amy Lowell. "Impressionist Picture
 of a Garden." THE COMPLETE POETICAL WORKS OF AMY LOWELL.
 Boston: Houghton Mifflin, 1925, pp. 222-23.

150 Remington, Frederic W. THE COWBOY. ca. 1902. Amon Carter Mu-
 seum of Western Art, Fort Worth, Tex. ---(2) John Antrobus. "The Cowboy."
 AN AMERICAN ANTHOLOGY, 1787-1900. Ed. Edmund Clarence Stedman.
 Boston and New York: Houghton Mifflin, c. 1900, pp. 452-53.

151 _____. THE COW PUNCHER. 1901. Sid W. Richardson Foundation
Collection. ---(1) Owen Wister. Untitled poem accompanying repro-
duction of painting as frontispiece in COLLIERS, 14 September 1901.

152 Rimmer, William. FLIGHT AND PURSUIT. 1872. Museum of Fine Arts,
Boston. ---(3) Ralph Waldo Emerson. "Brahma." THE NORTON AN-
THOLOGY OF POETRY. Ed. A.M. Eastman et al. New York: W.W.
Norton, 1970, p. 709. See Jean Lipman and Helen M. Franc. BRIGHT
STARS; AMERICAN PAINTING AND SCULPTURE SINCE 1776. New
York: E.P. Dutton, 1976, p. 99.

153 Robinson, Theodore. GIRL AT THE PIANO. ca. 1888. Toledo Museum
of Art, Toledo, Ohio. ---(2) Marya Zaturenska. "Woman at the Piano."
MODERN AMERICAN POETRY AND MODERN BRITISH POETRY. Ed.
Louis Untermeyer. New York: Harcourt, Brace & World, 1958, p. 562.

154 Ryder, Albert P. THE LOVER'S BOAT, OR MOONLIGHT ON THE
WATERS. ca. 1881. Guennol Collection. ---(1) Albert P. Ryder.
"In Splendor Rare, the Moon." Complete text of poem cited in Lloyd
Goodrich. ALBERT P. RYDER. New York: George Braziller, 1959,
p. 114.

155 _____. MOONLIT COVE. ca. 1890-1900. Phillips Collection, Wash-
ington, D.C. ---(3) Robinson Jeffers. "Night." (1925). THE NOR-
TON ANTHOLOGY OF POETRY. Ed. A.M. Eastman et al. New
York: W.W. Norton, 1970, pp. 987-88.

156 _____. THE TEMPLE OF THE MIND. ca. 1885. Albright Gallery,
Buffalo, N.Y. ---(3) Edgar Allan Poe. "The Haunted Place," from
THE FALL OF THE HOUSE OF USHER (1839), TALES BY EDGAR A.
POE. New York: Wiley and Putnam, 1845.

157 _____. TOILERS OF THE SEA. Before 1884. Metropolitan Museum of
Art, New York. ---(3) Robinson Jeffers. "Boats in a Fog." (1925).
THE SELECTED POETRY OF ROBINSON JEFFERS. New York: Random
House, 1925, p. 163.

158 Sargent, John Singer. PORTRAIT OF EDWIN BOOTH. ca. 1890. Players'
Club, New York. ---(1) Thomas Bailey Aldrich. "Sargent's Portrait of
Edwin Booth. At 'The Players.'" HARPER'S 82 (February 1891): 329.
Also, AN AMERICAN ANTHOLOGY, 1787-1900. Ed. Edmund Clarence
Stedman. Boston and New York: Houghton Mifflin, 1900, p. 381.

159 _____. PORTRAITS OF MRS. ISABELLA GARDNER. 1888-89, 1924.
Fenway Court, Boston. ---(1) Maxine W. Kumin. "Gardner Museum
Fenway, Boston." HALFWAY. New York: Holt, Rinehart and Winston,
1961, pp. 66-67.

160 Sloan, John. THREE A.M. 1909. Philadelphia Museum of Art. ---(3)
William Carlos Williams. "3 A.M. The Girl with the Honey Colored
Hair." THE COLLECTED LATER POEMS OF WILLIAM CARLOS WILLIAMS.
Greenwich, Conn.: New Directions, 1963, p. 166. Also, (3) Karl
Shapiro. "The Dome of Sunday." SELECTED POEMS. New York: Ran-
dom House, 1968, pp. 3-4.

161 _____. THE WAKE OF THE FERRY. 1907. Phillips Collection, Wash-
ington, D.C. ---(3) Walt Whitman. "Crossing Brooklyn Ferry." MAJOR
AMERICAN WRITERS. Ed. H.M. Jones and Ernest E. Leisy. New York:
Harcourt, Brace and Co., 1945, pp. 1151-55. Also, (3) James Schuyler.
"Hudson Ferry." FREELY ESPOUSING. New York: Doubleday, 1969,
pp. 49-50.

162 Whistler, James A. McNeill. CAPRICE IN PURPLE AND GOLD No. 2:
THE GOLDEN SCREEN. 1864. Freer Gallery of Art, Washington, D.C.
---(3) Ezra Pound. "The River-Merchant's Wife: a Letter." THE NOR-
TON ANTHOLOGY OF POETRY. Ed. A.M. Eastman et al. New York:
W.W. Norton, 1970, p. 981.

163 _____. NOCTURNE IN BLACK AND GOLD--THE FALLING ROCKET.
ca. 1874. Detroit Institute of Arts. ---(2) Babette Deutsch. "Fire-
works." THE COLLECTED POEMS OF BABETTE DEUTSCH. New York:
Doubleday, 1969, p. 168.

164 _____. THE WHITE GIRL. 1862. National Gallery of Art, Washington,
D.C. ---(1) Eleanor Rogers Cox. "Whistler's White Girl." POETRY 11
(October 1917): 25. Also, (3) Edgar Allan Poe. "Annabel Lee."
AMERICAN POETRY. Ed. Gay Wilson Allen et al. New York: Harper
& Row, 1965, pp. 281-82.

165 Whittredge, Worthington. SECOND BEACH, NEWPORT. 1870s-80s.
Walker Art Center, Minneapolis. ---(2) Henry Theodore Tuckerman.
"Newport Beach." POEMS. Boston: Ticknor, Reed, and Fields, 1851,
pp. 47-52.

166 _____. THE TROUT POOL. ca. 1880. Metropolitan Museum of Art,
New York. ---(2) Isaac McLellan. "The Brookside and the Hillside."
POEMS OF THE ROD AND GUN; OR, SPORTS BY FLOOD AND FIELD.
New York: Henry Thorpe, 1886, pp. 208-9.

Pairings 1910-40
BITTERNESS AND GLORY OF THE NATION'S GROWTH

167 Bellows, George W. DEMPSEY AND FIRPO. 1924. Whitney Museum of American Art, New York. ---(3) Harold Dicker. "The Boxers." THE EAST SIDE SCENE; AMERICAN POETRY 1960-1965. Ed. Allen Deloach. New York: Doubleday, 1972, p. 65. Also, (2) Horace Gregory. "Dempsey, Dempsey." COLLECTED POEMS. New York: Holt, Rinehart and Winston, 1964, pp. 5-6.

168 Benton, Thomas Hart. JESSE JAMES. 1936. Missouri State Capitol, Jefferson City. ---(2) William Rose Benét. "Jesse James" (subtitle: "A Design in Red and Yellow for a Nickel Library"). MODERN AMERICAN POETRY. Ed. Louis Untermeyer. New York: Harcourt, Brace, and Co., 1919, pp. 371-73.

169 _____. THE PATHFINDER (AN AMERICAN HISTORICAL EPIC). 1926. Collection of the Artist. or THE KENTUCKIAN. 1954. Private Collection. ---(2) Stephen Vincent Benet. "The Ballad of William Sycamore (1790-1871)." MODERN AMERICAN POETRY. Ed. Louis Untermeyer. New York: Harcourt, Brace, and Co., 1919, pp. 573-74.

170 Demuth, Charles. I SAW THE FIGURE 5 IN GOLD. 1928. Stieglitz Collection, Metropolitan Museum of Art, New York. ---(1) William Carlos Williams. "The Great Figure." THE COMPLETE COLLECTED POEMS OF WILLIAM CARLOS WILLIAMS. Norfolk, Conn.: New Directions, 1938, p. 100.

171 _____. TUBEROSES. 1922. Collection of William Carlos Williams. ---(1) William Carlos Williams. "A Pot of Flowers." SPRING AND ALL, 1923. See Bram Dijkstra. THE HIEROGLYPHICS OF A NEW SPEECH. Princeton, N.J.: Princeton University Press, 1969, p. 172.

172 Dove, Arthur. PLANT FORMS. 1915. Whitney Museum of American Art, New York. "Cows in Pasture." "Moon." ---(1) Ronald Johnson. "Three Paintings by Arthur Dove--I: Plant Forms, II: Cows in Pasture,

III: Moon." THE YOUNG AMERICAN POETS. Ed. Paul Carroll. Chicago: Follett, 1968, pp. 213–16.

173 Evergood, Philip. AMERICAN TRAGEDY. 1937. Collection of Armand Erpf. Terry Dintenfass Gallery, New York. ---(1) Ann Stanford. "An American Gallery: Philip Evergood, 'American Tragedy.'" THE DESCENT. New York: Viking Press, 1970, pp. 46–47.

174 Gropper, William. FOR THE RECORD. 1936. Philadelphia Museum. or Joseph Hirsh. THE SENATOR. 1941. Whitney Museum of American Art, New York. ---(3) e.e. cummings. "next to of course god america i." COMPLETE POEMS, 1913–1962. New York: Harcourt Brace Jovanovich, 1972, p. 268.

175 Hartley, Marsden. CAMDEN HILLS FROM BAKER'S ISLAND, PENOBSCOT BAY. 1938. Collection of Hudson Walker. ---(1) Marsden Hartley. "There Is an Island." SELECTED POEMS. New York: Viking Press, 1945, p. 18.

176 _____. DEAD PLOVER. 1943. Art Gallery, University of Minnesota. ---(1) Marsden Hartley. "Plover." SELECTED POEMS. New York: Viking Press, 1945, p. 35.

177 _____. EIGHT BELLS' FOLLY: MEMORIAL FOR HART CRANE. 1933. University Gallery, University of Minnesota, Minneapolis. ---(2) Hart Crane. "Voyages: II." (1926). A NEW ANTHOLOGY OF MODERN POETRY. Ed. Selden Rodman. New York: Random House, 1938, pp. 266–67.

178 _____. FISHERMEN'S LAST SUPPER. 1938–41. Collection of Mr. and Mrs. Roy R. Newberger. ---(1) Marsden Hartley. "Fishermen's Last Supper." SELECTED POEMS. New York: Viking Press, 1945, p. 30. Also, (1) Charles Olson. "Letter 7." THE MAXIMUS POEMS. New York: Jargon/Corinth Books, 1960, pp. 30–34. [Poem, set in Gloucester, Mass., reminisces on Hartley and alludes to this painting.]

179 _____. GULL. n.d. Museum of Modern Art, New York. ---(1) Marsden Hartley. "This Portrait of a Sea Dove, Dead." SELECTED POEMS. New York: Viking Press, 1945, pp. 34–35.

180 _____. IN THE MORAINE, DOGTOWN COMMON, CAPE ANN, 1931. 1931. University Gallery, University of Minnesota, Minneapolis. ---(1) T.S. Eliot. "Ash-Wednesday." On the back of this painting Hartley inscribed three lines from Eliot's poem. See Elizabeth McCausland. MARSDEN HARTLEY. Minneapolis: University of Minnesota Press, 1952, p. 43.

181 . ISLAND IN PENOBSCOT BAY. 1938. ---(1) Marsden Hartley. "Islands in Penobscot Bay." SELECTED POEMS. New York: Viking Press, 1945, pp. 5-7.

182 . LANDSCAPE NO. 15. 1908. Collection of E. Weyhe. ---(1) Marsden Hartley. Untitled fifteen-line poem beginning "In the Beau Shop. . . ." (1908). This poem, in Hartley's hand, is on the back of the panel. See Elizabeth McCausland. MARSDEN HARTLEY. Minneapolis: University of Minnesota Press, 1952, pp. 15-16.

183 . LANDSCAPE NO. 16. 1908. University Gallery, University of Minnesota, Minneapolis. ---(1) Marsden Hartley. "October Dying." (1908). Written in Hartley's hand on the back of this painting is this fifteen-line poem, two lines of which are obliterated. See Elizabeth McCausland. MARSDEN HARTLEY. Minneapolis: University of Minnesota Press, 1952, pp. 14-15.

184 . PORTRAIT OF ALBERT PINKHAM RYDER. 1938-39. Museum of Modern Art, New York. ---(1) Marsden Hartley. "Albert Ryder-- Moonlightist." SELECTED POEMS. New York: Viking Press, 1945, p. 111.

185 . ROBIN HOOD COVE, GEORGETOWN, MAINE. 1938-39. Art Gallery, University of Minnesota. ---(1) Marsden Hartley. "Robin Hood Cove--Georgetown, Maine." SELECTED POEMS. New York: Viking Press, 1945, pp. 19-20. Also, "In Robin Hood Cove." SELECTED POEMS, pp. 3-4.

186 . THREE FRIENDS. n.d. Museum of Modern Art, New York. ---(1) Marsden Hartley. "Three Friends (Outline for a Picture)." SELECTED POEMS. New York: Viking Press, 1945, pp. 98-99.

187 . WEARY OF THE TRUTH. n.d. Whitney Museum of American Art, New York. ---(1) Marsden Hartley. "A. Lincoln--Odd, or Even." SELECTED POEMS. New York: Viking Press, 1945, pp. 46-47. Also, (1) Marsden Hartley. "American Ikon--Lincoln." SELECTED POEMS. New York: Viking Press, 1945, p. 48. Also, (2) Edwin Arlington Robinson. "The Master (Lincoln)." This pairing is made in POETRY FROM LITERATURE FOR OUR TIME. Ed. Harlow O. Waite and Benjamin P. Atkinson. New York: Holt, Rinehart and Winston, 1958, p. 667.

188 Hopper, Edward. DRUG STORE. 1927. Museum of Fine Arts, Boston. ---(2) Karl Shapiro. "Drug Store." (1942). SELECTED POEMS. New York: Random House, 1968, p. 5.

189 . GROUND SWELL. 1939. Corcoran Gallery of Art, Washington, D.C. --(2) G. Stanley Koehler. "Ground Swell." NEW POEMS

BY AMERICAN POETS 2. Ed. Rolfe Humphries. New York: Ballantine Books, 1957, p. 96.

190 _____. HOUSE BY THE RAILROAD. 1925. Museum of Modern Art, New York. ---(3) Edwin Arlington Robinson. "The House on the Hill." COLLECTED POEMS. New York: Macmillan, 1961, p. 81. Also, (3) Robert Frost. "Ghost House." See EXPLICATOR 30 (1971): item #11. Also, (1) R.R. Cuscaden. "Edward Hopper's 'House by the Tracks.'" [sic] HEARTLAND: POETS OF THE MIDWEST. Ed. Lucien Stryk. De-Kalb: Northern Illinois University Press, 1967.

191 _____. NEW YORK MOVIE. 1939. Museum of Modern Art, New York. ---(2) Karl Shapiro. "Midnight Show." SELECTED POEMS. New York: Random House, 1968, p. 40.

192 _____. SUNDAY. 1926. Phillips Collection, Washington, D.C. or EARLY SUNDAY MORNING. 1930. Whitney Museum of American Art, New York. ---(3) Thomas Wolfe. "Brooklyn." (from YOU CAN'T GO HOME AGAIN). Arranged in verse by John S. Barnes. In A STONE, A LEAF, A DOOR: POEMS BY THOMAS WOLFE. New York: Charles Scribner's Sons, 1945, pp. 127-30. Also, (1) James H. Bowden. "Early Sunday Morning (after a painting by Edward Hopper)." KANSAS QUARTERLY 4 (Summer 1972): 58.

193 _____. TWO ON THE AISLE. 1927. Toledo Museum of Art, Toledo, Ohio. ---(2) Amy Lowell. "An Opera House." COMPLETE POETICAL WORKS. Boston: Houghton Mifflin, 1955, p. 150.

194 Marin, John. STORM OVER TAOS, NEW MEXICO. 1930. Alfred Stieglitz Collection, National Gallery of Art, Washington, D.C. [frontispiece in JOHN MARIN, dedicated to author]. ---(1) John Marin. "Foreword." JOHN MARIN. Ed. MacKinley Helm. Boston: Pellegrini and Cudahy, 1948.

195 O'Keeffe, Georgia. COW'S SKULL, RED, WHITE, AND BLUE. 1931. Metropolitan Museum of Art, New York. ---(1) Marsden Hartley. "Perhaps Macabre (To Georgia O'Keeffe)." SELECTED POEMS. New York: Viking Press, 1945, pp. 94-95.

196 Prendergast, Maurice. PROMENADE. 1913. Detroit Institute of Arts. ---(3) e.e. cummings. "in Just--/Spring." COMPLETE POEMS, 1913-1962. New York: Harcourt Brace Jovanovich, 1972, p. 24.

197 Rockwell, Norman. NO SWIMMING. 1921. Collection of the Artist. ---(2) James Whitcomb Riley. "The Old Swimmin' Hole." THE COMPLETE POETICAL WORKS OF JAMES WHITCOMB RILEY. New York: Grosset and Dunlap, 1937, pp. 245-46.

198 Shahn, Ben. THE PASSION OF SACCO AND VANZETTI. 1931-32. Whitney Museum of American Art, New York. ---(2) Edna St. Vincent Millay. "Justice Denied in Massachusetts." (1928). MODERN AMERICAN POETRY AND MODERN BRITISH POETRY. Ed. Louis Untermeyer. New York: Harcourt Brace & World, 1962, p. 447. Also, (2) William Carlos Williams. "Impromptu: The Suckers." THE COLLECTED EARLIER POEMS OF WILLIAM CARLOS WILLIAMS. Norfolk, Conn.: New Directions, 1951, pp. 315-17.

199 _____. SCOTT'S RUN, WEST VIRGINIA. 1937. Whitney Museum of American Art, New York. ---(3) James Wright. "Miners." HEART-LAND: POETS OF THE MIDWEST. Ed. Lucien Stryk. DeKalb: Northern Illinois University Press, 1967, p. 256. Also, (3) Anon. "A Paint Creek Miner." "The Kanawha Striker." MAY DAYS. Ed. Genevieve Taggard. New York: Boni & Liveright, 1925, p. 276.

200 _____. VACANT LOT. 1939. Wadsworth Atheneum, Hartford, Conn. ---(3) e.e. cummings. "impression--iv." COMPLETE POEMS, 1913-1962. New York: Harcourt Brace Jovanovich, 1972, p. 50.

201 Sheeler, Charles. AMERICAN INTERIOR. 1934. Yale University Art Gallery, New Haven, Conn. ---(3) William Carlos Williams. "The Red Wheelbarrow." THE NORTON ANTHOLOGY OF POETRY. Ed. A.M. Eastman et al. New York: W.W. Norton, 1970, p. 964.

202 _____. PERTAINING TO YACHTS AND YACHTING. 1922. Whitney Museum of American Art, New York. ---(2) William Carlos Williams. "The Yachts." THE NORTON ANTHOLOGY OF POETRY. Ed. A.M. Eastman et al. New York: W.W. Norton, 1970, p. 967.

203 Sloan, John. MCSORLEY'S BAR. 1912. Detroit Institute of Arts. ---(2) Reuel Denney. "McSorley's Bar." TWENTIETH-CENTURY AMERICAN POETRY. Ed. Conrad Aiken. New York: Random House, 1963, pp. 431-32. Also, (2) Richard Eberhart. "At McSorley's Bar." SELECTED POEMS, 1930-1965. New York: New Directions, 1965, p. 107.

204 Stella, Joseph. NEW YORK INTERPRETED: THE BRIDGE. 1920-22. Newark Museum, Newark, N.J. ---(1) Hart Crane. "Poem: To Brooklyn Bridge." and "Atlantis." --from THE BRIDGE. in COLLECTED POEMS. Ed. Waldo Frank. New York: Liveright, 1946, pp. 3-4, 55-60. See Irma B. Jaffe. JOSEPH STELLA. Cambridge, Mass.: Harvard University Press, 1970, p. 247.

205 _____. NOCTURNES: NIGHT, THE SONG OF THE NIGHTINGALE, AND MOON DAWN. 1917-19. Museum of Modern Art, New York. ---(1) Joseph Stella. "Nocturne." Unpublished poem found among Stella's papers. See Irma B. Jaffe. JOSEPH STELLA. Cambridge, Mass.: Harvard University Press, 1970, p. 82.

206　Wood, Grant. AMERICAN GOTHIC. 1930. Art Institute of Chicago.
---(3) Edgar Lee Masters. "Roscoe Purkapile" and "Mrs. Purkapile."
THE SPOON RIVER ANTHOLOGY. New York: Collier Books, 1962,
pp. 158-59.

207　_____. DAUGHTERS OF REVOLUTION. 1932. Cincinnati Art Mu-
seum. ---(3) e.e. cummings. "The Cambridge Ladies." COMPLETE
POEMS, 1913-1962. New York: Harcourt Brace Jovanovich, 1972,
p. 70.

208　_____. PAUL REVERE'S RIDE. 1931. Metropolitan Museum of Art,
New York. ---(2) Henry W. Longfellow. "Paul Revere's Ride." THE
COMPLETE POETICAL WORKS OF LONGFELLOW. Cambridge, Mass.:
Riverside Press, 1893, pp. 207-9.

209　Wyeth, Newell C. AT CONCORD BRIDGE. M. Knoedler and Company,
New York. ---(2) Ralph Waldo Emerson. "Concord Hymn." See OI
SAY CAN YOU SEE; THE STORY OF AMERICA THROUGH GREAT
PAINTINGS. Ed. Frederic Ray. Harrisburg, Pa.: Stackpole Books,
1970, pp. 42-43.

210　_____. BY THE DAWN'S EARLY LIGHT. Newman Galleries, Phila-
delphia. ---(1) Francis Scott Key. "The Star-Spangled Banner." See
O! SAY CAN YOU SEE; THE STORY OF AMERICA THROUGH GREAT
PAINTINGS. Ed. Frederic Ray. Harrisburg, Pa.: Stackpole Books,
1970, pp. 74-75.

Pairings after 1940
A SENSE OF URGENCY IN
CONTEMPORARY ARTISTIC EXPRESSION

211 Albers, Josef. HOMAGE TO THE SQUARE: 'ASCENDING.'" 1953.
Whitney Museum of American Art, New York. ---(3) Lou Lipsitz.
"Skinny Poem." THE YOUNG AMERICAN POETS: A BIG TABLE BOOK.
Ed. Paul Carroll. Chicago: Follett, 1968, pp. 246-47.

212 Albright, Ivan LeLoraine. THAT WHICH I SHOULD HAVE DONE I DID
NOT DO. 1941. Art Institute of Chicago. ---(3) Mark Strand. "The
Door." REASONS FOR MOVING. New York: Atheneum, 1968, p. 41.

213 Asher, Elise. MOTHER AND CHILD. n.d. Owned by the Artist. ---(1)
Stanley Kunitz. "River Road" and "To a Small Child Sleeping." See
listing no. 3 in Peter Bermingham, THE ART OF POETRY, catalog of an
exhibition at the National Collection of Fine Arts in Washington, D.C.,
November 19, 1976, to January 23, 1977.

214 Bechtle, Robert. 60 CHEVIES. 1971. Collection of Philippe Reichenbach
Galerie, Paris. ---(3) Karl Shapiro. "Buick." MID-CENTURY AMERI-
CAN POETS. Ed. John Ciardi. New York: Twayne, Publishers, 1950,
pp. 100-101.

215 Benton, Thomas Hart. JULY HAY. 1943. Metropolitan Museum of Art,
New York. ---(3) Robert Frost. "Mowing." A BOY'S WILL. New
York: Henry Holt, 1915, p. 36.

216 _____. WRECK OF THE OLE '97. 1943. Collection of Marilyn Goodman,
Great Neck, N.Y. ---(2) David Graves George [?]. "The Wreck of
Old 97." (1903). Freeman H. Hubbard. RAILROAD AVENUE. New
York: McGraw-Hill Book Co., 1945, pp. 257-58.

217 cummings, e.e. SUNSET. 1950. Collection Mrs. J.S. Watson, Jr.
--- (1) e.e. cummings. "Sunset." THE HARVARD ADVOCATE 95
(21 March 1913): 16.

218 deKooning, Willem. GOTHAM'S NEWS. ca. 1955. Albright-Knox Art Gallery, Buffalo, N.Y. ---(3) Frank O'Hara. "Ode to Willem de-Kooning." THE COLLECTED POEMS OF FRANK O'HARA. Ed. Donald M. Allen. New York: Knopf, 1971, p. 283.

219 _____. MARILYN MONROE. 1954. Collection of Mr. and Mrs. Ray Newberger. ---(3) Sylvia Plath. "Daddy." NAKED POETRY. Ed. Stephen Berg and Robert Mezey. Indianapolis: Bobbs-Merrill, 1969, pp. 314-17.

220 Evergood, Philip. THROUGH THE MILL. 1940. Whitney Museum of American Art, New York. ---(3) Herschel Horn. "Landscape Near a Steel Mill." POEMS OF PROTEST, OLD AND NEW. Ed. Arnold Kenseth. New York: Macmillan, 1968.

221 Hartigan, Grace. OH, THE CHANGING DIALECTIC OF OUR WORLD. 1952. Owned by the artist. ---(1) Frank O'Hara. "Oh, the changing dialectic of our world." ORANGES. See listing no. 22 in Peter Bermingham, THE ART OF POETRY, catalog of an exhibition at the National Collection of Fine Arts in Washington, D.C., November 19, 1976, to January 23, 1977.

222 Hazlewood, Dolly. [untitled]. ca. 1940. Collection of Ann Stanford. ---(1) Ann Stanford. "An American Gallery: Dolly Hazlewood, 'Untitled.'" THE DESCENT. New York: Viking Press, 1970, p. 45.

223 Hopper, Edward. GAS. 1940. Museum of Modern Art, New York. ---(2) Elizabeth Bishop. "Filling Station." THE NEW YORKER BOOK OF POEMS. New York: Viking Press, 1969, p. 229.

224 _____. NIGHT HAWKS. 1942. Art Institute of Chicago. ---(1) David Ray. "A Midnight Diner by Edward Hopper." POETRY 115 (January 1970): 242-43. Also, (1) Ira Sadoff. "Hopper's 'Nighthawks' (1942)." SETTLING DOWN. Boston: Houghton Mifflin, 1975, pp. 35-36. Also, (3) Amy Lowell. "Thompson's Lunch Room--Grand Central Station: Study in Whites." COMPLETE WORKS OF AMY LOWELL. Boston: Houghton Mifflin, 1925, pp. 149-50. Also, (3) Robert Frost. "Acquainted with the Night." This pairing is made in POETRY FROM LITERATURE FOR OUR TIME. Ed. Harlow O. Waite and Benjamin P. Atkinson. Freeport, N.Y.: Books for Libraries Press, 1970, p. 682. (Pagination is from the original edition published in 1958.)

225 _____. A WOMAN IN THE SUN. 1961. Collection of Mr. and Mrs. Albert Hackett, New York. ---(1) Lisel Mueller. "A Nude by Edward Hopper; for Margaret Gaul." RISING TIDES: 20TH CENTURY AMERICAN WOMEN POETS. Ed. Laura Chester and Sharon Barba. New York: Washington Square Press, 1973, pp. 135-36.

226 Levine, Robert. VISION OF FOSTER'S CAFETERIA IN SAN FRANCISCO.
 1955-56. San Francisco. ---(3) Allen Ginsberg. "Howl, Parts I and
 II." THE NEW AMERICAN POETRY. Ed. Donald M. Allen. New
 York: Grove Press, 1960, pp. 182-90.

227 Pickens, Alton. CARNIVAL. 1949. Buchholz Gallery. ---(3) Stephen
 Vincent Benet. "Nightmare Number Three." SELECTED WORKS OF
 STEPHEN VINCENT BENET. New York: Farrar & Rinehart, 1942,
 vol. 1: 452-54.

228 Pippin, Horace. JOHN BROWN GOING TO HIS HANGING. 1942.
 Pennsylvania Academy of Fine Arts, Philadelphia. ---(2) Stephen
 Vincent Benet. JOHN BROWN'S BODY. Book One. New York:
 Holt, Rinehart and Winston, 1968.

229 Pollock, Jackson. GOTHIC. 1944. Collection of Lee Krasner Pollock.
 ---(3) Walt Whitman. "Song of the Open Road," ll. 94-97. MAJOR
 AMERICAN WRITERS. Ed. H.M. Jones and Ernest E. Leisy. New York:
 Harcourt Brace, 1945, pp. 1144-50. Frank O'Hara pairs these in his
 ART CHRONICLES, 1954-1966. New York: G. Braziller, 1975.

230 _____. NUMBER 1. 1948. ---(1) Nancy Sullivan. "The History of
 the World as Pictures." A CONTROVERSY OF POETS. Ed. Paris Leary
 and Robert Kelly. New York: Anchor Books, 1965, pp. 446-51. Of
 the ten paintings comprising the history only the last (Pollock's NUMBER
 1.") is American. Also, (1) Frank O'Hara. "Digressions on NUMBER 1,
 1948." THE COLLECTED POEMS OF FRANK O'HARA. Ed. Donald M.
 Allen. New York: Knopf, 1971, pp. 260-61.

231 Rivers, Larry. WASHINGTON CROSSING THE DELAWARE. 1953. Mu-
 seum of Modern Art, New York. ---(1) Frank O'Hara. "On Seeing
 Larry Rivers' WASHINGTON CROSSING THE DELAWARE at the Museum
 of Modern Art." THE COLLECTED POEMS OF FRANK O'HARA. Ed.
 Donald M. Allen. New York: Knopf, 1971, pp. 233-34.

232 Scholder, Fritz. AMERICAN INDIAN. 1970. U.S. Department of the
 Interior, Indian Arts and Crafts Board. ---(3) Kenneth Kale. "Sorry
 About That." THE WAY: AN ANTHOLOGY OF AMERICAN INDIAN
 LITERATURE. Ed. Shirley Hill Witt and Stanley Steiner. New York:
 Vintage Books, 1972, pp. 144-46.

233 Sheeler, Charles. WATER. 1945. Metropolitan Museum of Art, New
 York. ---(3) Marianne Moore. "To a Steam Roller." TWENTIETH
 CENTURY AMERICAN WRITING. Ed. William T. Stafford. New York:
 Odyssey Press, 1965, p. 608.

234 Tooker, George. THE SUBWAY. 1950. Whitney Museum of American Art, New York. ---(2) Hart Crane. "The Tunnel." THE BRIDGE (1930) in MODERN AMERICAN POETRY. Ed. Louis Untermeyer. New York: Harcourt, Brace, 1919, pp. 573-77.

235 Warhol, Andy. CAMPBELL SOUP CAN 19¢." 1960. Collection of Mr. and Mrs. Robert A. Rowan. ---(3) Gary Snyder. "Smokey the Bear Sutra." (1969). CAMPFIRES OF THE RESISTANCE: POETRY FROM THE MOVEMENT. Ed. Todd Gitlin. Indianapolis: Bobbs-Merrill, 1971, pp. 77-79. Also, (1) Ronald Gross. "2/29¢ (for Andy Warhol)." OPEN POETRY. Ed. Ronald Gross and George Quasha. New York: Simon & Schuster, 1973, p. 474.

APPENDIXES

Appendix A
FROM <u>THE AMERICAN MUSE</u>

Pairings from Henri Dorra. THE AMERICAN MUSE. New York: Viking Press, 1961. In this work reproductions of American paintings are matched with excerpts from American poetry or prose. Only paintings and poems are listed here. The order of the citations is as listed in THE AMERICAN MUSE.

236 Samuel F.B. Morse. VIEW FROM APPLE HILL. ca. 1825. New York State Historical Association, Cooperstown. --- Philip Freneau. From "On the Uniformity and Perfection of Nature." 1815.

237 Asher B. Durand. KINDRED SPIRITS. 1849. New York Public Library --- William Cullen Bryant. From "Inscription for the Entrance to a Wood." 1821.

238 George Inness. PEACE AND PLENTY. 1865. Metropolitan Museum of Art, New York. --- Ralph Waldo Emerson. From "Pan." 1884.

239 Winslow Homer. MAINE COAST. Metropolitan Museum of Art, New York. --- Walt Whitman. From "Song of Myself." 1885. ["Sea of the Brine of Life."]

240 Arthur G. Dove. SEA-GULL MOTIF. 1928. Downtown Gallery, New York. --- Katherine Garrison Chapin. From "Plain Chant for America." 1941.

241 Balcomb Greene. COMPOSITION: THE STORM. 1954. Whitney Museum of American Art, New York. --- Marianne Moore. From "In Distrust of Merits." 1941.

242 C.S. Price. IN THE MOUNTAINS. ca. 1943. Downtown Gallery, New York. --- Conrad Aiken. From "Sea Holly." 1925.

243 Albert Bierstadt. THE BUFFALO TRAIL. 1869. Corcoran Gallery of
 Art, Washington, D.C. --- Joaquin Miller. From "Kit Carson's Ride."
 1871.

244 Frederic Remington. THE COWBOY. Amon G. Carter Foundation, Fort
 Worth, Tex. --- Francis Parkman. From "The New Hampshire Ranger."
 1845.

245 Thomas Cole. DEAD RISING FROM TOMBS. Art Museum, Princeton
 University, Princeton, N.J. --- Edgar Allan Poe. From "The Conquerer
 Worm." 1839.

246 Martin Johnson Heade. APPROACHING STORM: BEACH NEAR NEW-
 PORT. ca. 1860. Museum of Fine Arts, Boston. --- Robert Frost.
 From "Once by the Pacific." 1949.

247 William Rimmer. VICTORY. 1845-1855. Collection of Paul L. Grigaut.
 --- Edgar Allan Poe. From "To One in Paradise." 1834.

248 Albert Pinkham Ryder. DEAD BIRD. 1890-1900. Phillips Collection,
 Washington, D.C. --- Walt Whitman. From "When Lilacs Last in the Door-
 yard Bloomed." 1865-66.

249 Darrel Austin. THE BLACK BEAST. 1941. Smith College Museum of
 Art, Northampton, Mass. --- John Hall Wheelock. From "The Black
 Panther." 1922.

250 Franklin Watkins. SUICIDE IN COSTUME. 1931. Philadelphia Mu-
 seum of Art. --- T.S. Eliot. From "Four Quartets." 1943.

251 Willem deKooning. WOMAN I. 1950-52. Museum of Modern Art,
 New York. --- William Carlos Williams. THE DESCENT. From THE
 DESERT MUSIC. 1954.

252 John Hultberg. COLLISION. 1956. Martha Jackson Gallery, New
 York. --- Archibald MacLeish. From "Streets in the Moon." 1926.

253 Charles F. Ulrich. THE LAND OF PROMISE, CASTLE GARDEN. 1884.
 Corcoran Gallery of Art, Washington, D.C. --- Emma Lazarus. From
 "The New Colossus." (Inscription for the Statue of Liberty, New York
 Harbor, 1886).

254 George Bellows. UPPER BROADWAY. 1910. Collection of Mr. and
 Mrs. Allen Kander, Washington, D.C. --- Walt Whitman. From "Cross-
 ing Brooklyn Ferry." 1856.

255 Joseph Stella. THE BRIDGE. 1922. Newark Museum, Newark, N.J. --- Hart Crane. From "The Bridge." 1930.

256 Charles Sheeler. WINDOWS. 1951. Northern Trust Co., New York. --- Walt Whitman. From "Mannahatta." 1855.

257 Ben Shahn. WELDERS. 1943. Museum of Modern Art, New York --- Walt Whitman. From "Years of the Modern." 1865.

258 Erastus Salisbury Field. HISTORICAL MONUMENT OF THE AMERICAN REPUBLIC. ca. 1876. Morgan Wesson Memorial Collection of the Museum of Fine Arts, Springfield, Mass. --- Walt Whitman. From "Song of the Exposition." 1871.

Appendix B

FROM THE BEAUTY OF AMERICA

Pairings from Robert L. Polley, ed. THE BEAUTY OF AMERICA IN GREAT AMERICAN ART, with selections from the writings of renowned American authors. By the editors of COUNTRY BEAUTIFUL. Waukesha, Wis.: Country Beautiful Corp., 1965. In this work reproductions of American paintings are matched with excerpts from American poetry or prose. Only paintings and poems are listed here. The order of the citations is as listed in THE BEAUTY OF AMERICA.

259 Asher Brown Durand. KINDRED SPIRITS. New York Public Library. --- William Cullen Bryant. From "Thanatopsis."

260 Samuel F.B. Morse. VIEW FROM APPLE HILL. Collection of Stephen C. Clark, New York. --- Ralph Waldo Emerson. From "Woodnotes."

261 Ralph Earl. LOOKING EAST FROM DENNY HILL. Worcester Art Museum, Worcester, Mass. --- John Greenleaf Whittier. From "Among the Hills."

262 Unknown American primitive artist about 1850. PEACEFUL VILLAGE. From the Collection of Edgar William and Bernice Chrysler Garbisch. --- John Greenleaf Whittier. From "Pentucket."

263 Joseph H. Hidley. POESTENKILL, NEW YORK. Metropolitan Museum of Art, New York. --- William Cullen Bryant. From "The Ages."

264 George Inness. CATSKILL MOUNTAINS. Art Institute of Chicago. --- Ralph Waldo Emerson. From "Each and All."

265 Louis Michel Eilshemius. DELAWARE WATER GAP VILLAGE. Metropolitan Museum of Art, New York. --- Walt Whitman. From "Out of the Cradle Endlessly Rocking."

266 John Frederick Kensett. RIVER SCENE. Metropolitan Museum of Art, New York. --- William Cullen Bryant. From "The Ages."

267 Winslow Homer. WOODSMAN AND FALLEN TREE. Museum of Fine Arts, Boston. --- James Russell Lowell. From "The Pioneer."

268 George Inness. PEACE AND PLENTY. Metropolitan Museum of Art, New York. --- Jones Very. From "The Earth."

269 Thomas Cole. THE OXBOW. Metropolitan Museum of Art, New York. --- Jones Very. From "The Earth."

270 Benjamin West. PENN'S TREATY WITH THE INDIANS. Pennsylvania Academy of the Fine Arts, Philadelphia. --- Anne Bradstreet. From "The Prologue."

271 Gardner Symons. THROUGH SNOW-CLAD HILLS AND VALLEYS. City Art Museum, St. Louis. --- John Greenleaf Whittier. From "Snow-bound."

272 Frederic E. Church. SCENE IN THE CATSKILL MOUNTAINS. Walker Art Center, Minneapolis, Minn. --- William Cullen Bryant. From "Green River."

273 Edward Hicks. THE PEACEABLE KINGDOM. New York State Historical Association, Cooperstown. --- Edward Taylor. From "Sacramental Meditations."

274 Ralph A. Blakelock. MOONLIGHT. Brooklyn Museum, Brooklyn, N.Y. --- Henry Wadsworth Longfellow. From "Moonlight."

275 George Inness. AUTUMN OAKS. Metropolitan Museum of Art, New York. --- Henry David Thoreau. From "The Breeze's Invitation."

276 John Francis Murphy. FROSTBITTEN WOOD AND FIELD. Smithsonian Institution, Freer Gallery of Art, Washington, D.C. --- Henry David Thoreau. From "When Winter Fringes Every Bough."

277 Dwight Tryon. TWILIGHT-MAY. Smithsonian Institution, Freer Gallery of Art, Washington, D.C. --- Hazel Hall. From "Twilight."

278 John B. Neagle. PAT LYON AT THE FORGE. Boston Athenaeum. --- Henry Wadsworth Longfellow. From "The Village Blacksmith."

279 Joseph R. Meeker. THE LAND OF EVANGELINE. City Art Museum, St. Louis. --- Henry Wadsworth Longfellow. From "Evangeline."

280 Eastman Johnson. OLD KENTUCKY HOME. New York Historical Society, Cooperstown. --- Stephen Collins Foster. From "My Old Kentucky Home."

281 Winslow Homer. PROUT'S NECK, BREAKING WAVE. Art Institute of Chicago. --- Robinson Jeffers. From "November Surf."

282 Maurice Prendergast. YACHT RACE. Art Institute of Chicago. --- Thomas Fleming Day. From "The Main-Sheet Song."

283 Ivan Albright. HEAVY THE OAR TO HIM WHO IS TIRED, HEAVY THE COAT, HEAVY THE SEA. Art Institute of Chicago. --- Herman Melville. From JOHN MARR AND OTHER SAILORS, WITH SOME SEA-PIECES.

284 William Hart. SEASHORE-MORNING. Metropolitan Museum of Art, New York. --- Trumbull Stickney. From "In the Past."

285 Winslow Homer. THE GALE. Worcester Art Museum, Worcester, Mass. --- Henry Wadsworth Longfellow. From "The Secret of the Sea."

286 N. Currier. THE CLIPPER SHIP 'NIGHTINGALE'. --- George Sterling. From "Sails."

287 Marsden Hartley. NORTHERN SEASCAPE. Milwaukee Art Center. --- H.D. (Hilda Doolittle). From "The Helmsman."

288 Albert Pinkham Ryder. THE WASTE OF WATERS IS THEIR FIELD. Brooklyn Museum, Brooklyn, N.Y. --- Joseph C. Lincoln. From "The Cod-Fishers."

289 James Abbott McNeill Whistler. GRAY AND GREEN: THE SILVER SEA. Art Institute of Chicago, and John Marin. MOVEMENT--SEA AND SKY. Lane Foundation, Leominster, Mass. --- Robert P. Tristram Coffin. From "Mainland-Woman's Return."

290 Albert Pinkham Ryder. THE TOILERS OF THE SEA. Metropolitan Museum of Art, New York. --- Oliver Wendell Holmes. From "A Sea Dialogue."

291 Thomas Eakins. STARTING OUT AFTER RAIL. Wichita Art Museum, Wichita, Kan. --- Richard Hovey. From "The Sea Gipsy."

292 George Wesley Bellows. THE SAND TEAM. Brooklyn Museum, Brooklyn, N.Y. --- John Hall Wheelock. From "Autumn Along the Beaches."

293 Stuart Davis. GLOUCESTER WHARF. Milwaukee Art Center. --- Frances Frost. From "Sea Town."

294 Edward Hopper. LIGHTHOUSE AT TWO LIGHTS. Metropolitan Museum of Art, New York. --- Henry Wadsworth Longfellow. From "The Lighthouse."

295 Frederic Remington. HOWL OF THE WEATHER. Remington Art Memorial, Ogdensburg, N.Y. --- Alice Henson Ernst. From "Ya-lhl's Song to the North Wind."

296 Frederic Remington. THE OUTLIER. Remington Art Memorial, Ogdensburg, N.Y. --- Pawnee. "Song of the Pleiades."

297 John Steuart Curry. THE HOMESTEAD. Mural. U.S. Department of the Interior. --- Hamlin Garland. From "Prairie Songs."

298 George Caleb Bingham. LANDSCAPE. City Art Museum, St. Louis. --- Sidney Lanier. From "Psalm of the West."

299 Richard Florsheim. CITY LIGHTS. Courtesy of the artist. And Georgia O'Keeffe. NEW YORK AT NIGHT. Nebraska Art Association, Lincoln. --- Amy Lowell. From "New York at Night."

300 Charles E. Burchfield. RAINY NIGHT. Fine Arts Society of San Diego. Neb. --- Amy Lowell. From "New York at Night."

301 Lyonel Feininger. VILLAGE STREET. Art Institute of Chicago. --- Horace Gregory. From "Homestead."

302 William J. Glackens. CENTRAL PARK, WINTER. Metropolitan Museum of Art, New York. --- William Winter. From "Age."

303 Reginald Marsh. NEGROES ON ROCKAWAY BEACH. Whitney Museum of American Art, New York. --- Langston Hughes. From "Jazztet Muted."

304 Reginald Marsh. THE BOWERY. Metropolitan Museum of Art, New York. --- James Weldon Johnson. From "My City."

305 Loren MacIver. MANHATTAN. Johnson Collection of Contemporary American Paintings. --- Max Eastman. From "The City."

306 John Sloan. BACKYARDS, GREENWICH VILLAGE. Whitney Museum of American Art, New York. --- Merrill Moore. From "Streets in Dislocation, Stolid Snow . . . "

307 Joseph Stella. THE BRIDGE. Newark Museum, Newark, N.J. --- Hart Crane. From "The Bridge."

308 George Wesley Bellows. LOVE OF WINTER. Art Institute of Chicago. --- Robert P. Tristram Coffin. From "Winter Is My Year."

309 Willard L. Metcalf. ICEBOUND. Art Institute of Chicago. --- Mark Van Doren. From "December Setting."

310 Rockwell Kent. WINTER. Metropolitan Museum of Art, New York. --- William Cullen Bryant. From "A Winter Piece."

311 Grant Wood. MIDNIGHT RIDE OF PAUL REVERE. Metropolitan Museum of Art, New York. --- Henry Wadsworth Longfellow. From "Paul Revere's Ride."

312 John Marin. SPRING NO. 1. Phillips Collection, Washington, D.C. --- e.e. cummings. From "Spring is like a perhaps hand."

313 Ben Shahn. SPRING. Albright-Knox Art Gallery, Buffalo, N.Y. --- e.e. cummings. From "Spring is like a perhaps hand."

314 Arthur B. Davies. DIRGE IN SPRING. Art Institute of Chicago. --- Edgar Allan Poe. From "The Sleeper."

315 Charles E. Burchfield. SUN AND ROCKS. Albright-Knox Art Gallery, Buffalo, N.Y. --- Melville Cane. From "Sun and Cloud."

316 Arthur G. Dove. SUNRISE. Milwaukee Art Center. --- Sidney Lanier. From "A Sunrise Song."

317 John Singer Sargent. TWO GIRLS FISHING. Cincinnati Art Museum. --- Frederick Goddard Tuckerman. From THE SONNETS OF FREDERICK GODDARD TUCKERMAN.

318 George Wesley Bellows. A DAY IN JUNE. Detroit Institute of Arts. --- Amy Lowell. From "Spring Day."

49

319 Andrew Wyeth. AFTERNOON. Milwaukee Art Center. --- Clarissa Scott Delany. From "The Mask."

320 Andrew Wyeth. QUAKER LADIES. Collection of Mr. and Mrs. H.F. Du Pont, Wilmington, Del. --- Gloria Goddard. From "To the Commonplace."

321 Thomas Hart Benton. ROASTING EARS. Metropolitan Museum of Art, New York. --- Carl Sandburg. From "Improved Farm Land."

322 John Rogers Cox. WHITE CLOUD. Courtesy of Dr. Howard Laufman. --- Samuel Hoffenstein. From "Cloud."

323 Andrew Wyeth. THE SCARECROW. Johnson Collection of Contemporary American Paintings. --- Louis Untermeyer. From "Two Funerals."

324 William Gropper. THE HUNT. Metropolitan Museum of Art, New York. --- Richard Burton. From "Wood Witchery."

325 John H. Twachtman. THE WATERFALL. Metropolitan Museum of Art, New York. --- John Crowe Ransom. From "Persistent Explorer."

326 William Thon. GOLDEN AUTUMN. Midtown Galleries, New York. --- Elinor Wylie. "Golden Bough."

327 Mark Tobey. AUTUMN FIELD. Johnson Collection of Contemporary American Paintings. --- e.e. cummings. From "a wind has blown the rain away and blown."

328 Ben Foster. IN THE CONNECTICUT HILLS. Metropolitan Museum of Art, New York. --- Walt Whitman. From "Earth, My Likeness."

329 Mark Tobey. ABOVE THE EARTH. Art Institute of Chicago. --- Edwin Arlington Robinson. From "Hillcrest."

330 Willard L. Metcalf. THE NORTH COUNTRY. Metropolitan Museum of Art, New York. --- Walt Whitman. From "Song of Myself" ["Smile O voluptuous cool-breath'd earth"].

331 Charles Sheeler. THE ARTIST LOOKS AT NATURE. Art Institute of Chicago. --- Robert Penn Warren. From "Infant Boy at Midcentury: Modification of Landscape."

332 John Frederick Peto. LIGHTS OF OTHER DAYS. Art Institute of Chicago. --- Walt Whitman. From "Song of Myself." ["All truths wait in all things . . . "].

333 Peter Blume. LILIES. Museum of Fine Arts, Boston. --- Sara Teasdale. From "February."

334 William Michael Harnett. JUST DESSERT. Art Institute of Chicago. --- Emily Dickinson. "The Bustle in a House."

335 John Frederick Peto. MARKET BASKET, HAT AND UMBRELLA. Milwaukee Art Center. --- Oliver Wendell Holmes. From "Mare Rubrum."

336 Ivan Albright. THAT WHICH I SHOULD HAVE DONE I DID NOT DO. Art Institute of Chicago. --- Conrad Aiken. From "Music I Heard with You."

337 Rubens Peale. FRUIT ON A PEWTER PLATE. Milwaukee Art Center. --- Herman Melville. From "Fruit and Flower Painter."

338 Unknown American primitive artist about 1835. FRUIT AND FLOWERS. Collection of Edgar William and Bernice Chrysler Garbisch. --- Herman Melville. From "Fruit and Flower Painter."

Appendix C
FROM <u>ART IN AMERICA</u>, 1965

Pairings from "Painters and Poets," ART IN AMERICA 53 (October-November 1965): 24-56. The editor of this project, Francine duPlessix, explains it as follows: "I wrote a letter . . . to twenty-two American painters, asking them to choose a contemporary poem of their liking, of any nationality, and to make for it a work in black and white, in the medium of their choice." Stanley Kunitz's editorial "The Sister Arts" introduces the pairings. The order of the citations is as listed in ART IN AMERICA.

339 Stephen Greene. [untitled]. --- Robert Lowell. "New Year's Day."

340 Jasper Johns. SKIN. --- Frank O'Hara. "The clouds go soft . . . "

341 Jack Youngerman. [untitled]. --- Ezra Pound. "Epitaphs."

342 Helen Frankenthaler. [untitled]. --- James Merrill. "Swimming by Night."

343 Ben Shahn. [untitled]. --- Alan Dugan. "The Branches of Water or Desire."

344 George Segal. [untitled]. --- Wallace Stevens. "Angel Surrounded by Paysans."

345 Barnett Newman. [untitled]. --- Howard Nemerov. "On Certain Wits who amused themselves over the simplicity of Barnett Newman's paintings shown at Bennington College in May of 1958."

346 Joseph Albers. [untitled]. --- Da Capo. [+ = -].

347 Jim Dine. [untitled]. --- Allen Ginsberg. "Kaddish" [excerpt].

348 Edward Giobbi. [untitled]. --- Salvatore Quasimodo. "Ulysses Isle." Trans. Allen Mandelbaum. THE SELECTED WRITINGS OF SALVATORE QUASIMODO. Ed. Allen Mandelbaum. New York: Farrar, Strauss and Giroux, 1960.

349 Philip Guston. [untitled]. --- Musa McKim. "The Train."

350 Robert Motherwell. [untitled]. --- William Berkson. "Hudson."

351 Paul Brach. [untitled]. --- Pierre Emmanuel. "Nada." Trans. Wallace Fowlie. MID-CENTURY FRENCH POETS. Ed. Wallace Fowlie. New York: Twayne Publishers, 1955.

352 Loren MacIver. [untitled]. --- Lloyd Frankenberg. "L'Histoire d'une poire."

353 Theodoros Stamos. [untitled]. --- Robert Price. "Dead Girl: Saipan."

354 Robert Goodnough. [untitled]. --- Barbara Guest. "Blue Stairs."

355 James Books. AMONG THE GODS. --- Stanley Kunitz. "Among the Gods."

356 Paul Feeley. [untitled]. --- Lawrence Alloway. From "School of Scyros, 3 out of 9": 1. "Near Troy, New York"; 6. "Deidamia"; 8. [untitled].

357 Grace Hartigan. [untitled]. --- Theodore Roethke. "I Cry Love! Love! (excerpt)."

358 Jimmy Ernst. TWELVE VERSES FOR ANDREI VOZNESENSKY. --- Andrei Voznesensky. "Goya." Trans. Stanley Kunitz.

359 Minoru Kawabata. [untitled]. --- Seiji Tsutsumi. ["Ah oui, en effet!"].

360 Walter Murch. [untitled, on cover]. --- Wallace Stevens. "The Glass of Water."

Appendix D

FROM <u>ART IN AMERICA</u>, 1968

Pairings from Ronald Gross. "Pop Poems." ART IN AMERICA 56 (March 1968): 76-79. In this article, poems by Ronald Gross are matched with appropriate reproductions of paintings and mixed media by pop artists. The order of the citations is as listed in ART IN AMERICA.

361 James Rosenquist. WORLD'S FAIR MURAL. 1964. Leo Castelli Gallery, New York. --- Ronald Gross. "Ode: Homage to America."

362 Roy Lichtenstein. SCARED WITLESS. 1962. Collection of Mr. and Mrs. Frederick Weisman. --- Ronald Gross. "Sonnet." ["The morning mail brings us, every day"].

363 George Segal. THE GAS STATION. 1963. Sidney Janis Gallery, New York. --- Ronald Gross. "Heroic Couplets." ["Now it's Pepsi--for those who think young!"].

364 Tom Wesselmann. GREAT AMERICAN NUDE NO. 90. 1967. Sidney Janis Gallery, New York. --- Ronald Gross. "The Miracle of Creation."

365 Andy Warhol. JACKIE. 1964. Leo Castelli Gallery, New York. --- Ronald Gross. "Elegiac Verse: IN MEMORIAM: J.F.K."

366 Claes Oldenburg. HAMBURGER. 1963. Collection of Carroll Janis. --- Ronald Gross. "Panegyric." ["One scale-tipping half pound"].

367 Allan d'Arcangelo. US HIWAY 1, NO. 3. 1963. Collection of John Powers. --- Ronald Gross. "Song of the Road."

Appendix E
FROM ART NEWS ANNUAL

Pairings from "Poets and Pictures; Poems with Portfolio of Illustrations." ART NEWS ANNUAL 24 (1955): 80-96. "The editors commissioned seven poems from distinguished United States poets; with few exceptions, these were done specifically for the occasion. Each poem was then sent to an American artist whose work and temper seemed congenial to the verse, with a request he simply draw (or paint, as it happened in two cases) a companion piece, related as freely or closely as desired. The results are varied and striking." The order of the citations is as listed in ART NEWS ANNUAL.

368 Isabel Bishop. [untitled sketch]. --- William Carlos Williams. "The King." [on the mistress of Charles II].

369 Wolf Kahn. [untitled drawing]. --- Peter Viereck. "Some Refrains [3] at the Charles River."

370 John Graham. [untitled drawing of girl]. --- Randall Jarrell. "Cinderella."

371 Yves Tanguy. [untitled surrealist drawing]. --- Edwin Watkins. "A Plum Tree Twig."

372 Philip Guston. [untitled drawing]. --- Delmore Schwartz. "The Fulfillment."

373 Larry Rivers. [untitled drawing of boy]. --- Harvey Breit. "Ideas of Childhood."

374 Lee Gatch. [untitled sketch]. --- Marianne Moore. "The Sycamore."

Section II

AMERICAN POEMS ON PAINTINGS

AMERICAN POEMS ON PAINTING

375 Abel, Lionel. "On Man Considered as an Instrument for Hurting (as represented in the painting of Matta)." In "Poets on Painting, 7." ART NEWS 58 (March 1959): 44-45.

376 Allston, Washington. "Sonnet on Rembrandt; Occasioned by His Picture of Jacob's Dream." LECTURES ON ART AND POEMS (1850) AND MONALDI (1841). Gainesville, Fla.: Scholars' Facsimiles and Reprints, 1967, p. 274.

377 _____. "Sonnet on Seeing the Picture of Aeolus by Pelligrino Tibaldi, in the Institute at Bologna." LECTURES ON ART AND POEMS (1850) AND MONALDI (1841). Gainesville, Fla.: Scholars' Facsimiles and Reprints, 1967, p. 275.

378 _____. "Sonnet on the Group of the Three Angels before the Tent of Abraham, by Raffaelle, in the Vatican." LECTURES ON ART AND POEMS (1850) AND MONALDI (1841). Gainesville, Fla.: Scholars' Facsimiles and Reprints, 1967, p. 274.

379 _____. "Sonnet on the Pictures by Rubens in the Luxembourg Gallery." LECTURES ON ART AND POEMS (1850) AND MONALDI (1841). Gainesville, Fla.: Scholars' Facsimiles and Reprints, 1967, p. 277.

380 Ames, Evelyn. "Van Gogh: (1) The Field; (2) A Tea Garden; (3) Flowering Stems." THE HAWK FROM HEAVEN. New York: Dodd, Mead, 1957, pp. 17-19.

381 Anonymous. "Lines Suggested by David's Picture of Napoleon Asleep in his Study . . . " EMERALD AND BALTIMORE LITERARY GAZETTE 1 (March 1843): 426. (APS [313] reel 605.)

382 _____. "On the Picture of a young Lady drawn in the Picture of Diana." BOSTON GAZETTE, 15 September 1755.

383 Ashberry, John. "The Double Dream of SPRING." THE DOUBLE DREAM
OF SPRING. New York: E.P. Dutton, 1970, pp. 41-42. [Dedicated
to Gerrit Henry, this poem is about Chirico's painting at the Museum of
Modern Art, New York.]

384 _____. "Self-Portrait in a Convex Mirror." [on Parmigianino's painting].
SELF-PORTRAIT IN A CONVEX MIRROR: POEMS BY JOHN ASHBERY.
New York: Viking Press, 1975, pp. 68-83.

385 Berryman, John. "Winter Landscape." A LITTLE TREASURY OF AMERI-
CAN POETRY. Ed. Oscar Williams. New York: Charles Scribner's
Sons, 1952, p. 743. [Images taken from Pieter Breughel The Elder's
"Hunters in the Snow."]

386 Bishop, Elizabeth. "Large Bad Picture." (on her great-uncle's big paint-
ing). THE NEW YORKER BOOK OF POEMS. New York: Viking
Press, 1969, pp. 370-71.

387 Bluhm, Norman, and Frank O'Hara. Poem-Painting (1960): "May! Am
I a Pole?" ART CHRONICLES, 1954-1966. Ed. Frank O'Hara. New
York: George Braziller, 1975, p. 93.

388 _____. Poem-Painting (1960): "Somewhere Outside Yourself. . . . "
ART CHRONICLES, 1954-1966. Ed. Frank O'Hara. New York: George
Braziller, 1975, p. 94.

389 Bogan, Louise. "St. Christopher." [on Vasari's painting]. In "Poets on
Painting, 5." ART NEWS 57 (September 1958): 24-25.

390 Brodsky, George. "Gauguin's Tahitian Olympia." POETRY 40 (June
1932): 135.

391 Brumbaugh, Thomas B. "The Family of Lucien Bonaparte by Ingres."
ART JOURNAL 20 (Fall 1960): 18.

392 Burford, William. "On the Portrait of a Young Monk by Sofonisba An-
guissola." MAN NOW. Dallas: Southern Methodist University Press,
1954, p. 36.

393 _____. "Tintoretto's Senator in the Frick Collection." MAN NOW.
Dallas: Southern Methodist University Press, 1954, p. 33.

394 Cheney, John Vance. "The Man with the Hoe: a Reply." AN AMER-
ICAN ANTHOLOGY, 1787-1900. Ed. Edmund Clarence Stedman.
Boston and New York: Houghton Mifflin, 1900, pp. 586-87.

395 Coates, Florence Earle. "The Angelus [Jean François Millet, 1814-1875]."
THE HOME BOOK OF VERSE: AMERICAN AND ENGLISH. Ed. Burton
E. Stevenson. New York: Henry Holt, 1922, vol. 2, p. 36-46.

396 Cole, Thomas. "La Grande Jatte: Sunday Afternoon." NEW POEMS BY
AMERICAN POETS. Ed. Rolfe Humphries. New York: Ballantine Books,
1953, pp. 34-35.

397 Corso, Gregory. "Botticelli's 'Spring.'" SELECTED POEMS. London:
Eyre & Spottiswoode, 1962, pp. 22-23.

398 _____. "Rembrandt--Self Portrait." SELECTED POEMS. London: Eyre
& Spottiswoode, 1962, p. 60.

399 Cox, Eleanor Rogers. "To a Portrait of Whistler in the Brooklyn Art Mu-
seum." HOME BOOK OF MODERN VERSE. Ed. Burton E. Stevenson.
New York: Henry Holt, 1925, pp. 1017-18.

400 Derleth, August. "The Spider on THE VIEW OF TOLEDO." COLLECTED
POEMS, 1937-1967. New York: Candlelight Press; 1967, pp. 130-31.

401 Dubie, Norman. "Those Untitled Little Verses in Which, at Dawn, Two
Obscure Dutch Peasants Struggled with an Auburn Horse: After a Painting
by Willem van de Velde. The Elder." THE ILLUSTRATIONS. New
York: George Braziller, 1977, pp. 16-17.

402 Dyroff, Jan M. "Formalities (On El Greco's THE BURIAL OF COUNT
ORGAZ)." ART JOURNAL 28 (Spring 1969): 289.

403 Eberhart, Richard. "Throwing the Apple [based on D.H. Lawrence,
"Throwing Back the Apple"]." In "Poets on Painting, 7." ART NEWS
58 (March 1959): 44-45.

404 Elon, Florence. "Dream Fresco." THE SOUTHERN REVIEW 7 n.s.
(October 1971): 1062. On Michelangelo's "Creation of Man."

405 Engle, Paul. "Venus and the Lute Player (Tiziano Vecellio, 1477-1576)."
POETRY 101 (October-November 1962): 39.

406 Eshleman, Clayton. "Guernica." In "Poets on Art." COLLEGE ART
JOURNAL 19 (Fall 1959): 75-77.

407 Etter, Dave. "The Red Nude." 31 NEW AMERICAN POETS. Ed. Ron
Schreiber. New York: Hill and Wang, 1969, pp. 42-43.

408 Feldman, Irving. "Artist and Model: After Picasso's SUITE DE 180 DESSINS." THE PRIPET MARSHES AND OTHER POEMS. New York: Viking Press, 1965, pp. 6-11.

409 ____. "'Portrait De Femme,' After Picasso." THE PRIPET MARSHES AND OTHER POEMS. New York: Viking Press, 1965, pp. 16-17.

410 Ferlinghetti, Lawrence. "Monet's Lilies Shuddering." WHO ARE WE NOW? New York: New Directions, 1974, p. 53. On Monet's "Lilies."

411 ____. "The 'Moving Waters' of Gustav Klimt." WHO ARE WE NOW? New York: New Directions, 1974, pp. 17-18.

412 ____. "One of those paintings that would not die." A CONEY IS-LAND OF THE MIND. New York: New Directions, 1958, p. 23.

413 ____. "Short Story on a Painting of Gustav Klimt." WHO ARE WE NOW? New York: New Directions, 1974, pp. 15-16.

414 Ford, Charles Henri. POEMS FOR PAINTERS. New York: View Editions, 1945. [The poems' "true interest lies in the manner in which Ford has adapted the iconography of Chirico, Tchelitchew, and Dali to his verbal phantasies."]

415 Fussiner, Howard. "Uccello's 'A Battle of San Romano.'" COLLEGE ART JOURNAL 19 (Summer 1960): 306.

416 Gaertner, Johannes A. "'La Reve' by Henri Rousseau." COLLEGE ART JOURNAL 18 (Spring 1959): 225.

417 ____. "'The Persistence of Memory' by Salvador Dali." COLLEGE ART JOURNAL 17 (Summer 1958): 381.

418 Goodman, Paul. "Ballade to Venus." [on Rembrandt's painting in the Louvre]. In "Poets on Painting, 4." ART NEWS 57 (May 1958): 28-29.

419 ____. "Evening (after Rameau and Cézanne)." POETRY 78 (April 1951): 20-21.

420 Gregory, Horace. "Three Allegories of Bellini." COLLECTED POEMS. New York: Holt, Rinehart and Winston, 1964, p. 204.

421 ____. "Venus and the Lute Player." COLLECTED POEMS. New York: Holt, Rinehart and Winston, 1964, p. 116.

422 Grilikhes, Alexandra. "Melancholia: After Dinner." COLLEGE ART JOURNAL 19 (Summer 1960): 330.

423 Guest, Barbara. "Four Moroccan Studies (after Delacroix)." THE BLUE STAIRS. New York: Corinth Books, 1968, pp. 34–35.

424 Gullans, Charles. "Poussin: The Chrysler 'Bacchanal before a Temple.'" THE SOUTHERN REVIEW 2 n.s. (April 1966): 354-55.

425 Haislip, John. "Man in a Blue Box: After a Painting by Francis Bacon (1910--)." NOT EVERY YEAR. Seattle: University of Washington Press, 1971, p. 40.

426 Halleck, Fitz Greene. "To a Portrait of Red Jacket." [painting by Robert W. Weir]. WERNER'S READINGS AND RECITATIONS, NO. 10. New York: Edgar S. Werner and Co., 1892, pp. 151-53.

427 Hartley, Marsden. "Eagle of the Inner Eye (For a Picture by Morris Graves)." SELECTED POEMS. New York: Viking Press, 1945, p. 112.

428 Hayden, Robert. "Monet's 'Waterlilies.'" WORDS IN THE MOURNING TIME. New York: October House, 1970, p. 55.

429 Howard, Richard. "Giovanni da Fiesole On the Sublime or FRA ANGELI-CO'S LAST JUDGMENT." POETRY 117 (October 1970): 1-3.

430 Hubbell, Lindley Williams. "Malevich." SEVENTY POEMS. Denver: Alan Swallow, 1965, p. 29. On "Suprematist Composition" by Kasimir Malevich.

431 Jennings, Elizabeth. "Spring (Tribute to Botticelli's Primavera)." THE SOUTHERN REVIEW 12 (April 1976): 358.

432 Johnson, Ronald. "Assorted Jungles: Rousseau." VALLEY OF THE MANY-COLORED GRASSES. New York: W.W. Norton, 1969, pp. 99-104. (Four poems on Rousseau's paintings).

433 Justice, Donald. "On a Painting by Patient B of the Independence State Hospital for the Insane." (1954). CONTEMPORARY AMERICAN POETRY. Ed. Donald Hall. Baltimore, Md.: Penguin Books, 1962, pp. 114-15.

434 Kees, Weldon. "On a Painting by Rousseau." POETRY 58 (June 1941): 127. On Henri Rousseau's "The Cart of Père Juniet" (1908).

435 Kennedy, X.J. "Nude Descending a Staircase." (1969). NUDE DE-
SCENDING A STAIRCASE. New York: Doubleday, 1961, p. 69.

436 Krapf, Norbert. "Rural Lines after Brueghel: 1. Returning from the
Hunt; 2. Making Hay; 3. Harvesting Wheat; 4. Bringing Home the
Herd; 5. A Gloomy Day." POETRY 124 (September 1974): 338–42.

437 Krohn, Silvia. "After Having Seen Chagall's Fiancés at the Eiffel Tower
Next to a Sky Sharing Goats with a Yellow Violin Dream." NEW
GENERATION: POETRY ANTHOLOGY. Ed. Fred Wolven and Duane
Locke. Ann Arbor, Mich.: Review Book, 1971, p. 64.

438 Laing, Dilys. "Picasso's Candlefire." POETRY 97 (March 1961): 362.

439 Langland, Joseph. "Fall of Icarus: Brueghel." THE WHEEL OF SUM-
MER. New York: Dial Press, 1963, pp. 113–14.

440 _____. "Hunters in the Snow: Brueghel." Poem cited in Donald
B. Burness. "Pieter Brueghel: Painter for Poets." ART JOURNAL 32
(Winter 1972–73): 157–62.

441 Lattimore, Richmond. "Poussin's World: Two Pictures." SESTINA FOR
A FAR-OFF SUMMER. Ann Arbor: University of Michigan Press, 1962,
p. 25.

442 _____. "Tudor Portrait." POEMS. Ann Arbor: University of Michi-
gan Press, 1957, pp. 59–60.

443 Lowell, Amy. "A Bather; After a Picture by Andreas Zorn." COM-
PLETE WORKS OF AMY LOWELL. Boston: Houghton Mifflin, 1925,
p. 223.

444 Lowell, James Russell. "On a Portrait of Dante by Giotti." COM-
PLETE POETICAL WORKS OF JAMES RUSSELL LOWELL. Boston: Hough-
ton Mifflin, 1896, p. 87.

445 McCord, David. "Thirteen American Water Colors: Winslow Homer,
John Singer Sargent, Dodge MacKnight, Frank W. Benson, Charles
Hopkinson, Edward Hopper, Eliot O'Hara, Charles E. Burchfield, John
Lavalle, Harry Sutton, Jr., John Whorf, Millard Sheets, Andrew Wyeth."
THE OLD BATEAU AND OTHER POEMS. Boston: Little, Brown, and
Company, 1953, pp. 31–34.

446 McCormack, Virginia. "Thoughts in the Louvre before Leonardo's 'St.

John in the Wilderness.'" ANTHOLOGY OF MAGAZINE VERSE FOR
1928 AND YEARBOOK OF AMERICAN POETRY. Ed. William S.
Braithwaite. New York: Harold Vinal, 1928, p. 272.

447 McLellan, Isaac, Jr. "Lines, Suggested by a Picture by Washington All-
ston." THE POETS AND POETRY OF AMERICA. Ed. Rufus W.
Griswold. Philadelphia: Parry and McMillan, 1858, p. 456.

448 Mariah, Paul. "From Concordances with Dali." POETRY 118 (May
1971): 66-70. (Descriptions of six of Dali's paintings.)

449 Markham, Edwin. "The Man with a Hoe: Written after seeing Millet's
World-Famous Painting." (1899). AN AMERICAN ANTHOLOGY,
1787-1900. Ed. Edmund Clarence Stedman. Boston and New York:
Houghton Mifflin, 1900, pp. 541-42.

450 Marz, Roy. "Annunciation of the Unknown Master: Galleria Accademia,
Florence." POETRY 84 (June 1954): 150.

451 _____. "The Donatello Annunciation: Santa Croce." POETRY 84
(June 1954): 152.

452 _____. "Leonardo on the Annunciations." POETRY 84 (June 1954): 149.

453 _____. "Virgin to Angel as Bird: Botticelli." POETRY 84 (June
1954): 151.

454 Meeker, Marjorie. "For Rockwell Kent's TWILIGHT OF MAN." PO-
ETRY 31 (November 1927): 67.

455 Merrill, James. "The Book of Ephraim." DIVINE COMEDIES. New
York: Atheneum, 1976, pp. 45-136. Two sections of this long poem de-
scribe Giorgione's TEMPESTA, viewed in Venice. Part of the description
draws heavily upon an article by Nancy Thompson De Grummond. "Gior-
gione's Tempest: The Legend of St. Theodore." L'ARTE Giugno-Dicembre
1972-Anno V, nr. 18-19120, 5-53.

456 Miles, George Henry. "On Raphael's San Sisto Madonna." In THE
CATHOLIC ANTHOLOGY. Ed. Thomas Walsh. New York: Macmillan,
1943, p. 268.

457 Mills, Barriss. "La Grande Jatte." PARVENUS & ANCESTORS. New
York: Vagrom Chapbooks, 1959, pp. 22-23.

458 Mitchell, J.K. "The Greek Lovers." (poem on illustration of an en-

graving of "Greek Lovers" by Durand, after a painting by Weir). AMERI-
CAN MONTHLY MAGAZINE 4 n.s. (April 1838): 338–40.

459 Momaday, N. Scott. "Before an Old Painting of the Crucifixion; The
Mission Carmel, June, 1960." QUEST FOR REALITY. Ed. Yvor Winters
and Kenneth Fields. Chicago: Swallow Press, 1969, p. 188.

460 Monroe, Harriet. "Dürer's Portrait of Himself." POETRY 23 (March
1924): 298.

461 _____. "Fra Angelico's Annunciation." POETRY 23 (March 1924):
296.

462 _____. "The Romney." HOME BOOK OF MODERN VERSE. Ed. Bur-
ton E. Stevenson. New York: Henry Holt, 1925, pp. 403–4.

463 _____. "Titian on Charles V, Philip II, and the Empress Isobel."
POETRY 23 (March 1924): 294–95.

464 Moore, Marianne. "Leonardo da Vinci's." THE NEW YORKER BOOK
OF POEMS. New York: Viking Press, 1969, pp. 380–81. On "Saint
Jerome," unfinished sketch in the Vatican.

465 _____. "No Better than 'a Withered Daffodil.'" [on Sir Isaac Oliver,
"Portrait of Sir Philip Sidney"]. In "Poets on Painting, 7." ART NEWS
58 (March 1959): 44–45.

466 Morris, Harry. "Stanzas to be Placed under Fouquet's 'Madonna.'" THE
SORROWFUL CITY. Gainesville: University of Florida Press, 1965, p. 26.

467 Morse, Samuel French. "'The Sleeping Gypsy' (Henri Rousseau)." THE
CHANGES. Denver: Alan Swallow, 1964, p. 38.

468 Myron [pseud.]. "Lines Occasioned by Seeing a Portrait of the Goddess
of Liberty Treading the Keys of the Bastile under Her Feet, and Feeding
a Bald Eagle; Finely Executed by Mr. E. Savage." A FAMILY TABLET:
CONTAINING A SELECTION OF ORIGINAL POETRY. Boston: William
Spotswood, 1796, p. 55.

469 Nemerov, Howard. "Brueghel: The Triumph of Time." Poem cited in
Donald B. Burness. "Pieter Brueghel: Painter for Poets." ART JOUR-
NAL 32 (Winter 1972-73): 157-62.

470 _____. "Hope (as Brueghel drew her)." GNOMES & OCCASIONS.

Chicago: University of Chicago Press, p. 51.

471 Norse, Harold. "Monet's Venice." [on Monet, "Venice, Palazzo da Mula"]. In "Poets on Painting, 2." ART NEWS 56 (January 1958): 43–44.

472 O'Gorman, Ned. "L'Annunciazione; from Bellini." POETRY 90 (August 1957): 299–300.

473 O'Hara, Frank. "Lines While Reading Coleridge's 'The Picture.'" THE COLLECTED POEMS OF FRANK O'HARA. Ed. Donald M. Allen. New York: Knopf, 1971, p. 188.

474 _____. "On Looking at LA GRANDE JATTE, the Czar Wept Anew." THE COLLECTED POEMS OF FRANK O'HARA. Ed. Donald M. Allen. New York: Knopf, 1971, p. 63.

475 _____. "Variations on the 'Tree of Heaven' (In the Janis Gallery)." THE COLLECTED POEMS OF FRANK O'HARA. Ed. Donald M. Allen. New York: Knopf, 1971, p. 349.

476 Oliver, Raymond, "Fourteenth Century Fresco, St. Pierre, Bançion." THE SOUTHERN REVIEW 7, n.s. (July 1971): 866.

477 Padgett, Ron. "Joe Brainard's Painting 'Bingo.'" AN ANTHOLOGY OF NEW YORK POETS. Ed. Ron Padgett and David Shapiro. New York: Random House, 1970, pp. 457–58.

478 Petrie, Paul. "On Looking at a Vermeer." POETRY 97 (October 1960): 18.

479 Raab, Lawrence. "The Dream of Rousseau." MYSTERIES OF THE HORIZON. New York: Doubleday, 1972, pp. 62–64. On "The Sleeping Gypsy" (1897).

480 _____. "Magritte: The Song of the Glass Keys and the Cape of Storms." MYSTERIES OF THE HORIZON. New York: Doubleday, 1972, pp. 60–61.

481 Ransom, John Crowe. "Painted Head." ["Painting; a Head"]. A LITTLE TREASURY OF AMERICAN POETRY. Ed. Oscar Williams. New York: Charles Scribner's Sons, 1952, pp. 507–8.

482 Rich, Adrienne Cecile. "Mourning Picture." [on a painting by Edwin

Romanzo Elmer 1850-1923]. ADRIENNE RICH'S POETRY. Ed. Barbara
C. Gelpi and Albert Gelpi. New York: W.W. Norton, 1975, pp. 31-32.

483 Sadoff, Ira. "Vermeer: Girl Interrupted at Her Music." Also, "Ver-
meer: The Officer and the Laughing Girl." VIRGINIA QUARTERLY RE-
VIEW 52 (Winter 1976): 112-13.

484 Sarton, May. "Nativity; Piero della Francesca." NEW POEMS BY
AMERICAN POETS, NO. 2. Ed. Rolfe Humphries. New York: Bal-
lantine Books, 1957, p. 137.

485 Schwartz, Delmore. "Seurat's Sunday Afternoon along the Seine; To
Meyer and Lilian Schapiro." SELECTED POEMS. New York: New
Directions, 1967, pp. 190-96.

486 Scott, William. "Mr. [William] Scott has his Picture drawn by Mr.
[Joseph] Badger, under which is the following Lines, composed by him-
self." NEW HAVEN GAZETTE, February 3, 1764. Scott's poem has
three lines, but there is a fifteen-line answer.

487 Snodgrass, W.D. "Manet: The Execution of Emperor Maximilian."
AMERICAN POEMS: A CONTEMPORARY COLLECTION. Ed. Jascha
Kessler. Carbondale: Southern Illinois University Press, 1964, pp. 35-37.
Rpt. IN RADICAL PURSUIT. New York: Harper & Row, 1975, pp. 85-88.

488 _____. "Matisse: 'The Red Studio.'" IN RADICAL PURSUIT. New
York. Harper & Row, 1975, pp. 69-70.

489 _____. "Monet: 'Les Nympheas.'" IN RADICAL PURSUIT. New
York: Harper & Row, 1975, pp. 79-80.

490 _____. "Van Gogh: 'The Starry Night.'" IN RADICAL PURSUIT.
New York: Harper & Row, 1975, pp. 92-97.

491 _____. "Vuillard: 'The Mother and Sister of the Artist' (INSTRUCTIONS
FOR THE VISIT)." IN RADICAL PURSUIT. New York: Harper & Row,
1975, pp. 74-76.

492 Sobiloff, Hy. "Painting of A Lobster by Picasso." NEW POCKET AN-
THOLOGY OF AMERICAN VERSE FROM COLONIAL DAYS TO THE
PRESENT. Ed. Oscar Williams. New York: Washington Square Press,
1955, p. 492.

493 Solomon, Marvin. "Landscape with Yellow Birds: By Paul Klee." PO-
ETRY 96 (August 1960): 296.

494 Stevens, Wallace. "The Man with the Blue Guitar." A LITTLE TREAS-
 URY OF AMERICAN POETRY. Ed. Oscar Williams. New York:
 Charles Scribner's Sons, 1952, pp. 339-55.

495 Sullivan, Nancy. "The History of the World as Pictures." A CONTRO-
 VERSY OF POETS. Ed. Paris Leary and Robert Kelly. Garden City,
 N.Y.: Doubleday, 1965, pp. 446-51. [The "History" comprises ten
 poems: (1) "Prehistoric Cave Painting of a Bison"; (2) "Design on a
 Greek Amphora: Apollo on a Winged Tripod" (ca. 490 B.C.); (3) "Bud-
 dha Expounding the Doctrine to Yasas, the First Lay Member of the Bud-
 dhist Community" (5th century); (4) "A Triptych" by Van Eyck (ca. 1430);
 (5) "Spring in Chiang-nan" by Wen Cheng-Ming (1547); (6) "Les Meninas"
 by Velazquez (1656); (7) "Portrait of Mrs. Siddons" by Gainsborough
 (ca. 1785); (8) "La Gare Saint-Lazare" by Claude Monet (1877); (9)
 "Night Fishing at Antibes" by Picasso (1939); (10) "Number 1" by Jack-
 son Pollock (1948).]

496 Sweeney, James Johnson. "Guernica." POETRY 56 (June 1940): 128-29.

497 Swenson, May. "DeChirco [sic]: Superimposed Interiors." TO MIX
 WITH TIME; NEW AND SELECTED POEMS. New York: Charles
 Scribner's Sons, 1963, pp. 56-58.

498 _____. "Naked in Borneo (From a Painting by Tobias)." THE NEW
 YORKER BOOK OF POEMS. New York: Viking Press, 1969, pp. 473-74.

499 Thomas, Lorenzo Roberto. "Destruction of the Seated Man; After de
 Kooning's 'Seated Man' ca. 1938, now destroyed." ART JOURNAL 20
 (Winter 1960-61): 83.

500 Tuckerman, Henry Theodore. "On a Landscape by Backhuysen." Also,
 "On a Portrait of Mrs. Norton." POEMS. Boston: Ticknor, Reed, and
 Fields, 1851, pp. 153, 155.

501 Very, Jones. "On Seeing the Portrait of Helen Ruthven Waterston."
 POEMS AND ESSAYS. Boston: Houghton Mifflin, 1886, p. 473.

502 _____. "To the Misses Williams, On Seeing Their Beautiful Paintings
 of Wild Flowers." Also, "The Art Exhibition. On the Wild Flowers of
 the Art Exhibition." POEMS AND ESSAYS. Boston: Houghton Mifflin,
 1886, pp. 429, 474.

503 Viereck, Peter. "Nostalgia." [for engraving by Esteban Vicente]. "Poets
 and Painters, 6." ART NEWS 57 (November 1958): 26-27.

504 Vinograd, Julia. "I Saw the Picture." THE YOUNG AMERICAN POETS. Ed. Paul Carroll. Chicago: Follett, 1968, p. 460. [On Hieronymus Bosch, "A Musical Hell"].

505 Wakoski, Diane. "After Looking at a Painting of the Crucifixion by an Unknown Master of the 14th Century." TRILOGY. Garden City, N.Y.: Doubleday, 1974, pp. 14-15.

506 _____. "Van Gogh: Blue Picture." TRILOGY. Garden City, N.Y.: Doubleday, 1974, p. 20.

507 Watson, Robert. "A Second Look at Veronese's 'Mars and Venus United by Love.'" SELECTED POEMS. New York: Atheneum, 1974, p. 69.

508 Weinstein, Arnold. "From the Greek." (on pictures of Sappho and Medea). "Poets on Painting, 2." ART NEWS 56 (January 1958): 43-44.

509 Wilbur, Richard. "Ceremony." From CEREMONY (1950) in Charles F. Duffy. "'Intricate Neural Grace': The Esthetic of Richard Wilbur." CONCERNING POETRY 4, no. 1 (1971): 41-50. [On Bazille's "Family Reunion"].

510 _____. "The Giaour and the Pacha (Eugène Delacroix, 1856)." From THE BEAUTIFUL CHANGES (1947) in Charles F. Duffy. "'Intricate Neural Grace': The Esthetic of Richard Wilbur." CONCERNING POETRY 4, no. 1 (1971): 41-50.

511 _____. "L'Etoile (Degas, 1876)." From THE BEAUTIFUL CHANGES (1947) in Charles F. Duffy. "'Intricate Neural Grace': The Esthetic of Richard Wilbur." CONCERNING POETRY 4, no. 1 (1971): 41-50.

512 _____. "Objects." Also "A Dutch Courtyard." From THE BEAUTIFUL CHANGES (1947) in Charles F. Duffy. "'Intricate Neural Grace': The Esthetic of Richard Wilbur." CONCERNING POETRY 4, no. 1 (1971): 41-50.

513 Williams, Jonathan. "The Fourteen-Year-Old Samuel Palmer's Watercolour Notations For the Sketch, 'A Lane at Thanet.'" AN EAR IN BARTRAM'S TREE: SELECTED POEMS 1957-1967. Chapel Hill: University of North Carolina Press, 1969, unpaged.

514 Williams, William Carlos. "Book Five." PATERSON. New York: New Directions, 1963.

515 _____. "From 'The Birth of Venus', Song." (on Sandro Botticelli's "The Birth of Venus"). From THE TEMPERS, 1913. In THE COMPLETE COLLECTED POEMS OF WILLIAM CARLOS WILLIAMS, 1906-1938. Norfolk, Conn.: New Directions, 1938, p. 6.

516 _____. "March." (on Fra Angelico's "Annunciation"). THE EGOIST 3 (October 1916): 148-49. See Bram Dijkstra. THE HIEROGLYPHICS OF A NEW SPEECH; CUBISM, STIEGLITZ, AND THE EARLY POETRY OF WILLIAM CARLOS WILLIAMS. Princeton, N.J.: Princeton University Press, 1969, p. 62.

517 _____. "Pictures from Brueghel: I. Self-Portrait; II. Landscape with the Fall of Icarus; III. The Hunters in the Snow; IV. The Adoration of the Kings; V. Peasant Wedding; VI. Haymaking; VII. The Corn Harvest; VIII. The Wedding Dance in the Open Air; IX. The Parable of the Blind; X. Children's Games." PICTURES FROM BRUEGHEL AND OTHER POEMS, Norfolk, Conn.: J. Laughlin, 1962. (These poems on paintings by Brueghel were originally published in HUDSON REVIEW 13 (Spring 1960): 11-21.)

518 Wilson, Keith. "The Horses (two paintings by Hsü Pei-hung)." 31 NEW AMERICAN POETS. Ed. Ron Schreiber. New York: Hill and Wang, 1969, p. 238.

519 Wood, Allyn. "The Departure of Saint Ursula (as painted by Carpaccio)." COLLEGE ART JOURNAL 18 (Spring 1959): 240.

Section III

AMERICAN POEMS ON PAINTERS

AMERICAN POEMS ON PAINTERS

520 Allston, Washington. "To my Venerable Friend [Benjamin West] The President of the Royal Academy." THE POETS AND POETRY OF AMERICA. Ed. Rufus W. Griswold. Philadelphia: Parry and McMillan, 1858, pp. 94-95.

521 Anderson, Jack. "Still Life Variations (Hommage à Georges Braque)." In "Poets on Art." COLLEGE ART JOURNAL 19 (Fall 1959): 75-77.

522 Anonymous. Eugenius. "[untitled]." ["Dear Nymph! in vain has Ramsay shewn his Art."] SOUTH CAROLINA GAZETTE, November 14, 1754.

523 _____. "To the Painter, on seeing the Picture of a Lady, which he lately drew." PENNSYLVANIA GAZETTE, August 9, 1753.

524 _____. "Verses written while an artist [C.W. Peale] was drawing a lady's picture." COLUMBIAN MAGAZINE 1 (June 1787): 506.

525 Barlow, Joel. "American Painters." COLUMBIAN MUSE (1794): 106-8. Praises West, Copley, Trumbull, Steward, Brown, Wright. Also in BEAUTIES OF POETRY, BRITISH AND AMERICAN (1794): 171-72. Also appears expanded in COLUMBIAD. Philadelphia, 1807, Book 8.

526 Benson, Elizabeth Polk. "Marietta Strozzi." Also, "Botticelli." In "Poets on Art." COLLEGE ART JOURNAL 19 (Fall 1959): 75-77.

527 Berryman, John. "Rembrandt van Rijn obit 8 October 1669." HENRY'S FATE, AND OTHER POEMS, 1967-1972. New York: Farrar, Straus & Giroux, 1977, p. 41.

528 Bevington, Helen. "Nature Study, After Dufy." [Epigraph] When a friend accused him [Dufy] of playing fast and loose with nature, he replied: "But nature, my dear Sir, is only an hypothesis." From the section on "Fauvism" by Maurice Raynal in "The History of Modern Painting." THE NEW YORKER BOOK OF POEMS. New York: Viking Press, 1969, p. 478.

529 Bishop-Dubjinsky, G. "Pissarro's One Pure Note." 31 NEW AMERICAN POETS. Ed. Ron Schreiber. New York: Hill and Wang, 1969, p. 9.

530 Brumbaugh, Thomas B. "After Turner." COLLEGE ART JOURNAL 19 (Summer 1960): 352.

531 _____. "El Greco: A Poem." ART JOURNAL 28 (Summer 1969): 397.

532 _____. "Two Poems: About René Magritte; At Edward Malbone's Grave." ART JOURNAL 22 (Summer 1963): 245.

533 [Byles, Mather]. "To Mr. [John] Smibert on the Sight of His Pictures." BOSTON GAZETTE, ca. January 1729/30. Rpt. AMERICAN WEEKLY MERCURY (Philadelphia), February 19, 1729/30. Rpt. "To Pictorio, on the Sight of His Pictures." Mather Byles. POEMS ON SEVERAL OCCASIONS. Boston: S. Kneeland and T. Green, 1744; rpt. New York: Facsimile Text Society by Columbia University Press, 1940, pp. 89-93.

534 Bynner, Witter. "On a Painting by Paul Thevanaz." ANTHOLOGY OF MAGAZINE VERSE FOR 1929 AND YEARBOOK OF AMERICAN POETRY. Ed. William S. Braithwaite. New York: George Sully and Company, 1929, p. 43. Also, "Paul Thevanaz." CARAVAN. New York: Knopf, 1925, pp. 35-37.

535 Carruth, Hayden. "Matisse." THE CROW AND THE HEART, 1946-1959. New York: Macmillan, 1959, p. 23.

536 _____. "Mondrian." In "Poets on Painting, 5." ART NEWS 57 (September 1958): 24-25.

537 Channing, William Ellery, Jr. "Allston's Funeral." THE COLLECTED POEMS OF WILLIAM ELLERY CHANNING THE YOUNGER 1817-1901. Gainesville, Fla.: Scholars' Facsimiles and Reprints, 1967, p. 869.

538 Corso, Gregory. "Vermeer." SELECTED POEMS. London: Eyre & Spottiswoode, 1962, p. 55.

539 Crane, Hart. "Sunday Morning Apples; To William Sommer, Painter."
NEW ANTHOLOGY OF MODERN POETRY. Ed. Selden Rodman. New
York: Random House, 1938, p. 263.

540 cummings, e.e. (Dialogue on relationship of cummings's poetry to his
painting.) In Charles Norman. E.E. CUMMINGS, THE MAGIC-MAKER.
New York: Duell, Sloan and Pearce, 1964, pp. 175-76. Rpt. from fore-
word to exhibit catalog, Rochester Memorial Art Gallery, Rochester,
N.Y., 1945.

541 _____. "Picasso." COLLECTED POEMS. New York: Harcourt, Brace,
1938, p. 104.

542 Denby, Edwin. "Alex Katz Paints his North Window." COLLECTED
POEMS. New York: Full Court Press, 1975, p. 140.

543 Deutsch, Babette. "Ballade for Braque." THE COLLECTED POEMS OF
BABETTE DEUTSCH. New York: Doubleday, 1969, p. 105.

544 _____. "Cézanne." THE COLLECTED POEMS OF BABETTE DEUTSCH.
New York: Doubleday, 1969, p. 160.

545 _____. "Disasters of War: Goya at the Museum." THE COLLECTED
POEMS OF BABETTE DEUTSCH. New York: Doubleday, 1969, p. 134.

546 _____. "Homage to Braque." THE COLLECTED POEMS OF BABETTE
DEUTSCH. New York: Doubleday, 1969, p. 7.

547 _____. "Homage to Paul Klee." THE COLLECTED POEMS OF BAB-
ETTE DEUTSCH. New York: Doubleday, 1969, p. 95.

548 Drake, Leah Bodine. "Leonardo Before His Canvas." POETRY 74
(July 1949): 208-9.

549 Dubie, Norman. "February: The Boy Breughel." THE ILLUSTRATIONS.
New York: George Braziller, 1977, pp. 4-5.

550 _____. "Sun and Moon Flowers: Paul Klee, 1879-1940." THE IL-
LUSTRATIONS. New York: George Braziller, 1977, pp. 27-28.

551 Eshleman, Clayton. "Soutine." OPEN POETRY. Ed. Ronald Gross
and George Quasha. New York: Simon & Schuster, 1973, pp. 80-86.

552 Evans, Oliver. "The Art of Mr. Pavel Tchelitchew." POETRY 70 (September 1947): 302.

553 Fearing, Kenneth. "John Standish, Artist." NEW AND SELECTED POEMS. Bloomington: Indiana University Press, 1956, p. 5.

554 Ferlinghetti, Lawrence. "Don't Let That Horse Eat That Violin." (on Chagall). A CONEY ISLAND OF THE MIND. New York: New Directions, 1958, p. 26.

555 _____. "A Giacometti Summer." OPEN EYE, OPEN HEART. New York: New Directions, 1973, p. 44.

556 _____. "In Goya's Greatest Scenes We Seem to See." AN EYE ON THE WORLD; SELECTED POEMS. London: MacGibbon & Kee, 1967, pp. 37–38.

557 _____. "Sarolla's women in their picture hats." From PICTURES OF THE GONE WORLD in THE NEW AMERICAN POETRY. Ed. Donald M. Allen. New York: Grove Press, 1960, p. 128.

558 _____. "The Wounded Wilderness of Morris Graves." AN EYE ON THE WORLD; SELECTED POEMS. London: MacGibbon & Kee, 1967, pp. 50–51.

559 Fox, Ida. "Kline and Stein." [on Franz Kline]. In "Poets on Painting, 2." ART NEWS 56 (January 1958): 43–44.

560 Francis, Robert. "Picasso and Matisse." NEW POEMS BY AMERICAN POETS. Ed. Rolfe Humphries. New York: Ballantine Books, 1953, p. 67.

561 Fricke, Arthur Davidson. "A Watteau Melody." SELECTED POEMS. New York: George H. Doran Company, 1926, pp. 26–27.

562 Fussiner, Howard. "Bonnard." COLLEGE ART JOURNAL 18 (Fall 1958): 71.

563 _____. "Brancuşi." COLLEGE ART JOURNAL 18 (Spring 1959): 209.

564 _____. "Giotto." ART JOURNAL 21 (Winter 1961–62): 96.

565 _____. "Mondrian." COLLEGE ART JOURNAL 18 (Summer 1959): 357.

566 Goldman, Michael. "The Rothko Paintings." POETRY 99 (March 1962): 366.

567 Gray, Agnes Kendrick. "After Whistler." ANTHOLOGY OF MAGA-ZINE VERSE FOR 1921 AND YEAR BOOK OF AMERICAN POETRY. Ed. William S. Braithwaite. Boston: Small, Maynard, 1921, p. 62.

568 [Green, Joseph?]. "To Mr. B[yles], occasioned by his verses to Mr. Smibert on seeing his Pictures." BOSTON GAZETTE, April 13, 1730. A reply to Byles's poem above (no. 533).

569 Grigson, Geoffrey. "As Dufy Paints." POETRY 121 (December 1972): 132.

570 Haines, John. "Dürer's Vision." THE STONE HARP. Middletown, Conn.: Wesleyan University Press, 1964, p. 55.

571 _____. "Paul Klee." 31 NEW AMERICAN POETS. Ed. Ron Schreiber. New York: Hill and Wang, 1969, p. 74.

572 _____. "Ryder." TWENTY POEMS. Santa Barbara, Calif.: Unicorn Press, 1971, p. 28.

573 Hall, Donald. "Three Poems from Edvard Munch." THE DARK HOUSES. New York: Viking Press, 1958, pp. 40–44.

574 Hamilton, Marion Ethel. "Gauguin." THE MUSIC MAKERS; AN AN-THOLOGY OF RECENT AMERICAN POETRY. Ed. Stanton A. Coblentz. New York: Bernard Ackerman, 1945, p. 89.

575 Hartley, Marsden. "Modigliani's Death Mask." SELECTED POEMS. Ed. Henry W. Wells. New York: Viking Press, 1945, pp. 33–34.

576 Hays, H.R. "Douanier Rousseau" and "Paul Gauguin." SELECTED POEMS, 1933–67. San Francisco: City Lights Books, 1968, pp. 22, 23.

577 _____. "A Painter Commits Suicide; for Mark Rothko." INSIDE MY OWN SKIN; POEMS 1968–71. Santa Cruz, Calif.: Kayak Books, 1975, p. 47.

578 _____. "W.J. Hays, Artist." SELECTED POEMS, 1933–67. San Francisco: City Lights Books, 1968, p. 55.

579 Hemschemeyer, Judith. "Dürer Went to Sketch the Whale." I REMEM-BER THE ROOM WAS FILLED WITH LIGHT. Middletown, Conn.: Wesleyan University Press, 1973, p. 40.

580 [Hopkinson, Francis] F.H. "Verses Inscribed to Mr. Wollaston." AMERICAN MAGAZINE 1 (September 1758): 607-8. (Praise for John Wollaston and Benjamin West.)

581 Hubbell, Lindley Williams. "Mondrian." SEVENTY POEMS. Denver: Alan Swallow, 1965, p. 32.

582 Jennings, Elizabeth. "Klee's Last Years." THE SOUTHERN REVIEW 12 (April 1976): 354.

583 Johnson, Ronald. "Turner, Constable & Stubbs." THE BOOK OF THE GREEN MAN. New York: W.W. Norton, 1967, p. 57.

584 Josephs, Laurence. "Vermeer: For D.Y." THE SOUTHERN REVIEW 2 n.s. (January 1966): 99.

585 Kessler, Jascha. "Requiem for an Abstract Artist; Jackson Pollock, Dead August 1956, at the Wheel of his Convertible." AMERICAN POEMS: A CONTEMPORARY COLLECTION. Ed. Jascha Kessler. Carbondale: Southern Illinois University Press, 1964, pp. 164-65.

586 Kreymborg, Alfred. "Cézanne." THE NEW POETRY: AN ANTHOLOGY. Ed. Harriet Monroe and Alice Corbin Henderson. New York: Macmillan, 1917, p. 152.

587 Kroll, Ernest. "Marc Chagall." POETRY 83 (October 1953): 16.

588 _____. "Marin No More in Maine." POETRY 85 (November 1954): 131.

589 Kunitz, Stanley. "The Crystal Cage; for Joseph Cornell." In Dore Ashton. A JOSEPH CORNELL ALBUM. New York: Viking Press, 1974, pp. 121-22. The ALBUM also contains poems to the mixed-media artist Cornell by Octavio Paz, John Ashbery, and Richard Howard.

590 Langland, Joseph. "Henri Matisse." THE WHEEL OF SUMMER. New York: Dial Press, 1963, p. 108.

591 Lattimore, Richmond. "The Father." [on Pablo Picasso]. SESTINA FOR A FAR-OFF SUMMER. Ed. Richmond Lattimore. Ann Arbor: University of Michigan Press, 1962, p. 7.

592 Lehman, David. "Edvard Munch." POETRY 123 (December 1973): 142.

593 Lohf, Kenneth A. "Picasso at Vallauris." POETRY 94 (April 1959): 26.

594 McClure, Mike. "Ode to Jackson Pollock." EVERGREEN REVIEW 11 (Autumn 1958): 124-26.

595 Marin, John. "The Man and the Place." THE SELECTED WRITINGS OF JOHN MARIN. Ed. Dorothy Norman. New York: Pellegrini & Cudahy, 1949, pp. 156-59. Rpt. from AMERICA AND ALFRED STIEGLITZ. New York: Doubleday, Doran, and Co., 1934.

596 _____. "To My Paint Children." THE SELECTED WRITINGS OF JOHN MARIN. Ed. Dorothy Norman. New York: Pellegrini & Cudahy, 1949, pp. 177-78. Rpt. from catalog for a Marin exhibition, AN AMERICAN PLACE, February 14, 1938.

597 Mayo, E.L. "El Greco." MID-CENTURY AMERICAN POETS. Ed. John Ciardi. New York: Twayne Publishers, 1950, p. 154.

598 Monroe, Harriet. "Botticelli." CHOSEN POEMS, A SELECTION FROM MY BOOKS OF VERSE. Ed. Harriet Monroe. New York: Macmillan, 1935, p. 166.

599 _____. "El Greco." POETRY 23 (March 1924): 295.

600 _____. "Goya." POETRY 23 (March 1924): 297-98.

601 _____. "Murillo." POETRY 23 (March 1924): 296.

602 _____. "Rubens." POETRY 23 (March 1924): 297.

603 _____. "Velásquez." POETRY 23 (March 1924): 293-94.

604 Mooney, Stephen. "Water Color." THE NEW YORKER BOOK OF POEMS. New York: Viking Press, 1969, p. 790.

605 Nemerov, Howard. "Vermeer." THE NEXT ROOM OF THE DREAM. Chicago: University of Chicago Press, 1962, p. 37.

606. _____. "The World as Brueghel Imagined It." GNOMES & OCCA-SIONS. Chicago: University of Chicago Press, 1973, p. 47.

607 O'Hara, Frank. "About Courbet." In "Poets on Painting, 2." ART NEWS 56 (January 1958): 43–44.

608 _____. "Early Mondrian." THE COLLECTED POEMS OF FRANK O'HARA. Ed. Donald M. Allen. New York: Knopf, 1971, p. 37.

609 _____. "For Bob Rauschenberg." THE COLLECTED POEMS OF FRANK O'HARA. Ed. Donald M. Allen. New York: Knopf, 1971, p. 322.

610 _____. "Hieronymus Bosch." THE COLLECTED POEMS OF FRANK O'HARA. Ed. Donald M. Allen. New York: Knopf, 1971, p. 121.

611 _____. "Poem." (for Mario Schifano's 1964 show). THE COLLECTED POEMS OF FRANK O'HARA. Ed. Donald M. Allen. New York: Knopf, 1971, p. 477.

612 _____. "Sonnet for Larry Rivers & His Sister." THE COLLECTED POEMS OF FRANK O'HARA. Ed. Donald M. Allen. New York: Knopf, 1971, p. 138.

613 _____. "Walking with Larry Rivers." THE COLLECTED POEMS OF FRANK O'HARA. Ed. Donald M. Allen. New York: Knopf, 1971, p. 82.

614 Olson, Charles. "An 'enthusiasm.'" [a commemorative tribute for Fitz Hugh Lane]. Published originally in GLOUCESTER DAILY TIMES, October 9, 1965; rpt. in John Wilmerding. FITZ HUGH LANE. New York: Praeger Publishers, 1971, pp. 94–95.

615 Osgood, Frances S. "The Boy Painter." [on Benjamin West]. THE AMERICAN FEMALE POETS. Ed. Caroline May. Philadelphia: Lindsay and Blakiston, 1848, p. 394.

616 Petrie, Paul. "Renoir." POETRY 97 (October 1960): 17.

617 Pillin, William. "The Ascensions." (on Marc Chagall). POETRY 91 (November 1957): 104–5.

618 Pomeroy, Ralph. "Sentry Seurat." POETRY 99 (January 1962): 230.

619 Pound, Ezra. "To Whistler, American; On the Loan Exhibit of His Paintings at the Tate Gallery." POETRY 1 (October 1912): 7.

620 Rich, Adrienne Cecile. "Pictures by Vuillard." MID-CENTURY AMERICAN POETS. Ed. John Ciardi. New York: Twayne Publishers, 1950, pp. 459–60.

621 Robinson, Edwin Arlington. "Rembrandt to Rembrandt: (Amsterdam, 1645)." COLLECTED POEMS. New York: Macmillan, 1961, pp. 582-91.

622 Roseliep, Raymond. "Man at a Picasso Exhibit." In "Poets on Art." COLLEGE ART JOURNAL 19 (Fall 1959): 75-77.

623 Sadoff, Ira. "Seurat." SETTLING DOWN. Boston: Houghton Mifflin, 1975, pp. 49-50.

624 Schevill, James. "A Story of Soutine." POET'S CHOICE. Ed. Paul Engle and Joseph Langland. New York: Dial Press, 1962, pp. 188-89.

625 _____. "Seurat." FIFTEEN MODERN AMERICAN POETS. Ed. George P. Elliott. New York: Holt, Rinehart and Winston, 1962, p. 188.

626 Schuyler, James. "Unlike Joubert." HYMN TO LIFE. New York: Random House, 1972, pp. 28-29.

627 Schwartz, Delmore. "She Lives With the Furies of Hope and Despair" (to Jan Vermeer). VAUDEVILLE FOR A PRINCESS. New York: New Directions, 1950, p. 77.

628 Sewall, Samuel. "This Morning Tom Child, the Painter, Died." SEVEN-TEENTH-CENTURY AMERICAN POETRY. Ed. H.T. Meserole. New York: W.W. Norton, 1972, p. 306.

629 Sissman, L.E. "American Light: A Hopper Retrospective." BOSTON UNIVERSITY JOURNAL 22 (Autumn 1974): 32.

630 Sorrentino, Gilbert. "Two for Franz Kline: 1. The Gunner; 2. The Dark Hallway." BLACK AND WHITE. New York: Totem Press, 1964, unpaged.

631 Spacks, Barry. "Botticelli in Atlantic City." POETRY 95 (January 1960): 221.

632 Stoddard, Richard Henry. "To Jervis McEntee, Artist." THE BOOK OF THE EAST AND OTHER POEMS. Boston: James R. Osgood and Company, 1871, p. 181.

633 Strongin, Lynn. "Van Gogh." RISING TIDES: 20TH-CENTURY AMERI-CAN WOMEN POETS. Ed. Laura Chester and Sharon Barba. New York: Washington Square Press, 1973, pp. 315-16.

634 Sullivan, Nancy. "An Edward Hopper Poem." THE HISTORY OF THE
 WORLD AS PICTURES. Columbia: University of Missouri Press, 1965,
 p. 16.

635 Taylor, Bert Leston. "Post-Impressionism" (a satire on Arthur Dove).
 HOME BOOK OF MODERN VERSE. Ed. Burton E. Stevenson. New
 York: Henry Holt, 1925, pp. 527-28.

636 [Thornton, Thomas(?)] Dr. T.T. "Extempore: On seeing Mr. [John]
 Wollaston's Pictures, in Annapolis." MARYLAND GAZETTE (Annapolis),
 March 15, 1753. Rpt. in George C. Groce. "John Wollaston: A
 Cosmopolitan Painter in the British Colonies." ART QUARTERLY 15
 (1952): 132-49.

637 Todd, Ruthven. "A Sestina for Georges de La Tour." In "Poets and
 Painters, 7." ART NEWS 58 (March 1959): 44-45.

638 Towle, Tony. "Notes on Velásquez." NORTH. New York: Columbia
 University Press, 1970, p. 36.

639 Trimpi, W. Wesley. "To El Greco." POETRY 74 (August 1949):
 264-65.

640 Tuckerman, Henry Theodore. "On the Death of Allston." POEMS.
 Boston: Ticknor, Reed, and Fields, 1851, p. 160.

641 Tyler, Parker. "But Utamaro: Secretly." In "Poets on Painting, 3."
 ART NEWS 57 (March 1958): 44-45.

642 Warren, Robert Penn. "The Sound of That Wind." AUDUBON; A
 VISION. New York: Random House, 1969, pp. 25-29. On John
 James Audubon as painter.

643 Watson, Robert. "William Rimmer, M.D. (1816-1879)." SELECTED
 POEMS. New York: Atheneum, 1974, pp. 70-76.

644 Wheatley, Phyllis. "To S[cipio] M[oorhead] a Young African Painter, on
 Seeing His Works." (1773). EARLY BLACK AMERICAN POETS. Ed.
 William H. Robinson, Jr. Dubuque, Iowa: W.C. Brown Co., 1969,
 p. 110.

645 Whittier, John Greenleaf. "An Artist of the Beautiful: George Fuller."
 THE COMPLETE WORKS OF JOHN GREENLEAF WHITTIER. Cambridge
 ed. Boston: Houghton Mifflin, 1894, p. 216.

646 Wieners, John. "Contradicting Picasso." ACE OF PENTACLES. New York: James F. Carr & Robert A. Wilson, 1964, p. 42.

647 Wilbur, Richard. "Giacometti." POEMS, 1943-1956. London: Faber and Faber, 1956, pp. 78-79.

648 _____. "A Hole in the Floor; for René Magritte." ADVICE TO A PROPHET AND OTHER POEMS. New York: Harcourt, Brace, and World, 1961, p. 21.

649 _____. "A Miltonic Sonnet for Mr. Johnson on His Refusal of Peter Hurd's Official Portrait." CONTEMPORARY AMERICAN POETRY. Ed. A. Poulin, Jr. Boston: Houghton Mifflin, 1971, p. 350.

650 Williams, Donald. "At an Exhibit of Frank Reaugh Paintings." SOUTH DAKOTA REVIEW 12 (Winter 1974-75): 74.

651 Williams, Jonathan. "To Charles Oscar." AN EAR IN BARTRAM'S TREE: SELECTED POEMS, 1957-1967. Chapel Hill: University of North Carolina Press, 1969, unpaged. (Williams's note: "The painter, Charles Oscar, who did the drawings for my FOUR STOPPAGES (1953), was murdered in New York City in 1961.")

652 Williams, William Carlos. "The Botticellian Trees." THE COLLECTED EARLIER POEMS OF WILLIAM CARLOS WILLIAMS. Norfolk, Conn.: New Directions, 1951, pp. 80-81. Also in A LITTLE TREASURY OF AMERICAN POETRY. Ed. Oscar Williams. New York: Charles Scribner's Sons, 1952, p. 374.

653 _____. "The Crimson Cyclamen (To the Memory of Charles Demuth)." THE COLLECTED EARLIER POEMS OF WILLIAM CARLOS WILLIAMS. New York: New Directions, 1951, pp. 397-404.

654 Wilson, Susan. "The Painter of Seville." WERNER'S READINGS AND RECITATIONS--No. 33: FAVORITE SELECTIONS OF JULIA AND ANNIE THOMAS. New York: Edgar S. Werner, 1892, pp. 125-31.

655 Witz, Robert A. "Song for Van Gogh's Ear Allegro and Andante." ARTS IN SOCIETY 2 (1963): 160-71.

Section IV

AMERICAN POEMS ON UNSPECIFIED PAINTINGS
AND PAINTERS AND RELATED SUBJECTS

AMERICAN POEMS ON UNSPECIFIED PAINTINGS
AND PAINTERS AND RELATED SUBJECTS

656 Allentuck, Marcia. "Rococo Interior with Clavecin. Malgré Lessing."
ART JOURNAL 20 (Summer 1961): 228.

657 Allston, Washington. "The Paint King." LECTURES ON ART AND
POEMS (1850) AND MONALDI (1841). Gainesville, Fla.: Scholars'
Facsimiles and Reprints, 1967, pp. 255-62.

658 _____. "The Two Painters, A Tale." LECTURES ON ART AND POEMS
(1850) AND MONALDI (1841). Gainesville, Fla.: Scholars' Facsimiles
and Reprints, 1967, pp. 218-39.

659 Ames, Evelyn. "The Louvre Reopened after World War II." THE HAWK
FROM HEAVEN. New York: Dodd, Mead, 1957, p. 86.

660 Anonymous. "Cupid, On Seeing himself painted by a young Lady."
AMERICAN WEEKLY MERCURY, 18 June 1730.

661 _____. "The Painter's Portfolio." PUTNAM'S MONTHLY MAGAZINE
4 (October 1854): 364.

662 _____. "The Petition." BOSTON GAZETTE, 15 March 1756. First
line: "Artful Painter, by this Plan." Rpt. NEW YORK MERCURY, 29
March 1756.

663 [Anonymous. A young lady]. "Directions to a Painter." NEW YORK
GAZETTE, 30 April 1761.

664 Antin, Eleanor. "Painter Poems." OPEN POETRY. Ed. Ronald Gross
and George Quasha. New York: Simon & Schuster, 1973, p. 440.

665 Arensberg, Walter Conrad. "Dada IS American." REVOLUTION OF THE WORD: A NEW GATHERING OF AMERICAN AVANT GARDE POETRY, 1914-1945. Ed. Jerome Rothenberg. New York: Seabury Press, 1974, pp. 3-5.

666 Ashbery, John. "The Painter." SOME TREES. New Haven, Conn.: Yale University Press, 1956, pp. 65-66.

667 Ashbery, John and Koch, Kenneth. "Death Paints a Picture." In "Poets on Painting, 5." ART NEWS 57 (September 1958): 24-25.

668 Bennett, Gwendolyn B. "Quatrains: Brushes and Paints Are all I have." CAROLING DUSK: AN ANTHOLOGY OF VERSE BY NEGRO POETS. Ed. Countee Cullen. New York: Harper and Bros., 1927, p. 155.

669 Bode, Carl. "The Nocturne." ["Why the hell do you use all that black/In your painting . . ."] TODAY'S POETS, AMERICAN AND BRITISH POETRY SINCE THE 1930's. Ed. Chad Walsh. New York: Charles Scribner's Sons, 1972, pp. 55-56.

670 Burton, Richard. "An Unpraised Picture." AN AMERICAN ANTHOLO-GY, 1787-1900. Ed. Edmund Clarence Stedman. Boston and New York: Houghton Mifflin, 1900, pp. 646-47.

671 Bynner, Witter. "In Memory of a Young Painter (To Warren Rockwell)." A CANTICLE OF PAN AND OTHER POEMS. New York: Knopf, 1920, p. 141.

672 _____. "Inscriptions on Chinese Paintings." ANTHOLOGY OF MAG-AZINE VERSE FOR 1958. Ed. William S. Braithwaite. New York: Schulte Publishing Co., 1959, pp. 18-22.

673 _____. "Painter." GUEST BOOK. New York: Knopf, 1935, p. 53.

674 _____. "To a Painter." GREENSTONE POEMS A SEQUENCE. New York: Knopf, 1926, p. 204.

675 Carruth, Hayden. "The Buddhist Painter Prepares to Paint." THE CROW AND THE HEART, 1946-1959. New York: Macmillan, 1959, pp. 40-41.

676 Chamberlain, Will. "To Edna, Pointing Out Pictures." ANTHOLOGY OF MAGAZINE VERSE FOR 1927 AND YEARBOOK OF AMERICAN POETRY. Ed. William S. Braithwaite. Boston: B.J. Brimmer Company, 1927, pp. 54-55.

677 Clarke, James Freeman. "The Genuine Portrait." THE POETS AND
 POETRY OF AMERICA. Ed. Rufus W. Griswold. Philadelphia: Parry
 and McMillan, 1858, p. 461.

678 [_____]. "The Portrait." THE DIAL 1 (April 1841): 468.

679 [Cole, Thomas]. "Lines Occasioned by the Death of Mr. Luman Reed."
 KNICKERBOCKER 12 (September 1838): 272.

680 Cole, Thomas. THOMAS COLE'S POETRY. Ed. Marshall B. Tymn.
 York, Pa.: Liberty Cap Books, 1972.

681 Cooperman, Stanley. "El Prado." CANADIAN GOTHIC AND OTHER
 POEMS. Burnaby, British Columbia: West Coast Review Publishing
 Society, 1976, p. 78. Published as a special issue of the WEST COAST
 REVIEW.

682 Cranch, Christopher P. "My Old Palette." THE BIRD AND THE BELL
 WITH OTHER POEMS. Boston: James R. Osgood and Company, 1875,
 pp. 119–20.

683 cummings, e.e. "Words Into Pictures (VERBUM ETC.)." E.E. CUMMINGS:
 A MISCELLANY REVISITED. New York: October House, 1958, p. 329.
 Rpt. from ART NEWS, May 1949.

684 Drake, Joseph Rodman. "To the Directors of the Academy of Arts Writ-
 ten on Visiting the First Exhibition in 1816." THE LIFE AND WORKS
 OF JOSEPH RODMAN DRAKE. Boston: Merrymount Press, 1935,
 pp. 358–61.

685 Enslin, Theodore. "Landscape with Figures." A CONTROVERSY OF
 POETS. Ed. Paris Leary and Robert Kelly. New York: Anchor Books,
 1965, pp. 101–2.

686 Etter, David. "From a Nineteenth–Century Kansas Painter's Notebook."
 PICTURES THAT STORM INSIDE MY HEAD. Ed. Richard Peck. New
 York: Avon Books, 1976, p. 29.

687 Faugeres, Margaretta V. "On a Painter." THE AMERICAN FEMALE
 POETS. Ed. Caroline May. Philadelphia, 1848, p. 39.

688 Fearing, Kenneth. "Art Review." NEW AND SELECTED POEMS.
 Bloomington: Indiana University Press, 1956, p. 94.

689 Finn, Henry J. "Design for a Picture Gallery." AMERICAN MONTHLY
 MAGAZINE 4 (August 1837): 161–63.

690 Frankenstein, John. AMERICAN ART; ITS AWFUL ALTITUDE. A SATIRE.
 Cincinnati, 1864. Rpt. by Bowling Green, Ohio: Bowling Green Uni-
 versity Popular Press, 1972.

691 Fricke, Arthur Davidson. "Sonnets of a Portrait Painter." Also, "The
 Village Artist." SELECTED POEMS. New York: George Doran Co.,
 1926, pp. 71–94, 184.

692 _____. TWELVE JAPANESE PAINTERS. Chicago: Ralph Fletcher
 Seymour Co., Alderbrink Press, 1913. Group of poems on the Ukiyoe
 school of Japanese painting.

693 _____. "Wise Were the Chinese Painters," "The First Painter," "Poem
 Inscribed on a Chinese Painting," and "The Waterfall, a Painting by
 Wang Wei." TUMULTUOUS SHORE AND OTHER POEMS. New York:
 Knopf, 1942, pp. 48, 87, 102, 105.

694 Fussiner, Howard. "Two Poems: Redon; Recollection of the Rembrandts
 in the Louvre." ART JOURNAL 25 (Winter 1965): 137.

695 Garrigue, Jean. "Amsterdam Letter." THE NEW YORKER BOOK OF
 POEMS. New York: Viking Press, 1969, pp. 19–21.

696 Greene, Ashton. "A Bather in a Painting." NEW POEMS BY AMERI-
 CAN POETS. Ed. Rolfe Humphries. New York: Ballantine Books,
 1953, p. 78.

697 Gregory, Horace. "Mutum Est Pictura Poema." COLLECTED POEMS.
 New York: Holt, Rinehart and Winston, 1964, p. 95.

698 Griffin, Howard. "Ex-GI at the Show of Berlin Paintings." In "Poets
 on Painting, 2." ART NEWS 56 (January 1958): 43–44.

699 Hershon, Robert. "Paintings of Roses." 31 NEW AMERICAN POETS.
 Ed. Ron Schreiber. New York: Hill and Wang, 1969, pp. 96–97.

700 Hine, Daryl. Untitled. ["Here is another poem in a picture"]. TWEN-
 TIETH CENTURY POETRY: AMERICAN AND BRITISH (1900–1970). New
 York: McGraw-Hill, 1970, pp. 188–89.

701 Hitchcock, George. "Sketch for a Mural for the New Senate Office
 Bldg." TACTICS OF SURVIVAL. San Francisco: Bindweed Press, 1964,
 p. 19.

702 Howes, Barbara. "In a Prospect of Flowers; Of a painter drowned in his twentieth year." LIGHT AND DARK. Middletown, Conn.: Wesleyan University Press, 1959, p. 52.

703 _____. "The Gallery." LIGHT AND DARK. Middletown, Conn.: Wesleyan University Press, 1959, p. 21.

704 _____. "Portrait of the Boy as Artist." LIGHT AND DARK. Middletown, Conn.: Wesleyan University Press, 1959, p. 13.

705 Hudson, Hannah R. "Poet and Painter." HARPER'S MONTHLY MAGAZINE 43 (June 1871): 176.

706 Hughes, Ted. "Still-Life." THE NEW YORKER BOOK OF POEMS. New York: Viking Press, 1969, p. 680.

707 Ignatow, David. "The Painter and Her Subject." Also, "The Painter." POEMS 1934-1969. Middletown, Conn.: Wesleyan University Press, 1970, pp. 59, 96-97.

708 Jeffers, Robinson. "To a Young Artist." THE NATION, February 8, 1928.

709 Jennings, Elizabeth. "Reflections on a Still Life." THE SOUTHERN REVIEW 12 (April 1976): 357.

710 Johnson, Ronald. "Landscape with Bears, for Charles Olson." VALLEY OF THE MANY-COLORED GRASSES. New York: W.W. Norton, 1969, pp. 74-75.

711 Jones, Leroi. "The Politics of Rich Painters." A CONTROVERSY OF POETS. Ed. Paris Leary and Robert Kelly. New York: Doubleday, 1965, pp. 173-74.

712 Josephs, Laurence. "Trompe L'oeil." POETRY 78 (August 1951): 265-66.

713 Koch, Kenneth. "The Artist." In "Poets on Painting, 2." ART NEWS 56 (January 1958): 43-44.

714 Kunitz, Stanley. "The Artist." THE TERRIBLE THRESHOLD; SELECTED POEMS 1940-1970. London: Secker & Warburg, 1974, pp. 77-78.

715 Lattimore, Richmond. "The Painter's Eye." SESTINA FOR A FAR-OFF SUMMER. Ann Arbor: University of Michigan Press, 1962, p. 72.

716 _____. "Tudor Portrait." POEMS. Ann Arbor: University of Michigan Press, 1957, pp. 59-60.

717 Levertov, Denise. "Living with a Painting; for Albert Kresch." POETRY 101 (October-November 1962): 65.

718 Longfellow, Henry W. "A Dutch Picture." THE COMPLETE POETICAL WORKS OF LONGFELLOW. Cambridge, Mass.: Riverside Press, 1922, p. 534.

719 Lowell, Amy. "The Painter on Silk." THE COMPLETE POETICAL WORKS OF AMY LOWELL. Boston: Houghton Mifflin, 1925, pp. 128-29.

720 Lowell, James Russell. "My Portrait Gallery." COMPLETE POETICAL WORKS. Boston: Houghton Mifflin, 1896, p. 403.

721 McBlair, Robert. "Virginia Portraits, part four 'Ancestral Oil Portrait.'" ANTHOLOGY OF MAGAZINE VERSE FOR 1927. Ed. William S. Braithwaite. Boston: B.J. Brimmer Company, 1927, pp. 242-43.

722 MacLeish, Archibald. "Empire Builders." (on mural THE MAKING OF AMERICA in Five Panels). FRESCOES FOR MR. ROCKEFELLER'S CITY. New York: John Day Co., 1933, pp. 18-24.

723 _____. "Oil Painting of the Artist as the Artist." FRESCOES FOR MR. ROCKEFELLER'S CITY. New York: John Day Co., 1933, pp. 15-17.

724 McGinley, Phyllis. "Spectator's Guide to Contemporary Art." TIMES THREE; SELECTED VERSE FROM THREE DECADES. New York: Viking Press, 1961, pp. 69-70. Includes: "How to Tell Portraits from Still-Lifes"; "On the Farther Wall, Marc Chagall"; "The Golden Touch"; "The Modern Palette"; "Squeeze Play"; "The Casual Look."

725 Mayo, E.L. "To Catch the Common Face." AMERICAN DECADE. Ed. Tom Boggs. Cummington Press, 1943, p. 56.

726 Meixner, Mary. "Two Poems: The Fog ["Seurat would have gone forth . . . "]; To the Earth Painter." ART JOURNAL 25 (Fall 1965): 25.

727 Meredith, William. HAZARD, THE PAINTER. New York: Knopf, 1975. A volume of sixteen poems comprising a biography of Hazard.

728 Mills, Barriss. "Rembrandt Lecture." PARVENUS & ANCESTORS. New York: Vagrom Chapbooks, 1959, pp. 25-26.

729 Monroe, Harriet. "At the Prado." CHOSEN POEMS, A SELECTION
 FROM MY BOOKS OF VERSE. Ed. Harriet Monroe. New York: Mac-
 millan, 1935, pp. 28-33.

730 Moody, William Vaughn. "Faded Pictures." AMERICAN POETRY. Ed.
 Gay Wilson Allen et al. New York: Harper & Row, 1965, pp. 613-14.

731 Moore, Marianne. "When I Buy Pictures." THE COLLECTED POEMS
 OF MARIANNE MOORE. New York: Macmillan, 1961, p. 55.

732 Nemerov, Howard. THE PAINTER DREAMING IN THE SCHOLAR'S
 HOUSE. New York: Phoenix Book Shop, 1968. A poem dedicated to
 the painters Paul Klee and Paul Terence Freeley on what painters try to
 accomplish in their art.

733 _____. "Painting a Mountain Stream." FIVE AMERICAN POETS. Ed.
 Thom Gunn and Ted Hughes. London: Faber and Faber, 1963, pp. 41-
 42. Also in H. Nemerov. MIRRORS AND WINDOWS. Chicago:
 University of Chicago Press, 1958, pp. 97-98.

734 Nichols, Constance. "Desire." EBONY RHYTHM; AN ANTHOLOGY
 OF CONTEMPORARY NEGRO VERSE. Ed. Beatrice N. Murphy. Ex-
 position Press, 1948, pp. 110-11. ["An artist looked up from his paint-
 ing. . . ."]

735 O'Hara, Frank. "Barbizon." THE COLLECTED POEMS OF FRANK O'HARA.
 Ed. Donald M. Allen. New York: Knopf, 1971, p. 130.

736 _____. "Favorite Painting in the Metropolitan." THE COLLECTED POEMS
 OF FRANK O'HARA. Ed. Donald M. Allen. New York: Knopf, 1971,
 p. 423.

737 _____. "Poem for a Painter." THE COLLECTED POEMS OF FRANK O'HARA.
 Ed. Donald M. Allen. New York: Knopf, 1971, p. 80.

738 _____. "Study for Women on a Beach." THE COLLECTED POEMS OF
 FRANK O'HARA. Ed. Donald M. Allen. New York: Knopf, 1971,
 p. 128.

739 _____. "Why I Am Not a Painter." (1956). CONTEMPORARY PO-
 ETRY IN AMERICA. Ed. Miller Williams. New York: Random House,
 1973, p. 102.

740 Olson, Elder. "Exhibition of Modern Art." POETRY 101 (October-
 November 1962): 89-93.

741 Oppenheim, Garrett. "Oil of Dada: First Look." POETRY 51 (March 1938): 319.

742 Perreault, John. "The Metaphysical Paintings." AN ANTHOLOGY OF NEW YORK POETS. Ed. Ron Padgett and David Shapiro. New York: Random House, 1970, pp. 308-13.

743 Plath, Sylvia. "Water Color of Grantchester Meadows (Cambridge, England)." THE NEW YORKER BOOK OF POEMS. New York: Viking Press, 1969, pp. 790-91.

744 Pound, Ezra. "Dogmatic Statement Concerning the Game of Chess: Theme for a Series of Pictures." POETRY 5 (March 1915): 257.

745 Raine, Kathleen. "Old Paintings on Italian Walls." THE NEW YORKER BOOK OF POEMS. New York: Viking Press, 1969, pp. 501-2.

746 Ray, David. "The Art Museum." DRAGGING THE MAN AND OTHER POEMS. Ithaca, N.Y.: Cornell University Press, 1968, p. 41.

747 Rich, Adrienne Cecile. "Love in the [art] Museum." ADRIENNE RICH'S POETRY. Ed. Barbara C. Gelpi and Albert Gelpi. New York: W.W. Norton, 1975, p. 5.

748 Ridland, John M. "Painter with Child; for Sue and Carl Hertel." POETRY 99 (February 1962): 300-1.

749 Riley, James Whitcomb. "A Water-Color." THE COMPLETE POETICAL WORKS OF JAMES WHITCOMB RILEY. New York: Grosset and Dunlap, 1937, p. 184.

750 Rosenbaum, Nathan. "Pictures at an Exhibition." THE GOLDEN YEAR. Ed. Melville Cane et al. Freeport, N.Y.: Books for Libraries, 1969, pp. 227-28.

751 Rosenberg, Harold. "Situation of the Artist." In "Poets on Painting, 2." ART NEWS 57 (March 1958): 44-45.

752 Rothenberg, Jerome. "From Three Landscapes." A CONTROVERSY OF POETS; AN ANTHOLOGY OF CONTEMPORARY AMERICAN POETRY. Ed. Paris Leary and Robert Kelly. Garden City, N.Y.: Anchor Books, 1965, pp. 380-81.

753 Rukeyser, Muriel. "[Cave] Painters." THE GATES. New York: McGraw-Hill Book Co., 1976, p. 11.

754 Schreiber, Jan. "Digression Before a Painter." THE SOUTHERN REVIEW 8 n.s. (January 1972): 166-67.

755 Schwartz, Delmore. "She Was the Girl Within the Picture Frame." VAUDEVILLE FOR A PRINCESS. New York: New Directions, 1950, p. 68.

756 Seidman, Hugh. "The Artists." BLOOD LORD. Garden City, N.Y.: Doubleday, 1974, pp. 112-13.

757 _____. "The Making of Color." COLLECTING EVIDENCE. New Haven, Conn.: Yale University Press, 1970, pp. 74-75.

758 Sobiloff, Hy. "You Cannot Paint Nature." POETRY 100 (September 1962): 372.

759 Solomon, Marvin. "The Art Museums." POETRY 84 (June 1954): 133-34.

760 Stepanchev, Stephen. "The Artist and the Nude." POETRY 90 (May 1957): 88.

761 Stephens, Alan. "For a painter about to begin my portrait." BETWEEN MATTER AND PRINCIPLES; POEMS. Denver: Allan Swallow, 1963, p. 40.

762 Stevens, Wallace. "Nuns Painting Water-Lilies." OPUS POSTHUMOUS. New York: Knopf, 1957. Originally published in 1950.

763 Stork, Charles Wharton. "A Painter in New England." HOME BOOK OF MODERN VERSE. Ed. Burton Egbert Stevenson. New York: Henry Holt, 1925, pp. 265-66.

764 Sullivan, Nancy. "In and Out Museums." THE HISTORY OF THE WORLD AS PICTURES. Columbia: University of Missouri Press, 1965, p. 15.

765 Swenson, May. "At the Museum of Modern Art." TO MIX WITH TIME NEW AND SELECTED POEMS. New York: Charles Scribner's Sons, 1963, p. 50.

766 _____. "Parade of Painters." A CAGE OF SPINES. New York: Rinehart & Company, 1958, pp. 60-65.

767 Taylor, Henry. "Goodbye to the Goya Girl: Woman with a Scarf."
AN AFTERNOON OF POCKET BILLIARDS. Salt Lake City: University
of Utah Press, 1975, p. 10.

768 Taylor, Mary Atwater. "In the Antwerp Gallery." [on a Rembrandt por-
trait]. ANTHOLOGY OF MAGAZINE VERSE FOR 1925 AND YEARBOOK
OF AMERICAN POETRY. Ed. William S. Braithwaite. Boston: B.J.
Brimmer Company, 1925, p. 330.

769 Tolson, M.B. "Lambda; from HARLEM GALLERY." 100 AMERICAN
POEMS. Ed. Selden Rodman. New York: New American Library,
1972, pp. 173-74.

770 Touster, Saul. "Salo, the Artist." [in six parts]. STILL LIVES AND
OTHER LIVES. Columbia: University of Missouri Press, 1966, pp. 75-80.

771 Trowbridge, John Townsend. "The Restored Picture." THE POETICAL
WORKS OF JOHN TOWNSEND TROWBRIDGE. Boston: Houghton Mif-
flin, 1903, pp. 12-14.

772 Wakoski, Diane. "The Man Who Paints Mountains." DISCREPANCIES
AND APPARITIONS. New York: Doubleday, 1966, p. 67.

773 Wetmore, P.M. "Painting." (on "power . . . / To call back vanished
forms at will"). THE CRITIC: A WEEKLY REVIEW OF LITERATURE,
FINE ARTS, AND THE DRAMA 1 (6 December 1828): 95.

774 White, Elwyn Brooks. "I Paint What I See: A Ballad of Artistic Integ-
rity." A LITTLE TREASURY OF MODERN POETRY. Ed. Oscar Williams.
New York: Charles Scribner's Sons, 1952, pp. 575-76.

775 Whittemore, Reed. "Still Life." CONTEMPORARY AMERICAN POETRY.
Ed. Donald Hall. Baltimore: Penguin Books, 1962, p. 50.

776 Wieners, John. "A Poem for Painters." THE NEW AMERICAN POETRY,
1945-1960. Ed. Donald M. Allen, pp. 365-69.

777 Wilbur, Richard. "Museum Piece." CONTEMPORARY AMERICAN PO-
ETRY. Ed. Donald Hall. Baltimore: Penguin Books, 1962, p. 64.

778 _____. "My Father Paints the Summer." THE BEAUTIFUL CHANGES;
AND OTHER POEMS. New York: Harcourt, Brace, 1947, p. 26.

779 Williams, William Carlos. "The Painting." PICTURES FROM BRUEGHEL
AND OTHER POEMS. New York: New Directions, 1962.

780 _____. "Portrait of a Lady." THE COLLECTED EARLIER POEMS OF
WILLIAM CARLOS WILLIAMS. New York: New Directions, 1951,
p. 40.

 Alludes to Watteau and Fragonard.

781 _____. "Still Lifes." HUDSON REVIEW 16 (Winter 1963-64): 516.

782 _____. "Tapestries at the Cloisters." From PATERSON: BOOK FIVE.
In "Poets on Painting, 4." ART NEWS 57 (May 1958): 28-29.

783 _____. "Tribute to the Painters." PICTURES FROM BRUEGHEL AND
OTHER POEMS. New York: New Directions, 1949, pp. 135-37.

784 Winters, Yvor. "On the Portrait of a Scholar of the Italian Renaissance."
POETRY 51 (March 1938): 323.

785 Wirtz, Dorothy. "Reflections in the Louvre." POETRY 73 (February
1949): 262.

Section V

SOURCES ON THE RELATIONSHIP

OF POETRY AND PAINTING

SOURCES OF DIRECT OR PRIMARY IMPORTANCE

786 Alpers, Svetlana, and Alpers, Paul. "UT PICTURA NOESIS? Criticism in Literary Studies and Art History." NEW LITERARY HISTORY 3 (Spring 1972): 437–558. Rpt. NEW DIRECTIONS IN LITERARY HISTORY. Ed. Ralph Cohen. Baltimore, Md.: Johns Hopkins University Press, 1974, pp. 199–220.

787 Anonymous. "The Sister Arts; or, Poetry, Painting, and Sculpture." AMERICAN MONTHLY MAGAZINE 2 n.s. (October 1836): 357–67.

788 Babbitt, Irving. THE NEW LAOKOON: AN ESSAY ON THE CON-FUSION OF THE ARTS. Boston: Houghton Mifflin, 1910.

789 Beaver, Robert. "Painting and Poetry; an Experiment in Studio Teaching." COLLEGE ART JOURNAL 16 (Spring 1957): 232–34.

790 Bermingham, Peter. THE ART OF POETRY. Washington, D.C.: Smith-sonian Institution Press, 1976. This catalog of an exhibition of paired poems and paintings and visual poems at the National Collection of Fine Arts in Washington, November 19, 1976, to January 23, 1977, was ac-companied by an illustrated introductory essay. Its printing was limited.

791 Birney, Earle. "Poets and Painters: Rivals or Partners." CANADIAN ART 14 (Summer 1957): 148–50.

792 Bland, D.S. "The Pictorial Image in Poetry." TWENTIETH CENTURY 162 (1957): 243–50.

793 Brown, B.R. "Correlation of Literature and the Fine Arts." COLLEGE ART JOURNAL 9 (1949): 176–80.

794 Clough, Wilson O. "Poetry and Painting: A Study of the Parallels between the Arts." COLLEGE ART JOURNAL 18 (Winter 1959): 117-29.

795 Davies, Cicely. "Ut Pictura Poesis." MODERN LANGUAGE REVIEW 30 (1935): 159-69.

796 Dorra, Henri et al. "Parallel Trends in Literature and Art." ART IN AMERICA 47, no. 2 (Summer 1959): 20-47.

797 Dorra, Henri. THE AMERICAN MUSE. New York: Viking Press, 1961. Also, Frederick A. Sweet. "Review of Henri Dorra, AMERICAN MUSE." ART JOURNAL 21 (Spring 1962): 216, 218.

798 Embler, William. "Symbols in Literature and Art." COLLEGE ART JOURNAL 16 (1956): 47-58.

799 Fenton, Edward. "Word becomes image; an exhibition of prints and drawings inspired by literature." METROPOLITAN MUSEUM OF ART BULLETIN 13 (April 1955): 247-56.

800 Frankel, H.H. "Poetry and Painting: Chinese and Western Views of their Convertibility." COMPARATIVE LITERATURE 9 (1957): 289-307.

801 Frankenstein, Alfred. "American Art and the American Experience." AMERICAN QUARTERLY 17 (1965): 265-71.

 Review of exhibition of American painting at the Metropolitan Museum of Art, October 1965.

802 Gaither, Mary. "Literature and the Arts." COMPARATIVE LITERATURE: METHOD AND PERSPECTIVE. Ed. N.P. Stallknecht and Horst Frenz. Carbondale: Southern Illinois University Press, 1961, pp. 153-70.

803 Giovannini, G. "Method in the Study of Literature in its Relation to the Other Fine Arts." JOURNAL OF AESTHETICS AND ART CRITICISM 8 (March 1950): 185-95.

804 Grabar, Olez. "History of Art and History of Literature: Some Random Thoughts." NEW LITERARY HISTORY 3 (Spring 1972): 559-68.

805 Graham, John. "Ut Pictura Poesis." DICTIONARY OF THE HISTORY OF IDEAS; STUDIES OF SELECTED PIVOTAL IDEAS. Ed. Philip P. Wiener. New York: Charles Scriber's Sons, 1973, vol. 4: 465-76.

806 _____. "'Ut Pictura Poesis': A Bibliography." BULLETIN OF BIBLIOG-
RAPHY 29 (January-March 1972): 13-15, 18.

 A comprehensive listing of works on history and theory of the
 relationship in world literature.

807 Hagstrum, Jean H. "The Sister Arts: From Neoclassic to Romantic."
COMPARATISTS AT WORK: STUDIES IN COMPARATIVE LITERATURE.
Ed. Stephen G. Nichols and Richard B. Vowles. Waltham, Mass.:
Blaisdell Publishing Company, 1968.

808 _____. THE SISTER ARTS; THE TRADITION OF LITERARY PICTORIALISM
AND ENGLISH POETRY FROM DRYDEN TO GRAY. Chicago: Univer-
sity of Chicago Press, 1958.

809 Hamilton, George Heard. "Object and Image; Yale's Exhibition Points
Up the Correspondences between Modern Art and Modern Poetry." ART
NEWS 53 (May 1954): 18-21.

810 Herkscher, William S. ART AND LITERATURE. Art Treasures of the
World, no. 18. New York: Harry N. Abrams, 1954.

 Illustrated essay on the history of the relationship.

811 Howard, W.G. "Ut Pictura Poesis." PUBLICATIONS OF THE MOD-
ERN LANGUAGE ASSOCIATION 24 (1909): 40-123.

812 Kainz, L. "Abstractions in Art and Poetry; Address to a Class in English
Literature." DESIGN 46 (May 1945): 12-73.

813 Kolaja, Jiri, and Wilson, Robert N. "Theme of Social Isolation in Ameri-
can Painting and Poetry." JOURNAL OF AESTHETICS AND ART CRI-
TICISM 13 (Summer 1954): 37-45. Reply with rejoinder. N. Friedman.
13 (March 1955): 408-11.

814 Kunitz, Stanley. "Editorial: The Sister Arts." ART IN AMERICA 53
(October-November 1965): 23. Rpt. Stanley Kunitz. A KIND OF
ORDER, A KIND OF FOLLY. Boston: Little, Brown, 1975, pp. 131-34.

815 Labudde, Kenneth J. "American Romanticism and European Painting."
AMERICAN QUARTERLY 12 (1960): 95-101.

816 Laude, Jean. "On the Analysis of Poems and Paintings." Trans. Robert
T. Denomme. NEW LITERARY HISTORY 3 (Spring 1972): 471-86.

817 Lawall, Sally N. "Ut Pictura Poesis." PRINCETON ENCYCLOPEDIA OF POETRY AND POETICS. Ed. Alex Preminger. Princeton, N.J.: Princeton University Press, 1969, pp. 881-83.

818 Lee, Rensselaer Wright. UT PICTURA POESIS: THE HUMANISTIC THEORY OF PAINTING. New York: W.W. Norton, 1967. Rpt. from ART BULLETIN 22 (1940): 197-269.

819 Lee, W.J. "Listening to Art; correlating art and literature." DESIGN 59 (Summer 1957): 10-11ff.

 Children paint and sketch while listening to great poems.

820 Lemay, J.A. Leo. "Calendar of American Poetry . . . through 1765." AMERICAN ANTIQUARIAN SOCIETY PROCEEDINGS, 79, no. 2 (1970); 80, no. 1 (1970).

 Indexes ut pictura poesis theme.

821 Lessing, Gotthold Ephraim. LAOCOÖN; AN ESSAY ON THE LIMITS OF PAINTING AND POETRY. Trans. Edward Allen McCormick. Indianapolis: Bobbs-Merrill, 1962.

 LAOCOÖN, originally published in 1766, is the most widely known attack on ut pictura poesis.

822 "Literature and Art." ART NEWS 33 (22 December 1934): 8.

823 Merriman, James D. "The Parallel of the Arts: Some Misgivings and a Faint Affirmation, part 1." THE JOURNAL OF AESTHETICS AND ART CRITICISM 31 (Winter 1972): 153-64; pt. 2 (Spring 1973): 309-21.

824 Moramarco, Fred, and Michael Davidson. THE PAINTERLY POETS: AMERICAN POETRY AND VISUAL AESTHETIC. New York: Barlenmir House, forthcoming.

 A critical anthology of seventeen poems accompanied by reproductions of paintings paired with them.

825 Munro, Thomas. THE ARTS AND THEIR INTERRELATIONS. Rev. and enl. ed. Cleveland: Press of Western Reserve University, 1967.

826 Neumann, Alfred R.; Erdman, David B.; et al. LITERATURE AND THE OTHER ARTS: A SELECT BIBLIOGRAPHY, 1952-1958. New York: N.Y. Public Library, 1959. Supplements published as A BIBLIOGRAPHY ON THE RELATIONS OF LITERATURE AND THE OTHER ARTS collected under the auspices of the MLA Discussion Group, 1965.

827 "Painters and Poets." ART IN AMERICA 53 (October 1965): 23-56.

828 Park, Roy. "Ut Pictura Poesis: the Nineteenth-Century Aftermath." JOURNAL OF AESTHETICS AND ART CRITICISM 28 (Winter 1969): 155-64.

829 Peckham, Morse. BEYOND THE TRAGIC VISION: THE QUEST FOR IDENTITY IN THE NINETEENTH CENTURY. New York: George Braziller, 1962.

 This work contains material on literature and music, literature and painting.

830 "Poets and Painters, Etchings and Poems at the Morris Gallery." ART NEWS 57 (November 1958): 26-27.

831 "Poets and Pictures; Poems with Portfolios of Illustrations." ART NEWS ANNUAL 24 (1955): 80-96.

832 "Poets on Art." COLLEGE ART JOURNAL 19 (Fall 1959): 75-77.

 Five poems on painters and paintings.

833 Portnoy, Julius. "Is the Creative Process Similar in the Arts?" JOURNAL OF AESTHETICS AND ART CRITICISM 19 (1960): 191-96.

834 Pound, Ezra. "The Renaissance; I--The Palette." POETRY 5 (February 1915): 227-33.

835 Praz, Mario. MNEMOSYNE; THE PARALLEL BETWEEN LITERATURE AND THE VISUAL ARTS. Princeton, N.J.: Princeton University Press, 1970.

836 _____. "Modern Art and Literature: A Parallel." ENGLISH MISCELLANY 5 (1954): 217-45.

837 Quinn, Sister M. Bernetta, O.S.F. "A New Approach to Early American Literature." COLLEGE ENGLISH 25 (January 1964): 267-73.

 This important article describes an American Studies approach to the integration of American literature and painting and identifies several affinities and thematic relationships between American writers and painters. Sister Quinn provides, for example, a number of pairings between Poe and Ryder.

838 Ramsey, Paul, Jr., and John Galloway. "Art, Poetry, and Ideas." COLLEGE ART JOURNAL 18 (Fall 1958): 48-54.

This describes General Studies course with this title at University of Alabama.

839 Rogerson, Brewster. "The Art of Painting the Passions." JOURNAL OF THE HISTORY OF IDEAS 14 (1953): 68-94.

840 Rudikoff, Sonya. "Words and Pictures." ARTS 33 (November 1958): 32-35.

841 Schneider, Pierre. "Laocoön '54." ART NEWS 53 (December 1954): 63.

842 Schuyler, James. "Poet and Painter Overture" (Important statement on the relationship). THE NEW AMERICAN POETRY. Ed. Donald M. Allen. New York: Grove Press, 1960, pp. 418-19.

843 Seznec, Jean. "Art and Literature: A Plea for Humility." NEW LITER-ARY HISTORY 3 (1972): 569-74.

844 Sitwell, Osbert. "On the Relationships between Poetry and Painting." BURLINGTON MAGAZINE 78 (February 1941): 47-49.

845 Snodgrass, W.D. "Poems about Paintings." IN RADICAL PURSUIT. New York: Harper & Row, 1975, pp. 63-97.

846 Soby, J.T. "Writer as Artist." SATURDAY REVIEW OF LITERATURE 29 (August 17, 1946): 24-26.

847 Spencer, John R. "Ut Rhetorica Pictura." JOURNAL OF THE WAR-BURG AND COURTAULD INSTITUTES 20 (1957): 26-44.

848 Stein, Leo. APPRECIATION: PAINTING, POETRY AND PROSE. New York: Crown Publishers, 1947. Chapter 5, "On Reading Poetry and Seeing Pictures," pp. 91-138.

849 Sypher, Wylie. ROCOCO TO CUBISM IN ART AND LITERATURE. New York: Random House, 1960.

This work identifies four styles in the arts since 1700: Rococo, Picturesque, Neo-mannerism, and Cubism.

850 Tillim, Sidney. "Toward a Literary Revival?" ARTS MAGAZINE 39 (May-June 1965): 30-33.

The literary element in contemporary painting is considered.

851 Trimpi, Wesley. "Meaning of Horace's Ut Pictura Poesis." JOURNAL OF THE WARBURG AND COURTAULD INSTITUTES 36 (1973): 1-34.

852 Wellek, René. "The Parallelism between Literature and the Arts." ENGLISH INSTITUTE ANNUAL, 1941. New York: Columbia University Press, 1942, pp. 29-63.

 This work cautions against too easily imagined parallels between the arts.

853 Wellek, René, and Austin Warren. THEORY OF LITERATURE. New York: Harcourt, Brace & World, 1956. Chapter 11: "Literature and the Other Arts."

854 Williams, William Carlos, Bogan, Louise et al. "Poets on Painting: Poems by a group of young American poets." ART NEWS 56 (January (1958): 42-44; 57 (March 1958): 44-45; 57 (May 1958): 28; 57 (September 1958): 24-25; 57) (November 1958): 26-27; 58 (March 1959): 44-45.

855 Wimsatt, W[illiam].K., Jr., and T.M. Greene. "Is a General Theory of the Poetry as Pictures." LITERARY CRITICISM: A SHORT HISTORY. New York: Knopf, 1957.

856 _____. "Is a General Theory of the Arts of any Practical Value in the Study of Literature?" JOURNAL OF AESTHETICS AND ART CRITICISM 8 (June 1950): 213-28.

857 Yeh, Max W. "Poetry, Art, and the Structure of Thought." DISSERTATION ABSTRACTS INTERNATIONAL 32: 1489A-90A (September 1971). University of Iowa.

858 Zabel, Morton Dauwen. "Poems and Pictures." POETRY 34 (June 1929): 217-22.

 This is an essay on the kinship.

859 Zhuravlev, Igor. "The Relationships between Socialist Poetry in the U.S.A. at the Beginning of the Twentieth Century and the Graphic Arts of the Socialist Press." ZEITSCHRIFT FUR ANGLISTIK UND AMERIKANISTIK 18 (1970): 168-82.

SOURCES OF INDIRECT OR SECONDARY IMPORTANCE

860 Aschenbrenner, Karl, and Isenberg, Arnold, eds. AESTHETIC THEORIES;
STUDIES IN THE PHILOSOPHY OF ART. Englewood Cliffs, N.J.:
Prentice-Hall, 1965.

861 Ashton, Dore. "Art: The New Realism." ARTS AND ARCHITECTURE
76 (October 1959): 8-10.

862 _____. "Symbolist Legacy." ARTS AND ARCHITECTURE 81 (September 1964): 10, 37.

863 Barasch, Frances K. THE GROTESQUE: A STUDY IN MEANINGS.
The Hague: Mouton, 1971.

Of special interest are the sections on the Picturesque, the Gothic,
and the Absurd as forms of the Grotesque.

864 Bevilacqua, Vincent M. "Rhetoric and the Circle of Moral Studies."
THE QUARTERLY JOURNAL OF SPEECH 55 (1969): 343-57.

865 Blake, G. "Painters, Writers, and Ships." GLASGOW ART REVIEW
(1947): 2-6.

866 Boas, George (trans.). THE HIEROGLYPHICS OF HOROPOLLO (1505).
New York: Pantheon, 1950.

867 Bode, Carl. THE ANATOMY OF AMERICAN POPULAR CULTURE, 1840-
1861. Berkeley and Los Angeles: University of California Press, 1959.

868 Boyd, John D. THE FUNCTION OF MIMESIS AND ITS DECLINE. Cambridge, Mass.: Harvard University Press, 1968.

This work is restricted primarily to the theory of imitation in
poetry.

869 Broad, H.A. "Literature as a Stimulus to Expression." DESIGN, 37 (October 1935): 26–27 ff.

870 Calas, Nicolas. "The Image and Poetry." In ART IN THE AGE OF RISK AND OTHER ESSAYS. New York: E.P. Dutton, 1968, pp. 79–99.

This essay concerns the meaning in painterly and poetical imagery.

871 Cohen, Ralph. THE ART OF DISCRIMINATION: THOMSON'S 'THE SEASONS,' AND THE LANGUAGE OF CRITICISM. Berkeley and Los Angeles: University of California Press, 1964.

Important background on nature description in Chapter 4, "The Scope of Critical Analogy: 'of Pictura Poesis.'"

872 Fehr, Bernhard. "The Antagonism of Forms in the Eighteenth Century." ENGLISH STUDIES 18 (1936): 115–21, 193–205; 19 (1937): 1–13, 49–57.

Useful for its review of the movement from Baroque to Gothic in British and, indirectly, American aesthetic theory.

873 Fosel, Ida. "Spatial Form and Spatial Time." WESTERN HUMANITIES REVIEW 16 (1962): 223–34.

874 Frank, Joseph. THE WIDENING GYRE: CRISIS AND MASTERY IN MODERN LITERATURE. New Brunswick, N.J.: Rutgers University Press, 1963.

This concerns the achievement of spatial form in literature and the plastic arts.

875 Frankl, Paul. THE GOTHIC: LITERARY SOURCES AND INTERPRETATIONS THROUGH EIGHT CENTURIES. Princeton, N.J.: Princeton University Press, 1960.

This gives valuable background for Gothic imagery in nineteenth-century American poetry and painting.

876 Gilbert, Katherine E. "Art between the Distinct Idea and the Obscure Soul." JOURNAL OF AESTHETICS AND ART CRITICISM 6 (September 1947): 21–26.

This covers vogues for extremes in the criticism of the arts "in the recent past."

877 Gombrich, E.H. ART AND ILLUSION, A STUDY IN THE PSYCHOLOGY OF PICTORIAL REPRESENTATION, 4th ed. London: Phaidon, 1972.

878 _____. "ICONES SYMBOLICAE: The Visual Image in Neo-Platonic Thought." JOURNAL OF THE WARBURG AND COURTAULD INSTITUTES 11 (1948): 163-92.

879 Gottlieb, Carla. "Movement in Painting." JOURNAL OF AESTHETICS AND ART CRITICISM 17 (September 1958): 22-33.

880 Greene, Theodore M. THE ARTS AND THE ART OF CRITICISM. Princeton, N.J.: Princeton University Press, 1940.

This analysis of music, dance, architecture, sculpture, painting, and literature reveals analogical relationships between them and formulates categories which are applicable to all.

881 _____. "Beauty in Art and Nature." SEWANEE REVIEW 62 (1961): 236-80.

882 Harris, Neil. THE ARTIST IN AMERICAN SOCIETY: THE FORMATIVE YEARS, 1790-1860. New York: George Braziller, 1966.

883 Hatzfeld, Helmut A. "Literary Criticism through Art and Art Criticism through Literature." JOURNAL OF AESTHETICS AND ART CRITICISM 6 (September 1947): 1-21.

884 Hopwood, V.G. "Dream, Magic, and Poetry." JOURNAL OF AESTHETICS AND ART CRITICISM 10 (December 1951): 152-59.

885 Hunt, John D., ed. ENCOUNTERS: ESSAYS ON LITERATURE AND THE VISUAL ARTS. New York: W.W. Norton, 1971.

886 Hutchings, Patrick. "Imagination: 'as the Sun paints in the camera obscura.'" THE JOURNAL OF AESTHETICS AND ART CRITICISM 29 (Fall 1970): 63-76.

887 Jackson, Wallace. "Affective Values in Later Eighteenth-Century Aesthetics." JOURNAL OF AESTHETICS AND ART CRITICISM 24 (1965): 309-14.

888 Jaszi, Andrew O. "In the Realm of Beauty and Anguish: Some Remarks on the Poetry of Aestheticism." CHICAGO REVIEW 15 (1961): 57-70.

889 Kasson, Joy Schlesinger. "Muses and Guidebooks: The Importance of Tradition in American Literature and Painting, 1800-1860." DISSERTATION ABSTRACTS INTERNATIONAL 34: 322A (1973). Yale University.

890 Kayser, Wolfgang. THE GROTESQUE IN ART AND LITERATURE. Trans. Ulrich Weisstein. Bloomington: Indiana University Press, 1964.

> This is valuable for a discussion of Surrealistic poetry and painting in the twentieth century.

891 Kennick, W.E. "Does Traditional Aesthetics Rest on a Mistake?" MIND 67 (1958): 317-34.

> Although canons applicable to all works of art cannot be formulated, the search for similarities in different works of art should be pursued.

892 Kristeller, Paul A. "The Modern System of the Arts: A Study in the History of Aesthetics." JOURNAL OF THE HISTORY OF IDEAS 12 (1951): 496-527; 13 (1952): 7-46.

893 Kwiat, Joseph J., and Turpie, Mary C., eds. STUDIES IN AMERICAN CULTURE: DOMINANT IDEAS AND IMAGES. Minneapolis: University of Minnesota Press, 1960.

> This contains a reprint of Kwiat's "Robert Henri and the Emerson-Whitman Tradition."

894 Lalo, Charles. "A Structural Classification of the Fine Arts." JOURNAL OF AESTHETICS AND ART CRITICISM 11 (June 1953): 307-23.

895 Lawall, David B. "American Painters as Book Illustrators." PRINCETON UNIVERSITY LIBRARY CHRONICLE 20 (1958): 18-28.

896 Lawler, John Joseph. "Comments on Art and Literature from the Personal Writings of a Group of Well Travelled, Early American Writers and Artists. A Critical Collation." DISSERTATION ABSTRACTS 22: 262 (July 1961). Florida State University.

897 Lipking, Lawrence. "Periods in the Arts: Sketches and Speculations." NEW LITERARY HISTORY 1 (1970): 181-200.

898 Lipman, Jean, and Helen M. Franc. BRIGHT STARS; AMERICAN PAINTING AND SCULPTURE SINCE 1776. New York: E.P. Dutton, 1976.

> Some well documented and specific relationships are established.

899 McGinn, Donald J. LITERATURE AS A FINE ART. Ed. Donald J. McGinn and George Howerton. New York: Gordian Press, 1967.

900 McLuhan, Marshall, and Parker, Harley. THROUGH THE VANISHING POINT: SPACE IN POETRY AND PAINTING. New York: Harper & Row, 1969.

> Outstanding paintings and poems are juxtaposed in an effort to explore verbal space through space in the plastic arts.

901 Malraux, André. THE VOICES OF SILENCE: MAN AND HIS ART. Trans. Stuart Gilbert. Garden City, N.Y.: Doubleday, 1953.

> Part I, iii, "Poetry and the Plastic Arts"; part III, iv, "The Creator's 'Schema' in Literature and Painting."

902 Manuel, Frank Edward. THE EIGHTEENTH CENTURY CONFRONTS THE GODS. Cambridge, Mass.: Harvard University Press, 1959.

> Influence of eighteenth-century mythographers, notably Charles Dupuis, on thought of John Adams, is traced. See pages 271-80.

903 Margolis, Joseph. "The Identity of a Work of Art." MIND 68 (January 1959): 34-50.

904 Matthiessen, F.O. AMERICAN RENAISSANCE: ART AND EXPRESSION IN THE AGE OF EMERSON AND WHITMAN. New York: Oxford University Press, 1941.

905 Michelis, P.A. "Aesthetic Distance and the Charm of Contemporary Art." JOURNAL OF AESTHETICS AND ART CRITICISM 18 (September 1959): 1-45.

906 Morgan, Douglas N. "Icon, Index and Symbol in the Visual Arts." PHILOSOPHICAL STUDIES 6 (1955): 49-54.

907 Motckat, Helmut. "'Variations in Blue,' or Romantic Elements in Modern Lit." YEARBOOK OF COMPARATIVE AND GENERAL LITERATURE 10 (1961): 39-48.

> Significance of blue in interpreting twentieth-century poetry and painting is discussed.

908 Nelson, Cary. THE INCARNATE WORD, LITERATURE AS VERBAL SPACE. Urbana: University of Illinois Press, 1973.

909 O'Malley, Glenn. "Literary Synesthesia." JOURNAL OF AESTHETICS AND ART CRITICISM 15 (June 1957): 391-411.

910 "On Art and the Definitions of Arts: A Symposium." JOURNAL OF AESTHETICS AND ART CRITICISM 20 (Fall 1961): 175-98.

911 Osborne, Mary Tom. ADVICE-TO-A-PAINTER POEMS: 1633-1856. Austin: University of Texas Press, 1949.

912 Panoksky, Erwin. IDEA: A CONCEPT IN ART THEORY. Columbia, S.C.: University of South Carolina Press, 1968.

 History of modifications of the Platonic ideal of beauty in art and literature is considered.

913 Passmore, John. "History of Art and History of Literature: A Commentary." NEW LITERARY HISTORY 3 (Spring 1972): 575-87.

914 Picasso, Pablo. PICASSO ON ART: A SELECTION OF VIEWS. Ed. Dore Ashton. Documents of Twentieth-Century Art Series. Ed. Robert Motherwell. New York: Viking Press, 1972. Picasso on "Poetry" and "Writing and Painting."

915 POETS OF THE CITIES NEW YORK AND SAN FRANCISCO 1950-1965; AN EXHIBITION ORGANIZED BY THE DALLAS MUSEUM OF FINE ARTS AND SOUTHERN METHODIST UNIVERSITY, UNDER THE DIRECTION OF NEIL A. CHASSMAN, CHAIRMAN, DEPARTMENT OF ART HISTORY. New York: E.P. Dutton, 1976.

916 Praz, Mario. THE ROMANTIC AGONY. Trans. Angus Davidson. London: Oxford University Press, 1933.

 This is useful background on the relationship of Romanticism to Decadence in art.

917 Rosand, David. "Ut Pictor Poeta: Meaning in Titian's POESIE." NEW LITERARY HISTORY 3 (1972): 527-46.

 Titian's conception of six mythological paintings as poetry in paint.

918 Sachs, Curt. THE COMMONWEALTH OF ART: STYLE IN THE ARTS, MUSIC AND THE DANCE. Washington, D.C.: Library of Congress, 1950.

 This is mostly on music and its relation to the other arts.

919 Saisselin, R.G. "Portrait in History: Some Connections between Art and Literature." APOLLO 78 (October 1963): 281-88.

920 Schoper, Eva. "The Art Symbol." BRITISH JOURNAL OF AESTHETICS 4 (1964): 228-40.

 This concerns the symbolic modification of the expressive theory of art.

921 Schueller, Herbert M. "Romanticism Reconsidered." JOURNAL OF
 AESTHETICS AND ART CRITICISM 20 (1962): 359–68.

 A new definition of romanticism is proposed.

922 Sircello, Guy. MIND AND ART: AN ESSAY ON THE VARIETIES OF
 EXPRESSION. Princeton, N.J.: Princeton University Press, 1972.

923 Smith, James Steel. "Visual Criticism: A New Medium for Critical
 Comment." CRITICISM 4 (1962): 241–55.

924 Sorell, Walter. THE DUALITY OF VISION; GENIUS AND VERSATILITY
 IN THE ARTS. London: Thames and Hudson, 1970.

 This richly illustrated book is on painters who write and writers
 who paint.

925 Souriau, Etienne. "Time in the Plastic Arts." JOURNAL OF AESTHET-
 ICS AND ART CRITICISM 7 (1949): 294–307.

926 Stallknecht, Newton P. "On Poetry's Geometric Truth." KENYON RE-
 VIEW 18 (1956): 1–21.

927 Stevenson, Charles L. "Symbolism and the Representative Arts." LAN-
 GUAGE, THOUGHT, AND CULTURE 13 (1959): 226–57.

928 _____. "Symbolism in the Nonrepresentative Arts." LANGUAGE,
 THOUGHT, AND CULTURE 13 (1959): 196–225.

929 Sypher, Wylie. LOSS OF THE SELF IN MODERN LITERATURE AND
 ART. New York: Vintage Books, 1962.

 Chapter 3, "The Romantic Touch in Painting," pp. 42–57 is
 especially useful.

930 Vivas, Eliseo. "Animadversions on Imitation and Expression." JOURNAL
 OF AESTHETICS AND ART CRITICISM 19 (1961): 425–32.

931 Weiss, Paul. NINE BASIC ARTS. Carbondale, Ill., 1961.

 Components of aesthetic experience in the arts, including
 poetry and painting.

932 Weitenkampf, Frank. "What does the Illustration Illustrate?" SATUR-
 DAY REVIEW 38 (16 April 1955): 11–12.

933 Wimsatt, W[illiam].K., Jr. THE VERBAL ICON: STUDIES IN THE MEANING OF POETRY. Lexington, Ky., 1954.

> The last four chapters cover the relationship of literature to other arts and of literary criticism to a general theory of the arts.

PARTICULAR APPLICATIONS

934 Benamou, Michel. "Jules Laforgue and Wallace Stevens." ROMANTIC
REVIEW 50 (1959): 107-17.

Influence of Impressionism in painting is discussed.

935 _____. "Wallace Stevens: Some Relations Between Poetry and Paint-
ing." COMPARATIVE LITERATURE 11 (1959): 47-60.

936 Buchwald, Emilie. "Wallace Stevens: The Delicatest Eye of the Mind."
AMERICAN QUARTERLY 14 (Summer 1962): 185-96.

Significance of painterly techniques in Stevens' poetry is ex-
plored.

937 Burlingame, Robert. "Marsden Hartley's ANDROSCOGGIN: Return to
Place." NEW ENGLAND QUARTERLY 31 (1958): 447-62.

938 _____. "Marsden Hartley: Painter and Poet." Ph.D. dissertation,
Brown University, 1954.

939 Bryant, William C. II. "Poetry and Painting: A Love Affair of Long
Ago." AMERICAN QUARTERLY 22 (1970): 859-82.

This article mainly concerns Bryant and Cole.

940 Colsman-Freyberger, Heidi. "Robert Motherwell: Words and Images."
ART JOURNAL 34 (Fall 1974): 19-24.

941 Corrington, John W. "Lawrence Ferlinghetti and the Painter's Eye."
NINE ESSAYS IN MODERN LITERATURE. Louisiana State University
Studies Humanities Series, no. 15. Ed. Donald E. Stanford. Baton
Rouge: Louisiana State University Press, 1965, pp. 107-16.

942 Chamberlain, John E. "Wallace Stevens and the Aesthetics of Modern Art." DISSERTATION ABSTRACTS INTERNATIONAL 32: 910A (1970). University of Toronto.

943 Conarroe, Joel O. "The Measured Dance: Williams' 'Pictures from Brueghel.'" JOURNAL OF MODERN LITERATURE 1 (May 1971): 565-77.

944 Cummings, E.E. "Words into Pictures." E.E. CUMMINGS: A MIS-CELLANY. Ed. George J. Firmage. New York: Argophile Press, 1958. Rpt. from ART NEWS 48 (May 1949): 15.

945 Demos, John. "George Caleb Bingham: The Artist as Social Historian." AMERICAN QUARTERLY 17 (Summer 1965): 218-28.

946 Dijkstra, Bram. THE HEIROGLYPHICS OF A NEW SPEECH: CUBISM, STIEGLITZ, AND THE EARLY POETRY OF WILLIAM CARLOS WILLIAMS. Princeton, N.J.: Princeton University Press, 1970.

 On the impact of post-Impressionist art on Williams's early poetry. Many specific relationships between Williams's poems and American paintings are documented in this excellent book.

947 _____. "Wallace Stevens and William Carlos Williams: Poetry, Painting, and the Function of Reality." ENCOUNTERS: ESSAYS ON LITERATURE AND THE VISUAL ARTS. Ed. John Dixon Hunt. London: Studio Vista, 1971, pp. 156-71.

948 Duffy, Charles F. "'Intricate Neural Grace': The Esthetic of Richard Wilbur." CONCERNING POETRY 4 (Spring 1971): 41-50.

949 Eder, Doris L. "Wallace Stevens' Landscapes and Still Lifes." MOSAIC 4 (1970): 1-5.

950 Edgerton, Samuel Y., Jr. "The Murder of Jane McCrea: The Tragedy of an American TABLEAU D'HISTOIRE." ART BULLETIN 47 (December 1965): 481-92.

951 Furrow, Sharon. "Psyche and Setting: Poe's Picturesque Landscapes." CRITICISM 15 (Winter 1973): 16-27.

952 Gidley, Mick. "Picture and Poem: e.e. cummings in Perspective." POETRY REVIEW 59 (Autumn 1968): 179-85.

953 Goldstein, Jesse Sidney. "Edwin Markham, Ambrose Bierce, and 'The Man with the Hoe.'" MODERN LANGUAGE NOTES 58 (March 1943): 165-75.

954 Guimond, James. THE ART OF WILLIAM CARLOS WILLIAMS: A DIS-
COVERY AND POSSESSION OF AMERICA. Urbana: University of
Illinois Press, 1968.

The relationship of Williams with the painters Demuth and
Sheeler is discussed.

955 Hall, Dorothy J. "Painterly Qualities in Frost's Lyric Poetry." BALL
STATE UNIVERSITY FORUM 11 (Winter 1970): 9-13.

956 Hartley, Marsden. ADVENTURES IN THE ARTS: INFORMAL CHAPTERS
ON PAINTERS, VAUDEVILLE AND POETS. New York: Boni and
Liveright, 1921.

957 _____. SELECTED POEMS. Ed. Henry W. Wells. New York: Viking
Press, 1945.

958 Hendricks, Gordon. "Thomas Eakins' Gross Clinic." ART BULLETIN
61 (March 1969): 57-63.

959 Huntington, David C. THOMAS COLE, POET-PAINTER, 1801-1848.
Forthcoming.

960 Hutchinson, Alexander. "The Resourceful Mind: William Carlos Williams
and 'Tribute to the Painters.'" UNIVERSITY OF WINDSOR REVIEW 8
(Fall 1972): 81-89.

961 Hyman, Neil. "Eakins' Gross Clinic Again." ART QUARTERLY 35
(Summer 1972): 158-63.

962 Jaffe, Irma B. "Contemporary Words and Pictures: Drawings (1782-1810)
by John Trumbull." EARLY AMERICAN LITERATURE 11 (Spring 1976):
31-51.

Sources in poems for some of Trumbull's drawings and paint-
ings are given.

963 _____. "Joseph Stella and Hart Crane: The Brooklyn Bridge." CHAL-
LENGES IN AMERICAN CULTURE. Ed. Ray B. Brown, L.L. Landrum,
and William K. Bottorff. Bowling Green, Ohio: Bowling Green Uni-
versity Popular Press, 1970, pp. 29-39. Rpt. from AMERICAN ART
JOURNAL 1 (Fall 1969): 98-107.

964 Johns, Sara Elizabeth Bennett. "Washington Allston's Theory of the
Imagination." DISSERTATION ABSTRACTS INTERNATIONAL 35: 2862A
(November 1974). Emory University.

965 Johnson, Ellen H. "Oldenburg's Poetics, Analogues, Metamorphoses and Sources." ART INTERNATIONAL 14 (April 1970): 42–45, 51.

966 Kasson, Joy S. "THE VOYAGE OF LIFE: Thomas Cole and Romantic Disillusionment." AMERICAN QUARTERLY 27 (March 1975): 42–56.

967 Kenner, Hugh. THE POUND ERA. Berkeley and Los Angeles: University of California Press, 1971.

968 Knox, George. "Crane and Stella: Conjunction of Painterly and Poetic Worlds." TEXAS STUDIES IN LITERATURE AND LANGUAGE 12 (Winter 1971): 689–707.

 This discusses the relationship of Stella's painting of Brooklyn Bridge with THE BRIDGE.

969 Korg, Jacob. "Modern Art Techniques in THE WASTE LAND." JOURNAL OF AESTHETICS AND ART CRITICISM 18 (June 1960): 456–63.

970 Kwiat, Joseph J. "The Newspaper Experience: The 'Ash-Can' Painters." WESTERN HUMANITIES REVIEW 6 (1952): 335–41.

971 Lasser, Michael L. "The Agony of E.E. Cummings." LITERARY REVIEW 5 (Autumn 1961): 133–41.

 Cummings' criteria for painting may be applied to literature.

972 Laurentia, Sister M. "Adventures in Looking." TODAY 10 (1955): 10–11.

 Roy Mary's "The Cat at the Last Supper" and Ghirlandajo's painting are considered.

973 Levine, Edward. "The Inflated Image: Satire and Meaning in Pop Art." SATIRE NEWSLETTER 6 (Fall 1968): 43–50.

974 Lippord, L.R. "Max Ernst: Passed and Pressing Tensions." ART JOURNAL 33 (Fall 1973): 12–17.

975 McGlinchee, Claire. "Three Indigenous Americans (Whitman, Eakins, Gilbert)." PROCEEDINGS OF THE SIXTH INTERNATIONAL CONGRESS OF AESTHETICS. Ed. Rudolf Zeitler. Uppsala, Swed., 1972, pp. 709–13.

976 Mazzaro, Jerome. "Dimensionality in Dr. Williams' 'Paterson.'" MODERN POETRY STUDIES 1 (1970): 98–117.

 Relationship of the poem to Cubism is discussed.

977 Melander, Ingrid. "'Watercolour of Grantchester Meadows': An Early Poem by Sylvia Plath." MODERNA SPRAK (Stockholm) 65 (1971): 1-5.

978 Meyer, A.N. "A Portrait of Coleridge by Washington Allston." CRITIC 48 (February 1906): 138-41.

979 Miller, Ralph N. "Thomas Cole and Alison's Essays on Taste." NEW YORK HISTORY 37 (July 1956): 281-99.

980 Moramarco, Fred. "John Ashbery and Frank O'Hara: The Painterly Poets." JOURNAL OF MODERN LITERATURE 5 (September 1976): 436-62.

981 Moore, S.C. "Bishop's Ballet." EXPLICATOR 23 (1964): item 12.

 This concerns John Peale Bishop's poem and de Chirico.

982 Noverr, Douglas A. "Bryant and Cole in the Catskills." BULLETIN OF THE NEW YORK PUBLIC LIBRARY 78 (Spring 1975): 270-72.

983 Oamber, Ukhtar. "THE MAN WITH THE BLUE GUITAR by Wallace Stevens." LITERARY HALF YEARLY 14 (1973): 49-60.

 Poem's connection with Picasso's THE GUITARIST.

984 O'Connor, W.V. "Wallace Stevens: Impressionism in America." REVUE DES LANGUES VIVANTES (Bruxelles) 32 (1966): 66-67.

985 O'Neale, Charles Robert. "Wallace Stevens and the Arts." DISSERTATION ABSTRACTS 25: 6632-33 (May 1965). Indiana University.

986 Parry, Ellwood C. "Gothic Elegies for an American Audience: Thomas Cole's Repackaging of Imported Ideas." AMERICAN ART JOURNAL 8 (November 1976): 27-46.

 Literary sources for four of Cole's landscapes: THE DEPARTURE and THE RETURN, PAST and PRESENT.

987 Patterson, Rebecca. "Emily Dickinson's Palette." MIDWEST QUARTERLY 5 (1964): 265-91.

988 Perloff, Marjorie. FRANK O'HARA: A CRITICAL INTRODUCTION. New York: George Braziller, 1977.

989 _____. "New Thresholds, Old Anatomies: Contemporary Poetry and the

Limits of Exegesis." ILIFF REVIEW 5 (1974): 83-99.

This places Frank O'Hara's poetry in relation to his work as curator at the Museum of Modern Art.

990 Peters, Robert L. "Whistler and the English Poets of the 1890's." MODERN LANGUAGE QUARTERLY 18 (September 1957): 251-61.

991 Picht, Douglas R. "Robert Henri and the Transcendental Spirit." RESEARCH STUDIES 36 (March 1968): 50-56.

992 Quinn, Sister M. Bernetta. "PATERSON: Landscape and Dream." JOURNAL OF MODERN LITERATURE 1 (1971): 523-48.

In part: Williams dramatized landscape in Paterson as an imaginary construct conceived under the influence of the Surrealists.

993 _____. "Robert Penn Warren's Promised Land." SOUTHERN REVIEW 8 (April 1972): 320-58.

Affinities in Warren's verse with Ryder, Munch, and landscape conventions and techniques in painting are analyzed.

994 Ramsey, Paul, Jr. "Poe and Modern Art." COLLEGE ART JOURNAL 28 (1959): 210-15.

995 Richardson, Edgar P. "The Romantic Genius of Thomas Cole." ART NEWS 55 (December 1956): 43, 52.

Cole's work is considered in relation to romantic literature, especially Bryant and Volney.

996 Ringe, Donald A. "Bryant's Criticism of the Fine Arts." COLLEGE ART JOURNAL 17 (Fall 1957): 43-54.

997 _____. "Kindred Spirits: Bryant and Cole." AMERICAN QUARTERLY 6 (Fall 1954): 233-44.

998 _____. "Painting as Poem in the Hudson River Aesthetic." AMERICAN QUARTERLY 12 (Spring 1960): 71-83.

999 _____. THE PICTORIAL MODE: SPACE & TIME IN THE ART OF BRYANT, IRVING, AND COOPER. Lexington: University Press of Kentucky, 1971.

The influence of Cole is considered.

1000 Riordon, John C. "Thomas Cole: A Case Study of the Painter-Poet Theory of Art in American Painting from 1825-1850," DISSERTATION ABSTRACTS INTERNATIONAL 31: 2811-A (1970). Syracuse University.

1001 Rule, Henry B. "Walt Whitman and George Caleb Bingham." WALT WHITMAN REVIEW 15 (December 1969): 248-53.

1002 ____. "Walt Whitman and Thomas Eakins: Variations on Some Common Themes." TEXAS QUARTERLY 17 (Winter 1974): 7-57.

1003 Sanford, Charles L. "The Concept of the Sublime in the Works of Thomas Cole and William Cullen Bryant." AMERICAN LITERATURE 28 (January 1957): 434-48.

1004 Schmitt, Evelyn L. "Two American Romantics--Thomas Cole and William Cullen Bryant." ART IN AMERICA 41 (Spring 1953): 61-68.

1005 Schroeder, Fred E.H. "Andrew Wyeth and the Transcendental Tradition." AMERICAN QUARTERLY 17 (Fall 1965): 559-67.

Wyeth's later paintings are linked with Emerson, Thoreau, Frost, and Dickinson.

1006 Shepherd, Allen. "Robert Penn Warren's AUDUBON: A VISION: The Epigraph." NOTES ON CONTEMPORARY LITERATURE 3 (January 1973:) 8-11.

1007 Soria, Regina. "Washington Allston's Lectures on Art: The First American Art Treatise." JOURNAL OF AESTHETICS AND ART CRITICISM 18 (March 1960): 329-44.

1008 Stevens, Wallace. "The Relations Between Poetry and Painting." THE NECESSARY ANGEL. New York: Knopf, 1951, pp. 159-76. Rpt. in MODERN CULTURE AND THE ARTS. Ed. James B. Hall and Barry Ulanov. New York: McGraw-Hill Book Co., 1967, pp. 274-85.

1009 Todd, Edgeley W. "Indian Pictures and Two Whitman Poems." HUNTINGTON LIBRARY QUARTERLY 19 (November 1955): 1-11.

Whitman's use of Alfred Jacob Miller's painting THE TRAPPER'S BRIDE" in section 10 of "Song of Myself" is discussed.

1010 Tolles, Frederick B. "The Primitive Painter as Poet." BULLETIN FRIENDS HISTORICAL ASSOCIATION 50 (Spring 1961): 12-30.

Hick's versions of the "Peaceable Kingdom" appear to have been inspired by some verse he wrote on the progress of religious liberty.

1011 Tucker, Robert. "E.E. Cummings as an Artist: The DIAL Drawings." MASSACHUSETTS REVIEW 16 (Spring 1975): 329-52.

1012 Von Weigand, Charmion. "The Vision of Mark Tobey." ARTS 34 (September 1959): 34-40.

1013 Wagner, Linda W. "SPRING AND ALL: The Unity of Design." TEN-NESSEE STUDIES IN LITERATURE 16 (1970): 61-73.

This is on a volume of William Carlos Williams' poems, dedi-cated to Charles Demuth. The poems are seen as illustrating Williams' artistic principles.

1014 Watkins, Floyd C. "T.S. Eliot's Painter of the Umbrian School." AMERICAN LITERATURE 36 (March 1964): 72-75.

1015 Weaver, Mike. WILLIAM CARLOS WILLIAMS: THE AMERICAN BACK-GROUND. London: At the University Press, 1971.

1016 Weston, Susan Brown. "The Artist as Guitarist: Stevens and Picasso." CRITICISM 17 (Spring 1975): 111-20.

1017 White, Robert L. "Washington Allston: Banditti in Arcadia." AMERI-CAN QUARTERLY 13 (Fall 1961): 387-401.

Ambivalence in the paintings and writings of Allston is ana-lyzed.

1018 Williams, William Carlos. "E.E. Cummings' Poems and Paintings." ARTS DIGEST 29 (1 December 1954): 7-8.

SPECIFIC TRENDS, PERIODS, SCHOOLS, AND INFLUENCES

1019 American Landscape Issue. ART IN AMERICA 64 (January–February 1976). See especially, Barbara Novak, "The Double-Edged Axe," pp. 45–50.

1020 Aubin, Robert A. TOPOGRAPHICAL POETRY IN EIGHTEENTH-CENTURY ENGLAND. New York: Modern Language Association, 1936.

> Conventions of landscape description are discussed. The work includes some American poems.

1021 Bender, Bert. "Hanging Stephen Crane in the Impressionist Museum." JOURNAL OF AESTHETICS AND ART CRITICISM 35 (Fall 1976): 47–56.

> Influence of Impressionism on Crane's writings.

1022 Bennett, Marilyn H. "The Scenic West: Silent Mirage." COLORADO QUARTERLY 8 (Summer 1959): 15–25.

1023 Block, H.M. "Surrealism and Modern Poetry: Outline of an Approach." JOURNAL OF AESTHETICS AND ART CRITICISM 18 (December 1959): 174–82.

1024 Bredeson, Robert. "Landscape Description in Nineteenth-Century American Travel Literature." AMERICAN QUARTERLY 20 (Spring 1968): 86–94.

1025 Callow, James T. KINDRED SPIRITS: KNICKERBOCKER WRITERS AND AMERICAN ARTISTS, 1807-1855. Chapel Hill: University of North Carolina Press, 1967.

> This gives a detailed discussion of both major and minor New York writers and artists of the period.

1026 Clough, Rosa. FUTURISM: THE STORY OF A MODERN ART, A NEW REAPPRAISAL. Westport, Conn.: Greenwood, 1961.

Futurism in literature and the other arts, including theater and architecture, are discussed.

1027 Czyzewski, Tytys. "Expressionist and Futurist Poetry (1919)." QUEENS SLAVIC PAPERS, VOL. I: MODERN POLISH WRITING: ESSAYS AND DOCUMENTS. Ed. Thomas E. Bird. Trans. Helena Goscils. New York: Queens College, 1973, pp. 102-5.

1028 Dahl, Curtis. "The American School of Catastrophe." AMERICAN QUARTERLY 11 (1959): 380-90.

1029 Edenbaum, Robert I. "Dada and Surrealism in the United States." ARTS IN SOCIETY 5 (Spring-Summer 1968): 114-25.

1030 Finkelstein, Haim N. "Surrealism and the Crisis of the Objects. DISSERTATION ABSTRACTS INTERNATIONAL 33: 6353A-54A (1973). New York University.

1031 Foster, Edward Halsey. THE CIVILIZED WILDERNESS; BACKGROUNDS TO AMERICAN ROMANTIC LITERATURE, 1817-1860. New York: Free Press, 1975.

Chapter 2, "Landscapes, Real and Imagined," pp. 26-47, is particularly relevant.

1032 _____. "Picturesque America: A Study of the Popular Use of the Picturesque in Considerations of the American Landscape, 1835-1860." DISSERTATION ABSTRACTS INTERNATIONAL 34: 2622A (1974). Columbia University.

1033 Gillespie, H. Gary. "A Collateral Study of Selected Paintings and Poems from Marsden Hartley's Maine Period." DISSERTATION ABSTRACTS INTERNATIONAL 35: 7804A (June 1975). University of Ohio.

1034 Gordon, Donald E. "On the Origin of the Word 'Expressionism.'" JOURNAL OF THE WARBURG AND COURTAULD INSTITUTES. 29 (1966): 368-85.

1035 Gross, Ronald. POP POEMS. New York: Simon and Schuster, 1967.

1036 Hipple, Walter J., Jr. THE BEAUTIFUL, THE SUBLIME, AND THE PICTURESQUE IN 18TH-CENTURY BRITISH AESTHETIC THEORY. Carbon-

dale: Southern Illinois University Press, 1957.

> This is significant as background for nineteenth-century American landscape painting.

1037 Hoopes, Donelson. AMERICAN NARRATIVE PAINTING. Los Angeles: Los Angeles County Museum of Art in association with Praeger Publishers, 1974.

1038 Huddleston, Eugene L. "Topographical Poetry in the Early National Period." AMERICAN LITERATURE 38 (November 1966): 303-22.

> This article surveys influence of frontier on the genre in terms of the sublime, beautiful, and picturesque.

1039 Hussey, Christopher. THE PICTURESQUE: STUDIES IN A POINT OF VIEW. London: Frank Cass, 1967. Originally published in 1927.

> Background on reconciliation of Art and Nature in eighteenth-century British aesthetic theory is given.

1040 Huth, Hans. NATURE AND THE AMERICAN: THREE CENTURIES OF CHANGING ATTITUDES. Berkeley and Los Angeles: University of California Press, 1957.

1041 Krieger, Murray. "Ekphrasis and the Still Movement of Poetry; or, LAOKOÖN Revisited." THE POET AS CRITIC. Ed. Frederick P.W. McDowell. Evanston, Ill.: Northwestern University Press, 1967, pp. 3-26.

1042 Lipke, William C., and Bernard W. Rozran. "Ezra Pound and Vorticism: A Polite Blast." WISCONSIN STUDIES IN CONTEMPORARY LITERATURE 7 (1966): 201-10.

1043 Matthews, J.H. "Forty Years of Surrealism (1924-1964): A Preliminary Bibliography." COMPARATIVE LITERATURE STUDIES 3 (1966): 309-50.

1044 _____. "Surrealism, Politics, and Poetry." MOSAIC 3, no. 1 (1969): 1-13.

1045 Mattson, Jeremy L. "The Conflict of Civilization and the Wilderness: A Study of a Theme in American Literature and Painting of the Early Nineteenth Century." DISSERTATION ABSTRACTS INTERNATIONAL 33: 4424A (1973). Ohio State University.

1046 Monk, Samuel H. THE SUBLIME: A STUDY OF CRITICAL THEORIES IN EIGHTEENTH-CENTURY ENGLAND. New York: Modern Language

Association of America, 1935.

> An authoritative discussion of the sublime in painting and in natural scenery is presented.

1047 Motherwell, Robert, ed. THE DADA PAINTERS AND POETS: AN ANTHOLOGY. Documents of Modern Art, VIII. New York: Wittenborn, Schultz, 1951.

1048 Nevius, Blake. COOPER'S LANDSCAPES: AN ESSAY ON THE PIC-TURESQUE VISION. Berkeley and Los Angeles: University of California Press, 1976.

1049 Redding, Saunders. "The Black Arts Movement in Negro Poetry." AMERICAN SCHOLAR 42 (Spring 1973): 330-36.

1050 Rozran, B.W. "Vorticist Poetry with Visual Implications: the 'forgotten' Experiment of Ezra Pound." STUDIO 173 (April 1967): 170-72.

1051 Rye, Jane. FUTURISM. New York: E.P. Dutton and Co., 1976.

> This book covers Futurists not only in painting and sculpture, but also in the theater, literature, and politics.

1052 Skelton, Robin. "Pop Art and Pop Poetry." ART INTERNATIONAL 13 (October 1969): 39-41.

1053 Stubbs, John C. "The Ideal in the Literature and Art of the American Renaissance." EMERSON SOCIETY QUARTERLY 55 (II Quarter 1969): 55-63.

1054 Wees, William C. "Pound's Vorticism: Some New Evidence and Further Comments." WISCONSIN STUDIES IN CONTEMPORARY LITERATURE 7 (1966): 211-16.

1055 Weiskel, Thomas. THE ROMANTIC SUBLIME: STUDIES IN THE STRUC-TURE AND PSYCHOLOGY OF TRANSCENDENCE. Baltimore, Md.: Johns Hopkins University Press, 1976.

1056 Wodehouse, Lawrence. "'New Path' and the American Pre-Raphaelite Brotherhood." ART JOURNAL 25 (1966): 351-54.

1057 Zweig, Paul. "The New Surrealism." SALMAGUNDI 22-23 (1973): 269-84.

CONCRETE, MINIMAL, OR VISUAL POETRY

1058 Asher, Elise. THE MEANDERING ABSOLUTE. New York: Morris Gallery Press, 1973.

 This is a collection of poem-paintings.

1059 Ashton, Dore. "Everything should be as simple as it is but not simpler." STUDIO INTERNATIONAL 184 (September 1972): 86-88.

 This concerns minimal or visual poetry.

1060 Begg, John. "Abstract Art and Typographic Format." MAGAZINE OF ART 45 (January 1952): 27-33.

1061 Boultenhouse, Charles. "Poems in the Shapes of Things." ART NEWS ANNUAL 28 (1959): 64-83, 178.

1062 Bowles, Jerry G. "Tom Phillips; Words and Pictures." ART IN AMERICA 62 (January-February 1974): 65-67.

 Visual poetry is considered.

1063 Bowles, Jerry G., and Russell, Tony, eds. THIS BOOK IS A MOVIE. New York: Delta Books, 1971.

 This is a collection of visual poetry.

1064 "Concrete Poetry Is." ARCHITECTURAL REVIEW 142 (Summer 1967): 193-95.

1065 Doyle, Mike. "Notes on Concrete Poetry." CANADIAN LITERATURE 46 (1970): 91-95.

1066 Draper, R.P. "Concrete Poetry." NEW LITERARY HISTORY 2 (1971): 329-40.

1067 Finch, Peter. "Concrete Poetry: A Brief Outline." THE ANGLO-WELSH REVIEW 19 (1970): 207-12.

1068 Gross, Ronald, and Quasha, George, eds. OPEN POETRY; FOUR AN-THOLOGIES OF EXPANDED POEMS. New York: Simon and Schuster, 1973.

1069 Hertz, Peter D. "Minimal Poetry." WESTERN HUMANITIES REVIEW 24 (Winter 1970): 31-40.

1070 Klonsky, Milton, ed. SPEAKING PICTURES: A GALLERY OF PICTORIAL POETRY FROM THE SIXTEENTH CENTURY TO THE PRESENT. New York: Crown Publishers, 1975.

1071 Kostelanetz, Richard, ed. FUTURE FICTIONS. New York: Panache, 1971.

 This is a collection of visual poetry.

1072 _____, ed. IMAGED WORDS, WORDED IMAGES. New York: Outerbridge, 1971.

 This is a collection of visual poetry.

1073 _____. "Words and Images Artfully Entwined." ART INTERNATIONAL 14 (Summer 1970): 44-56.

1074 Merritt, Francine. "Concrete-Poetry--Verbivocovisual." SPEECH TEACHER 18 (1969): 109-14.

1075 North, Jessica Nelson. "Visual Poetry." POETRY 31 (March 1928): 334-38.

 An early essay on the type.

1076 O'Doherty, Brian. "Elise Asher: Ut Pictura Poesis." ART IN AMERICA 61 (November-December 1973): 107-8.

 An innovative practitioner of the type writes.

1077 Reichart, Jasia. "The Whereabouts of Concrete Poetry." STUDIO INTERNATIONAL 171 (February 1966): 56-59.

1078 Rosenthal, David. "Concretist Poets and Poetry." POETRY 112 (May 1968): 125-27.

 A review of seven volumes of concrete poetry is presented.

1079 Russell, John. "Concrete Poetry." ART IN AMERICA 54 (January-February 1966): 86-89.

1080 Schjeldahl, Peter. "Dwan Gallery's LANGUAGE III Show." ART INTERNATIONAL 13 (October 1969): 74-76.

A showing of 79 works on "Word Art."

1081 Schwerner, Armand. THE TABLETS I-XV. New York: Grossman, 1971.

This is also a collection of visual poetry.

1082 Sharkey, John. "An Evaluation of Visual Poetry in Terms of Movement." STUDIO INTERNATIONAL 176 (December 1968): 237-38. Reply: Stuart Mills, 177 (February 1969): 63.

1083 Solt, Mary Ellen, ed. CONCRETE POETRY: A WORLD VIEW. Bloomington: Indiana University Press, 1968.

1084 Wall, Jeffrey. "Vancouver: Concrete Poetry." ARTFORUM 7 (Summer 1969): 70-71.

1085 Williams, Emmett. SELECTED SHORTER POEMS, 1950-1970. New York: New Directions, 1975.

Concrete poetry, some in color, is presented.

1086 _____, ed. AN ANTHOLOGY OF CONCRETE POETRY. New York: Something Else Press, 1967.

Section VI

SOURCES ON THE RELATIONSHIP

OF AMERICAN FICTION AND PAINTING

SOURCES ON THE RELATIONSHIP
OF AMERICAN FICTION AND PAINTING

1087 Arnavon, Cyrille. "Theodore Dreiser and Painting." AMERICAN LIT-
ERATURE 17 (May 1945): 113-26.

1088 "Art and the Writer." ART IN AMERICA 47, no. 2 (1959): 48-61.
This includes: "A Narrative Painting," by John Dos Passos; "The Painted
Personage," by M.G. Eberhart; "Concept of the Painter in Fiction," by
F.P. Keyes; "Writers as Artists," by E.C. Jessup; "American Illustrators,"
by F. Weitenkampf.

1089 Bell, Millicent. HAWTHORNE'S VIEW OF THE ARTIST. Albany: State
University of New York Press, 1962.

1090 Betsky-Zweig, S. "The Cannonballed of Popular Culture: Nathanael
West's MISS LONELYHEARTS and THE DAY OF THE LOCUST." DUTCH
QUARTERLY REVIEW OF ANGLO-AMERICAN LETTERS, vol. 4: 145-56.

 This compares West to Hieronymus Bosch.

1091 Blow, Suzanne. "Pre-Raphaelite Allegory in THE MARBLE FAUN."
AMERICAN LITERATURE 44 (1972): 122-27.

1092 Bochner, Jay. "Life in a Picture Gallery: Things in THE PORTRAIT OF
A LADY and THE MARBLE FAUN." TEXAS STUDIES IN LITERATURE
AND LANGUAGE 11 (Spring 1969): 761-77.

1093 Bowden, Edwin T. THEMES OF HENRY JAMES: A SYSTEM OF OBSER-
VATION THROUGH THE VISUAL ARTS. New Haven, Conn.: Yale Uni-
versity Press, 1956.

1094 Braddock, Richard. "Literary World of Albert Pinkham Ryder; with List
of Sources of Literary Subjects." GAZETTE DES BEAUX ARTS 33
(January 1948): 47-56.

1095 Brodtkorb, Paul, Jr. "Art Allegory in THE MARBLE FAUN." PMLA 77 (1962): 254-67.

1096 Brown, Milton W. "The Ash Can School." AMERICAN QUARTERLY 1 (Summer 1949): 127-34.

 The kinship of literary and artistic realists of the early twentieth century.

1097 Budz, Judith Kaufman. "Cherubs and Humble Bees: Nathaniel Hawthorne and the Visual Arts." CRITICISM 17 (Spring 1975): 168-81.

1098 _____. "Nathaniel Hawthorne and the Visual Arts." DISSERTATION ABSTRACTS INTERNATIONAL 34: 4245 A-46 A (1974). Northwestern University.

1099 Fendelman, Earl. "Gertrude Stein Among the Cubists." JOURNAL OF MODERN LITERATURE 2 (1972): 481-90.

1100 Firebaugh, J.J. "Relativism of Henry James." JOURNAL OF AESTHETICS AND ART CRITICISM 12 (December 1953): 237-42.

1101 Fitz, L.T. "Gertrude Stein and Picasso: The Language of Surfaces." AMERICAN LITERATURE 45 (May 1973): 228-37.

1102 Furrow, Sharon. "Psyche and Setting: Poe's Picturesque Landscapes." CRITICISM 15 (Winter 1973): 16-27.

1103 Gale, Robert L. "Art Imagery in Henry James's Fiction." AMERICAN LITERATURE 29 (March 1957): 47-63.

1104 George, Jonathan C. "Stein's 'A Box.'" EXPLICATOR 31 (1973): item 42.

 Stein's prose poem "The Box" as a cubist still life is analyzed.

1105 Gerdts, W.H. "Inman and Irving: Derivatives from Sleepy Hollow." ANTIQUES 74 (November 1958): 420-23.

1106 Gneiting, Teona Tone. "Picture and Text: A Theory of the Illustrated Novel in the Nineteenth Century." A dissertation in progress at U.C.L.A.

1107 Goldenthal, Janice B. "Henry James and Impressionism: A Method of Stylistic Analysis." DISSERTATION ABSTRACTS INTERNATIONAL 35: 2967A (1974). New York University.

1108 Gollin, Rita K. "Painting and Character in THE MARBLE FAUN." ESQ; A JOURNAL OF THE AMERICAN RENAISSANCE 21 (First Quarter 1975): 1-10.

1109 Hess, Jeffrey A. "Sources and Aesthetics of Poe's Landscape Fiction." AMERICAN QUARTERLY 22 (1970): 177-89.

 Kinship with Cole's "The Voyages of Life" series is analyzed.

1110 Hoffman, Michael J. THE DEVELOPMENT OF ABSTRACTIONISM IN THE WRITINGS OF GERTRUDE STEIN. Philadelphia: University of Pennsylvania Press, 1965.

1111 Hopkins, Viola. "Visual Art Devices and Parallels in the Fiction of Henry James." PMLA 76 (December 1961): 561-74.

1112 Hornberger, Theodore. "Painters and Painting in the Writings of F. Hopkinson Smith." AMERICAN LITERATURE 16 (March 1944): 1-10.

 This mainly deals with Smith's autobiographical novel THE FORTUNES OF OLIVER HORN (1902).

1113 Horne, Helen. BASIC IDEAS OF JAMES'S AESTHETICS AS EXPRESSED IN THE SHORT STORIES CONCERNING ARTISTS AND WRITERS. Marburg: Erich Mauersberger, 1960.

1114 Idol, John L., Jr. "Thomas Wolfe and Painting." RE: ARTS AND LETTERS 2 (1969): 14-20.

1115 James, Henry. THE PAINTER'S EYE: NOTES & ESSAYS ON THE PICTORIAL ARTS. Ed. John L. Sweeney. Cambridge, Mass.: Harvard University Press, 1956.

1116 Jones, Howard Mumford. "James Fenimore Cooper and the Hudson River School." MAGAZINE OF ART 45 (October 1952): 243-51.

1117 Kirby, David K. "A Possible Source for James's 'The Death of the Lion.'" COLBY LIBRARY QUARTERLY 10 (1972): 39-40.

1118 Kirk, Clara (Marburg). WILLIAM DEAN HOWELLS AND ART IN HIS TIME. New Brunswick, N.J.: Rutgers University Press, 1965.

1119 Kirschke, James J. "Henry James's Use of Impressionist Painting Techniques in THE SACRED FOUNT and THE AMBASSADORS." STUDIES IN THE TWENTIETH CENTURY 13 (1974): 83-116.

1120 Kwiat, Joseph J. AMERICA'S CULTURAL COMING OF AGE. Hydera-
bad, India: American Studies Research Centre, 1967.

> This work concerns Crane, Norris, and Dreiser as well as
> those painters of the Ash Can School, Henri, Glackens,
> Sloan, and Shinn, who sympathized with minority groups and slum
> dwellers and opposed materialist values, economic injustice,
> and American imperialism.

1121 _____. "Dreiser and the Graphic Artist." AMERICAN QUARTERLY 3
(Summer 1951): 127-41.

> Dreiser's relationship with members of the Ash Can School.

1122 _____. "Dreiser's THE GENIUS and Everett Shinn, The 'Ash-Can'
Painter." PMLA 67 (March 1952): 15-31.

1123 _____. "The Social Responsibilities of the American Painter and Writer:
Robert Henri and John Sloan; Frank Norris and Theodore Dreiser." THE
CENTENNIAL REVIEW 21 (Winter 1977): 19-35.

> This article is on issues generated by artists' sense of their
> social responsibilities during the Progressive era.

1124 _____. "Stephen Crane and Painting." AMERICAN QUARTERLY 4
(Winter 1952): 331-38.

1125 Levy, Leo B. "Hawthorne and the Sublime." AMERICAN LITERATURE
37 (January 1966): 391-402.

> Levy places the author in context of conventions of painting
> of his day.

1126 _____. "THE MARBLE FAUN: Hawthorne's Landscape of the Fall."
AMERICAN LITERATURE 42 (1970): 139-56.

1127 _____. "Picturesque Style in HOUSE OF THE SEVEN GABLES."
NEW ENGLAND QUARTERLY 39 (June 1966): 147-56.

1128 Light, James F. "The Christ Dream" in NATHANAEL WEST: AN
INTERPRETATIVE STUDY. Evanston, Ill.: Northwestern University Press,
1961, pp. 74-98.

> The discussion includes painterly imagery in MISS LONELY-
> HEARTS.

1129 "Literary Inspiration in Art; Exhibition at the Denver Art Museum." ART
DIGEST 27 (1 March 1953): 10.

1130 Maynard, Reid. "Abstractionism in Gertrude Stein's THREE LIVES." BALL STATE UNIVERSITY FORUM 15 (January 1973): 68-71.

1131 Mellow, James R. CHARMED CIRCLE: GERTRUDE STEIN AND COMPANY. New York: Praeger Publishers, 1974.

The circle included Picasso, Matisse, Hemingway, and others.

1132 Meyers, Jeffrey. "Brueghel and AUGIE MARCH." AMERICAN LITERATURE 49 (March 1977): 113-19.

Symbolic significance of Pieter Brueghel's "The Misanthrope" in Saul Bellow's novel.

1133 _____. PAINTING AND THE NOVEL. New York: Barnes & Noble Import Division, 1975.

This includes select general bibliography on the relation of art and literature, foreign and American.

1134 Muller, Herbert J. "Impressionism in Fiction: Prism vs. Mirror." AMERICAN SCHOLAR 7 (Summer 1938): 355-67.

How techniques of the Impressionist painters were adapted to fiction.

1135 Murray, Donald M. "James and Whistler at the Grosvenor Gallery." AMERICAN QUARTERLY 4 (Spring 1952): 49-65.

1136 Nagel, James. "Impressionism in 'The Open Boat' and 'A Man and Some Others.'" RESEARCH STUDIES (Washington State University) 43 (1975): 27-37.

1137 Putt, Samuel Gorley. HENRY JAMES, A READER'S GUIDE. Ithaca, N.Y.: Cornell University Press, 1966.

This commentary includes the thematic heading "art stories."

1138 Ringe, Donald A. "Chiaroscuro as an Artistic Device in Cooper's Fiction." PMLA 78 (September 1963): 349-57.

1139 _____. "Early American Gothic: Brown, Dana, and Allston." AMERICAN TRANSCENDENTAL QUARTERLY 19 (Summer 1973): 3-8.

1140 _____. "James Fenimore Cooper and Thomas Cole: An Analogous Technique." AMERICAN LITERATURE 30 (1958): 26-36.

1141 _____. "Man and Nature in Cooper's THE PRAIRIE." NINETEENTH CENTURY FICTION 15 (March 1961): 313-23.

Cooper's descriptive scenes and the Hudson River School are discussed.

1142 Rogers, Rodney O. "Stephen Crane and Impressionism." NINETEENTH-CENTURY FICTION 24 (December 1969): 292-304.

1143 Rogers, W.H. "Form in the Art Novel." HELICON 2 (1939): 1-7.

1144 Rose, Sir Francis Cyril. GERTRUDE STEIN AND PAINTING. London: BOOK COLLECTING AND LIBRARY MONTHLY, 1968.

1145 St. Armand, Barton. "Jewett and Marin: The Inner Vision." COLBY LIBRARY QUARTERLY 9 (1972): 632-43.

This article discusses Sarah Orne Jewett, Winslow Homer, and John Marin.

1146 Schulz, Max F. "Pop, Op, and Black Humor: The Aesthetics of Anxiety." COLLEGE ENGLISH 30 (December 1968): 230-41.

Important connections between contemporary writers and artists in terms of themes and techniques are analyzed.

1147 Sokol, David. "John Quidor and the Literary Sources for His Paintings." ANTIQUES 52 (October 1972): 675-79.

1148 _____. "John Quidor, Literary Painter." AMERICAN ART JOURNAL 2 (Spring 1970): 60-73.

1149 Star, Morris. "Melville's Markings in Walpole's ANECDOTES OF PAINTING IN ENGLAND." PAPERS OF THE BIBLIOGRAPHICAL SOCIETY OF AMERICA 66 (1972): 321-27.

1150 Stearns, Bertha M. "Nineteenth-Century Writers in the World of Art." ART IN AMERICA 40 (Winter 1952): 29-41.

Paintings based on the writings of Bryant, Irving, and Cooper are discussed.

1151 Sweeney, J.L. "The Demuth Pictures." KENYON REVIEW 5 (Autumn 1943): 522-32.

This article discusses two watercolors by Charles Demuth which were inspired by Henry James's "The Turn of the Screw" and "The Beast in the Jungle."

1152 Thissen, John Hughes. "Sherwood Anderson and Painting." DISSERTA-
TION ABSTRACTS INTERNATIONAL 35: 6736A (1975). Northwestern
University.

1153 Tinter, Adeline R. "Henry James and a Watteau Fan." APOLLO 99
(1974): 488.

1154 Torchiana, Donald. "THE DAY OF THE LOCUST and The Painter's Eye."
In NATHANAEL WEST: THE CHEATERS AND THE CHEATED. Ed.
David Madden. Deland, Fla.: Everett/Edwards, 1973, pp. 249-82.

1155 Ward, Susan P. "Painting and Europe in THE AMERICAN." AMERICAN
LITERATURE 46 (1975): 566-73.

1156 Watts, Emily Stipes. ERNEST HEMINGWAY AND THE ARTS. Urbana:
University of Illinois Press, 1971.

 Hemingway borrowed techniques from Cézanne, Goya, Bosch,
 Miro, Masson, and Klee.

1157 Weisman, Donald L. LANGUAGE AND VISUAL FORM: THE PERSONAL
RECORD OF A DUAL CREATIVE PROCESS. Austin: University of Texas
Press, 1968.

 "I attempted to objectify the process of creating a complex of
 paintings and [narrative] writing at the same time this complex
 was being created."

1158 West, Rebecca. "The Classic Artist." NEW YORK HERALD TRIBUNE
BOOK REVIEW, September 11, 1927.

 Willa Cather is compared, in part, to Velásquez.

1159 Williams, R.S. "Irving's Stories in Quidor's Paintings." ANTIQUES 72
(November 1957): 443-45.

1160 Winner, Viola Hopkins. HENRY JAMES AND THE VISUAL ARTS.
Charlottesville: University Press of Virginia, 1971.

1161 _____. "Pictorialism in Henry James's Theory of the Novel." CRITI-
CISM 9 (Winter 1967): 1-21.

1162 Wolff, Cynthia Griffin. "Lily Bart and the Beautiful Death." AMERI-
CAN LITERATURE 46 (March 1974): 16-40.

 This work treats the influence of the American Neoclassical
 school of portraiture and Art Nouveau on the idealized woman
 and Edith Wharton's use of this tradition in THE HOUSE OF
 MIRTH (1905).

Sources on Relationship of Fiction & Painting

1163 Woodard, Philip Allen. "Washington Irving and Washington Allston:
The Presence of the Past." DISSERTATION ABSTRACTS INTERNATIONAL
36: 292A (1975). Unpublished doctoral dissertation, George Washington
University, 1974.

1164 Wright, Nathalia. "Roderick Usher: Poe's Turn-of-the-Century Artist."
ARTFUL THUNDER: VERSIONS OF THE ROMANTIC TRADITION IN
AMERICAN LITERATURE IN HONOR OF HOWARD P. VINCENT. Ed.
Robert J. DeMott and Sanford E. Marovitz. Kent, Ohio: Kent State
University Press, 1975, pp. 55-67.

1165 Wynne, Carolyn. "Aspects of Space: John Marin and William Faulkner."
AMERICAN QUARTERLY 16 (Spring 1964): 59-71.

1166 Zlotnick, Joan. "Nathanael West and the Pictorial Imagination."
WESTERN AMERICAN LITERATURE 9 (Fall 1975): 177-85.

 Like a painter, West "communicates primarily through images"
 in his fiction.

146

ADDENDA TO CHAPTERS V AND VI

1167 Blair, Harold R. "The American Titian: A Study of Washington Allston and His Age." DISSERTATION ABSTRACTS INTERNATIONAL 35 (1975) 7294A.

1168 Brater, E. "Empty Can: Samuel Beckett and Andy Warhol." JOURNAL OF MODERN LITERATURE 3 (July 1974): 1255-64.

1169 Conley, T. K. "Beardsley and Faulkner." JOURNAL OF MODERN LITERATURE 5 (September 1976): 339-56.

1170 Edgington, K. Ann. "Abstraction as a Concept in the Criticism of Gertrude Stein and Wassily Kandinsky." DISSERTATION ABSTRACTS INTERNATIONAL 37 (1976): 1540A

1171 Hakeem, A. "Sylvia Plath's Elm and Munch's 'The Scream.'" ENGLISH STUDIES 55 (December 1974): 531-37.

1172 Hubert, R.R. "Writers as Art Critics: Three Views of the Paintings of Paul Klee." CONTEMPORARY LITERATURE 18 (Winter 1977): 75-92.

1173 Hunt, John Dixon. "'Broken Images': T.S. Eliot and Modern Painting." THE WASTE LAND IN DIFFERENT VOICES, ed. A.D. Moody. London: University of York, 1974, pp. 163-84.

 An art exhibition in Boston from April to May 1913, consisting of holdovers from the Armory Show, may have influenced Eliot while he was a student at Harvard.

1174 Kidder, Rushworth M. "E.E. Cummings, Painter." HARVARD LIBRARY BULLETIN 33 (1975): 117-38.

1175 KNOWLES, A.S., Jr. "Dos Passos in the Twenties." THE TWENTIES: FICTION, POETRY, DRAMA, ed. Warren French. Deland, Fla.: Everett/Edwards, 1975, pp. 123-37.

 On influence of Cézanne and Monet on THREE SOLDIERS.

1176 Libby, A. "O'Hara on the Silver Range." CONTEMPORARY LITERA-
 TURE 17 (Spring 1976): 240-62.

1177 Ljungquist, Kent Paul. "Poe's Landscape Aesthetics and Pictorial Tech-
 niques." DISSERTATION ABSTRACTS INTERNATIONAL 36 (1976):
 6687A.

1178 Lycette, R.L. "Perceptual Touchstones for the Jamesian Artist-Hero."
 STUDIES IN SHORT FICTION 14 (Winter 1977): 55-62.

1179 McCormick, E.A. "Poema Pictura Loquens: Literary Pictorialism and
 the Psychology of Landscape." COMPARATIVE LITERATURE STUDIES
 13 (Summer 1976): 196-213.

1180 Mariani, P. "Eighth Day of Creation: William Carlos Williams' Late
 Poems." TWENTIETH-CENTURY LITERATURE 21 (October 1975):
 305-18.

1181 Prince, Jeffrey R. "The Iconic Poem and the Aesthetic Tradition." ELH
 43 (Winter 1976): 567-83.

1182 Rose, Marilyn Gaddis. "Gertrude Stein and Cubist Narrative." MOD-
 ERN FICTION STUDIES 22 (Winter 1976-77): 543-55.

1183 Shea, Jerome Paul. "Sherwood Anderson, Charles Burchfield, and the
 American Small Town." DISSERTATION ABSTRACTS INTERNATIONAL
 37 (1976): 2176A.

1184 Silverman, Kenneth. A CULTURAL HISTORY OF THE AMERICAN REV-
 OLUTION: PAINTING, MUSIC, LITERATURE, AND THE THEATRE IN
 THE COLONIES AND THE UNITED STATES FROM THE TREATY OF
 PARIS TO THE INAUGURATION OF GEORGE WASHINGTON. 1763-
 1789. New York: Crowell, 1976.

1185 Spangler, William. "Rockwell Kent and MOBY-DICK." EXTRACTS:
 AN OCCASIONAL NEWSLETTER (June 1976): 7-10.

1186 Spencer, T.J.B. The Imperfect Parallel Betwixt Painting and Poetry."
 GREECE AND ROME, 2d ser., 7 (October 1960): 173-86.

1187 Starr, Margaret Morgan. "The Visual Imagination of William Carlos
 Williams: A Study of PICTURES FROM BRUEGHEL." DISSERTATION
 ABSTRACTS INTERNATIONAL 37 (1976): 317A-18A.

1188 Stein, Roger B. "Copley's WATSON AND THE SHARK and Aesthetics
 in the 1770's." DISCOVERIES AND CONSIDERATIONS: ESSAYS ON
 EARLY AMERICAN LITERATURE AND AESTHETICS PRESENTED TO HAR-
 OLD JANTZ, ed. Calvin Israel. Albany: State University of New
 York Press, 1976, pp. 85-130.

Links the painting with other phases of early American aes-
thetic thought and practice, including the painting's distinc-
tive American identity and its iconography of the sublime.

1189 Wasserstrom, William. "The Sursymamericubealism of Gertrude Stein."
TWENTIETH-CENTURY LITERATURE 21 (1975): 90-106.

Argues that mainstreams in modern art merge in Stein's work.

1190 Webb, Dorothy M. "Fitzgerald on El Greco: A View of THE GREAT
GATSBY." FITZGERALD-HEMINGWAY ANNUAL, 1975, pp. 89-91

Cites parallels between El Greco's "View of Toledo" and the
novel.

1191 Wimsatt, W[illiam].K. "Laokoön: An Oracle Reconsulted" and "In
Search of Verbal Mimesis." In his DAY OF THE LEOPARDS: ESSAYS IN
DEFENSE OF POEMS. New Haven, Conn. and London: Yale Univer-
sity Press, 1976, pp. 40-56.

The articles cover four areas: interpretation of visual art in
literary terms, the analogy between visual and literary art,
the union of analogous arts, and the medium of communica-
tion—words compared to pictures.

1192 Wolf, Jack C. "Henry James and Impressionist Painting." CEA CRITIC
38 (1976): 14-16.

1193 Yasuna, Edward Carl. "The Power of the Lord in the Howling Wilder-
ness: The Achievement of Thomas Cole and James Fenimore Cooper."
DISSERTATION ABSTRACTS INTERNATIONAL 37 (1976): 2885A.

1194 Zessin, Bruce Delmar. "Images of the Artist in Nineteenth-Century
Fiction." DISSERTATION ABSTRACTS INTERNATIONAL 36 (1976):
6693A-94A.

Deals with Allston, N.P. Willis, Curtis, Hawthorne, Melville,
H. James, Howells, and Norris.

INDEXES

INDEX OF AUTHORS

This index includes all authors, editors, compilers, and translators cited in the text. In some cases the authors are also painters and have been cross-referenced with the Index of Painters, pp. 161-65. Alphabetization is letter by letter and references are to entry numbers.

A

Abel, Lionel 375
Adams, John 902
Addison, Joseph 855
Aiken, Conrad 242, 336
Aldrich, Thomas Bailey 158
Alison, Archibald 979
Allentuck, Marcia 656
Alloway, Lawrence 356
Allston, Washington 24, 57, 376-79, 520, 657-58. See also Index of Painters
Alpers, Paul 786
Alpers, Svetlana 786
Ames, Evelyn 380, 659
Anderson, Jack 521
Anderson, Sherwood 1152, 1183
Antin, Eleanor 664
Antrobus, John 150
Appleton, Thomas Gold 55
Arensberg, Walter Conrad 665
Ashbery, John 383-84, 589, 666-67, 980
Asher, Elise 1058
Ashton, Dore 861-62
Atlanticus 19
Aubin, Robert A. 1020

B

Babbitt, Irving 788
Barlow, Joel 53, 525
Beckett, Samuel 1168
Bell, Millicent 1089
Bellow, Saul 1132
Benet, Stephen Vincent 47, 169, 227-28
Benét, William Rose 168
Bennett, Gwendolyn B. 668
Benson, Elizabeth Polk 526
Berkeley, George 9
Berkson, William 350
Bermingham, Peter 790
Berryman, John 385, 527
Bevington, Helen 528
Bierce, Ambrose 953
Bishop, Elizabeth 223, 386
Bishop, John Peale 981
Bishop-Dubjinsky, G. 529
Blair, Harold R. 1167
Bluhm, Norman 387-88
Bode, Carl 669, 867
Bogan, Louise 389, 854
Brackenridge, H.H. 9
Bradstreet, Anne 2, 270
Brainard, John G.C. 70
Brater, E. 1168

Index of Authors

INDEX OF PAINTERS

This index includes all painters cited in the text; in some cases the painters are also authors and have been cross-referenced with the Index of Authors, pp. 153-60. Alphabetization is letter by letter and references are to entry numbers.

A

Albers, Josef [Joseph] 211, 346
Albright, Ivan LeLoraine 212, 283, 336
Allston, Washington 22-24, 57, 175-87, 447, 537, 640, 964, 978, 1007, 1017, 1139, 1163, 1167, 1194. See also Index of Authors
Angelico, Fra. See Fiesole, Giovanni da
Anguissola, Sofonisba 392
Asher, Elise 213, 1076
Audubon, John James 28-29, 642, 1006
Austin, Darrel 249

B

Backhuysen, Ludolf 500
Bacon, Francis 425
Badger, Joseph 486
Baker, Charles 58
Bazille, Frédéric 509
Beardsley, Aubrey 1169
Bechtle, Robert 214
Bellini, Giovanni 420, 472
Bellows, George Wesley 126, 167, 254, 292, 308, 318
Benson, Frank W. 445
Benton, Thomas Hart 168-69, 215-16, 321

Bierstadt, Albert 243
Bingham, George Caleb 60-63, 298, 945, 1001
Birch, Thomas 30-32
Bishop, Isabel 368
Blakelock, Ralph A. 274
Blume, Peter 333
Bonnard, Pierre 562
Books, James 355
Bosch, Hieronymus 504, 610, 1156
Botticelli, Sandro 397, 431, 453, 515, 526, 598, 631, 652
Brach, Paul 351
Brainard, Joe 477
Brancuşi, Constantin 563
Braque, Georges 521, 543, 546
Brueghel, Pieter 385, 436, 439-40, 469-70, 517, 549, 606, 943, 1132
Burchfield, Charles E. 300, 315, 445, 1183

C

Carpaccio, Vittore 519
Cézanne, Paul 419, 544, 586, 1156, 1175
Chagall, Marc 437, 554, 587, 617, 724
Child, Tom 628
Chirico, Giorgio de 383, 414, 497, 981
Church, Frederic Edwin 64-67, 272

INDEX OF PAINTINGS, BOOKS, POEMS,
AND FIRST LINES OF POEMS

Titles of paintings and books are capitalized. Titles of poems are in upper
and lower case. First lines of poems have been set off by quotation marks.
Alphabetization is letter by letter and references are to entry numbers.

A

About Courbet 607
ABOVE THE EARTH 329
Acquainted with the Night 224
Across the Delaware 108
Addressed to George Washington
 . . . after the battles of Trenton
 Princeton . . . 7
Address to the Springs 49
After a Tempest 89, 148
After Having Seen Chagall's
 Fiances . . . 437
After Looking at a Painting of the
 Crucifixion . . . 505
AFTERNOON 319
AFTER THE HUNT 134
AFTER THE STORM 89
After Turner 530
After Whistler 567
Age (W. Winter) 302
Ages, The (W.C. Bryant) 263, 266
AGNEW CLINIC, THE 127
"Ah oui, en effet!" 359
Albert Ryder—Moonlightist 184
Alex Katz Paints his North Window
 542
A. Lincoln—Odd, or Even 187
Allston's Funeral 537
AMERICAN, THE 1155

AMERICAN ART: ITS AWFUL ALTI-
 TUDE . . . 66, 690
American Gallery: Dolly Hazlewood,
 "Untitled," An 222
American Gallery: Edward Hicks,
 "The Peaceable Kingdom," An 40
American Gallery: John James Audu-
 bon, "The Passenger Pigeon," An
 29
American Gallery: Philip Evergood,
 "American Tragedy," An 173
American Gallery: Robert Fulton,
 "Plate the Second," An 37
American Gallery: William Strick-
 land, "View of Ballston Spa, New
 York," An 49
American Gallery: Winslow Homer,
 "Snap the Whip," An 139
AMERICAN GOTHIC 206
American Ikon—Lincoln 187
AMERICAN INDIAN 232
AMERICAN INTERIOR 201
American Light: A Hopper Retrospec-
 tive 629
AMERICAN MUSE, THE 797
American Painters 525
AMERICAN TRAGEDY (Evergood) 173
AMONG THE GODS (J. Books) 355
Among the Gods (S. Kunitz) 355
Among the Hills 261

167

C